modiglian

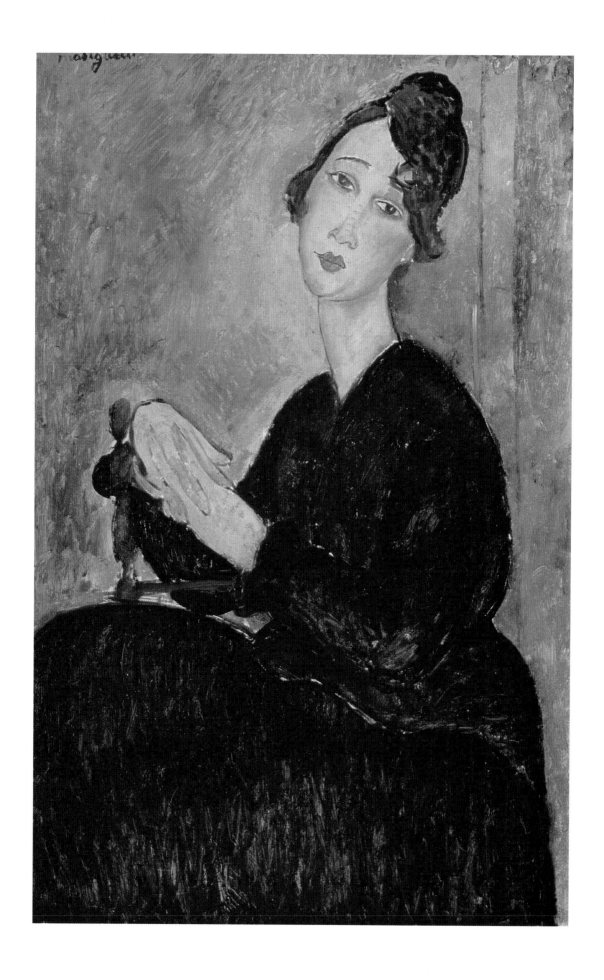

Christian Parisot

modigliani

the Easton Press

Preceding page:
SEATED WOMAN, 1918.
Oil on canvas, 92 x 60 cm.
Musée National d'Art Moderne, Paris.

PHOTOGRAPHS:
Foto Angelica, Livorno,
Foto Arte, Livorno,
Claudio Barontini, Livorno,
Florence Rapinat, Paris.Coupreau-Franzin, Orléans.

© ÉDITIONS TERRAIL/ÉDIGROUP, SN des éditions Vilo, Paris, France 2007
25, rue Ginoux - 75015 Paris

Printed in France
Bound in the United States of America

ISBN : 2-87939-005-2

© ÉDITIONS TERRAIL/ÉDIGROUP, SN des éditions Vilo, Paris, France 2007
25, rue Ginoux - 75015 Paris - FRANCE

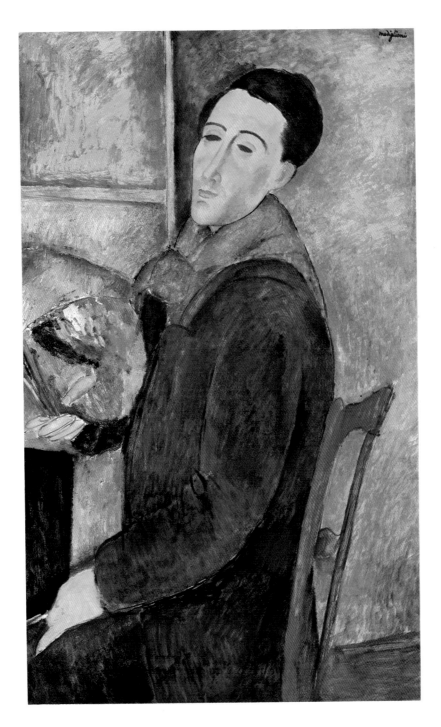

SELF-PORTRAIT, 1919.
Oil on canvas, 100 x 65 cm. Museu de Arte, São Paulo.

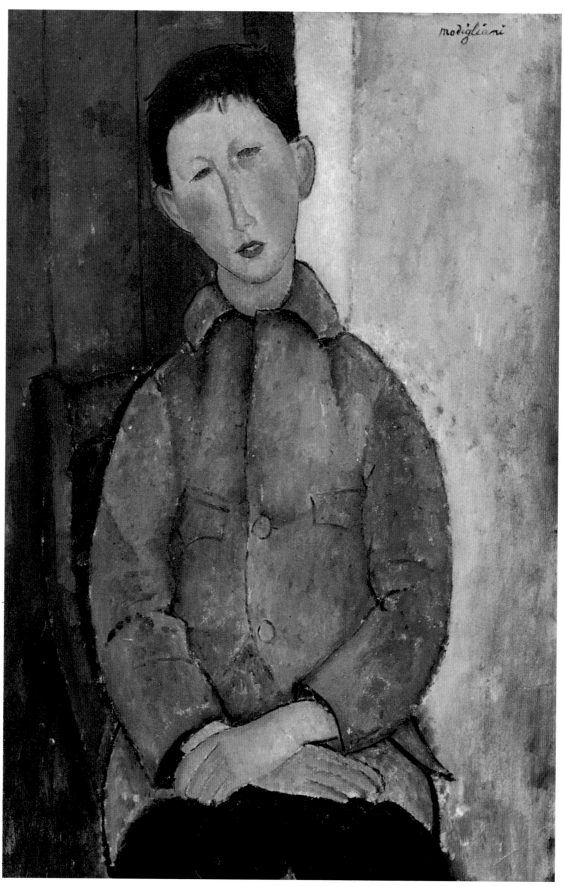

Boy in Blue Jacket, 1918.
Oil on canvas, 92 x 63 cm. The Solomon R. Guggenheim Museum, New York.

Contents

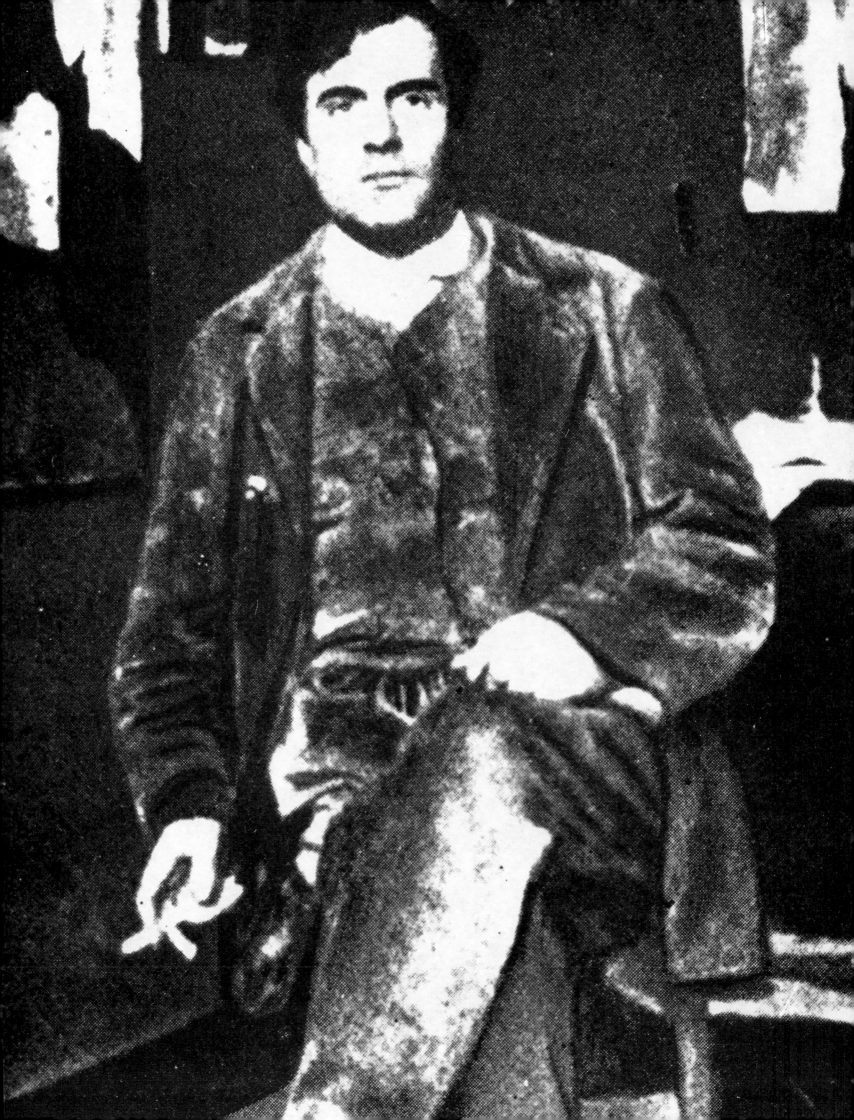

The Life of Amedeo Modigliani
Christian Parisot

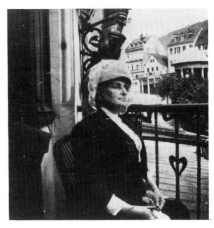

The family home in Livorno.

Top: The artist's mother, Eugénie Garsin-Modigliani, in 1925.

In the 19th century, the great Tuscan port of Livorno was home to a large community of Sephardic Jews. They were immigrants from North Africa, Spain and Portugal who lived a life of great freedom. The members of this community conducted business throughout the Mediterranean and as far afield as England, and were by no means confined to a ghetto. Once they had amassed enough money, they bought houses in the country and so widened their circle of friends. One of these Jews, Solomon Garsin, established himself in Livorno at the end of the 18th century. The Garsin family belonged to the great tradition of lettered Jews: writers on the sacred books and founders of Talmudic schools. The family had always indulged in philosophical discussion.

Joseph Garsin, Solomon's son, settled in Marseilles in 1835 and in 1849 his son, Isaac, married Régine Spinoza who claimed to be a descendant of the famous philosopher Baruch Spinoza. Eugénie Garsin their daughter, later to become the mother of the painter Modigliani, had a Protestant governess and attended a Catholic school, which explains her tolerant attitudes in later life and her fondness for France.

At the age of 15 Eugénie Garsin became engaged to Flaminio Modigliani, a member of a Jewish family from a village of the same name south of Rome. In 1849, Emmanuel Modigliani had supplied copper to the Papal State to make printing plates for the Vatican mint and, believing himself to be protected by these dealings, had bought a vineyard. But Pontifical law prohibited Jews from owning land and, given 24 hours to sell back the vineyard, he decided upon voluntary exile to Livorno.

Preferring to forget this episode, the family were in the habit of describing themselves as having been "Bankers to the Popes..."

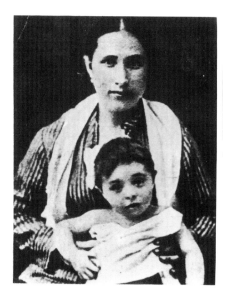

The artist's father, Flaminio Modigliani.

Top: Dedo in the arms of his nurse.

Opposite: Amedeo Modigliani.

Flaminio, Amedeo's father, dealt in wood and charcoal and ran a *banco*, or money broking syndicate, without ever making enough for his own family's needs.

In 1872, after a two-year engagement, Flaminio Modigliani and Eugénie Garsin were married. A year later, installed in the family house in the Via Roma, the couple had a child, Emmanuel, who was to become a lawyer and a Socialist member of parliament. There followed a daughter, Margherita, who was to remain at home and eventually be an adoptive mother to Jeanne, Amedeo's daughter. A second son was born, Umberto, who was to become a mining engineer, and on 12 July 1884, their fourth child, Amedeo, was born. At this time the "groaning board and ever open door" of the Via Roma were but distant memories*. Family finances were at their lowest ebb and even the furniture was under distraint. On Eugénie's bed were piled up the few treasures and items of jewellery they had managed to hang on to - an ancient Roman law prescribed that all goods on the bed of a woman who was about to give birth were safe from seizure against debt. True to Jewish tradition, Amedeo's mother was a mixture of practical philosophy and natural superstition which made her look upon this strange lying-in as a funereal omen.

Amedeo seems to have inherited his mother's leanings in this direction, as can be seen in the prophecies of Nostradamus which he sometimes wrote on the back of his drawings, the inscriptions on his portraits and the symbolic signs which adorn his later work.

From 17 May 1886, Eugénie kept a private diary, which despite containing gaps is still a precious source of documentary information. Her husband, Flaminio, spent most of his time in Sardinia where he was busy with mining operations. She lived therefore with "Granny" and Isaac (her parents), her sisters Gabrielle and Laure and the four children. Her diary is full of memories of her family who used to live in a big house at 21, rue Bonaparte, Marseilles, and of what she learned about her husband's family. She obviously developed her critical and analytical faculties very early on.

In the house where Eugénie now lived, discipline and austerity reigned, happily softened by the presence of the women, who outnumbered the men. The children received a good education. Amedeo attended the primary school and the secondary school for four years where he received a traditional classical education. From an

(*) Quotations taken from the book by Jeanne Modigliani, Modigliani raconte Modigliani, Graphis Arte, Livorno, 1984.

early age he was familiar with the writings of the great Italian poets: Dante, Petrarch, Leopardi, Carducci and D'Annunzio, and he also read Baudelaire, Nietzsche and Spinoza, learning long passages by heart which he was later to declaim to astonished friends in Paris. While he owed his excellent knowledge of the French language to his mother, it is to his aunt Laure that he was indebted for his introduction to philosophy – she was well versed in Kropotkin and Populist theories. Laure loved him very much and was to be a help to him over a long period of time.

Amedeo was also very close to his grandfather Isaac, and they formed the habit of going for long walks together. We do not know what they talked about, but Amedeo would return from these promenades with a precociously serious air which earned him the nickname of "the Philosopher". Both were avid readers and Isaac, who spoke four languages, particularly loved history and philosophy. He was also an excellent chess player.

In the summer of 1895 Amedeo caught a chill and became seriously ill as a result. His mother wrote in her diary: "Dedo has suffered terribly with pleurisy and I am still not over the shock. The child's character is not yet formed enough for me to comment on it. His manners are those of a spoilt but not unintelligent child. We shall see later on what this chrysalis contains. An artist perhaps?"

It was not until 1898 that Amedeo's vocation evinced itself. On 17 July his mother wrote: "Dedo did not do brilliantly in his exams, which is hardly surprising since he has worked very little during the year. On 1 August he starts drawing lessons – which he has long wanted to do. He already feels he is a painter but I don't encourage him in this as I am too afraid he will neglect his studies chasing after shadows. In the meantime I wanted to give him something which would pull him out of this lethargy."

However, that August he was to fall ill again: this time with typhoid fever followed by pulmonary complications. He had been in tears on his sick bed at the thought of

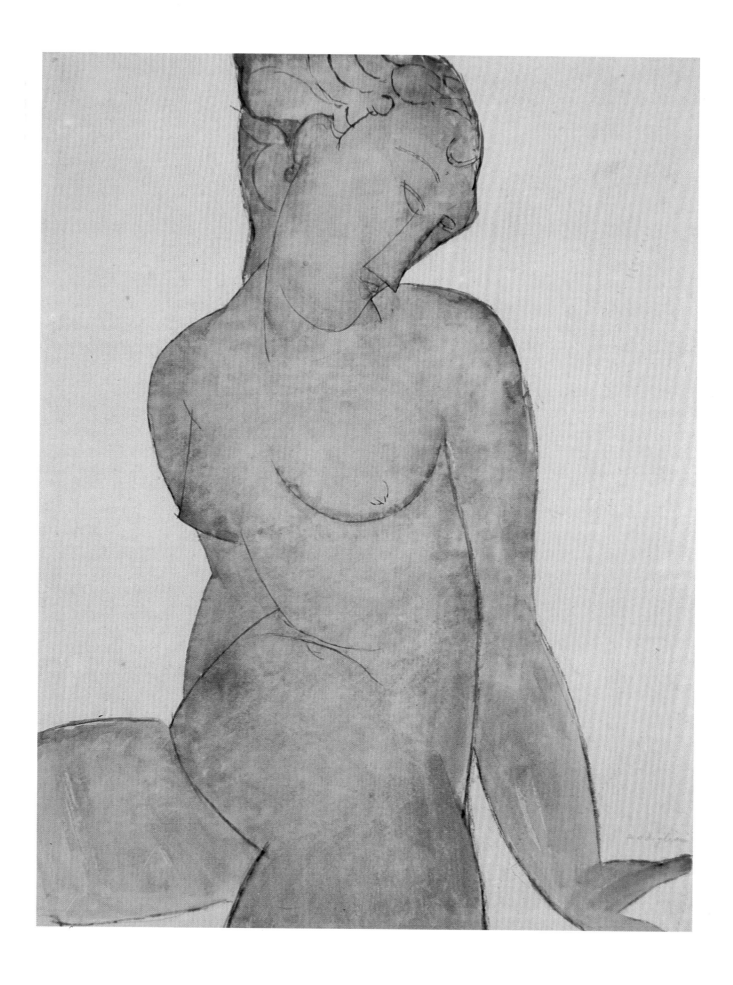

12

never seeing the paintings in the Uffizi and the Pitti Palace in Florence, of which he had heard so much. His mother promised to take him on a visit as soon as he was better. She enrolled him with the best teacher of art in Livorno, the painter Guglielmo Micheli (1866-1926), a pupil of Giovanni Fattori, one of the founders of the "Macchiaiola" school (from the word "Macchia", meaning "spot"). This was a movement started by a group of artists inspired by landscape and Populist subjects around 1860-1870, rather as were the French Impressionists. Micheli was a second generation "Macchiaiolo".

On 10 April 1899, Eugénie wrote in her diary: "Dedo has totally abandoned his studies (at the Lycée) and does nothing but paint. He paints all day and every day with an unflagging enthusiasm which astounds and delights me. If this is not the way to success, nothing is. His master is very pleased with him. I do not really understand anything about it, but it seems to me that after only a few months studying he paints not at all badly and draws extremely well..."

Fattori, now an old man, often visited the studio at the Villa Baciocchi, where a dozen or so boys worked alongside Modigliani, amongst them Benvenuto Benvenuti, Manlio Martinelli, Renato Natali, Llewelyn Lloyd, Aristide Sommati, Oscar Ghiglia, Lando Basto and Gino Romiti. Amedeo was closest to Oscar Ghiglia, a dozen years older than himself, and with whom he later corresponded. They painted still lifes and life models and, in the best tradition of art students, sketched the countryside, the poor quarters of Livorno and the scenery along the canals of the old town. The fact that few early pictures by Amedeo have survived should not lead us to underestimate the importance of his student days spent under the influence of 19th century Italian art, which was indeed a real inspiration to him. From this era a portrait of Micheli's son has survived, as have a self-portrait and one of his rare landscapes: *Landscape in Tuscany*, a small painting on board. Although he later virtually renounced this style of painting, critics link this rapid sketch, with its muted tones, to the Tuscan tradition and to those small landscapes which can be found on Siennese reredos.

But "it was perhaps in his paintings of nudes" declared a friend from those days, "that he best expressed his own ideas, giving free rein to his love of line". Current research suggests that there must certainly still be hidden treasures in the hands of Livorno private collectors which may one day reveal an œuvre in the Macchiaiolian style: works which Modigliani could have painted during this period and which would throw light on his beginnings as an artist.

The typhoid fever had weakened Amedeo's lungs, and he contracted tuberculosis during the winter of 1901, which forced him to interrupt his studies with Micheli.

Against the doctors' advice (they had recommended a stay in the

Above: Identity card photograph, profile.

Opposite: Pink Nude, 1914. Pencil and watercolour on paper, 54.5 x 44.5cm. Private collection.

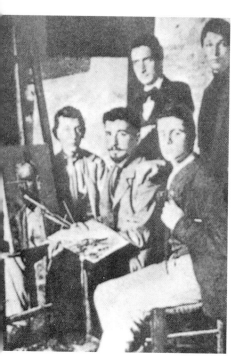

Modigliani with painter friends in Gino Romiti's studio in Livorno in 1900.

mountains), Eugénie Modigliani took her son south: they toured Rome, Capri, Amalfi and Florence, visiting some of the great Italian museums. Amedeo wrote several letters to his friend, Oscar Ghiglia, which alternate advice with justification of his love of art. Five of these letters have survived.

"I am writing to you to cheer myself up and boost my self-confidence. I am a prey to the birth and flowering of extremely strong forces. Really, I would like my life to be like a river, rich in plenty, flowing joyously over the earth. You are the one person to whom I can tell everything: from now on I shall be rich and fecund with the seeds of creativity and I need to work..."

Throughout this trip, he was to feel for the first time the influence of certain great Italian schools of painting and the stimulating atmosphere of the towns he visited. At Santa Clara, San Lorenzo, San Domenico and Santa Maria Domina Regina, Amedeo found happy solutions to the problems of expressing form, which he was to use throughout his short artistic career: notably the angle at which an oval head inclines against a cylindrical neck, the synthesis of mannerist decorative design and sculptural volume and, above all, the use of line as a medium to

SELF-PORTRAIT, 1899.
Charcoal drawing on paper.
Private collection.

14

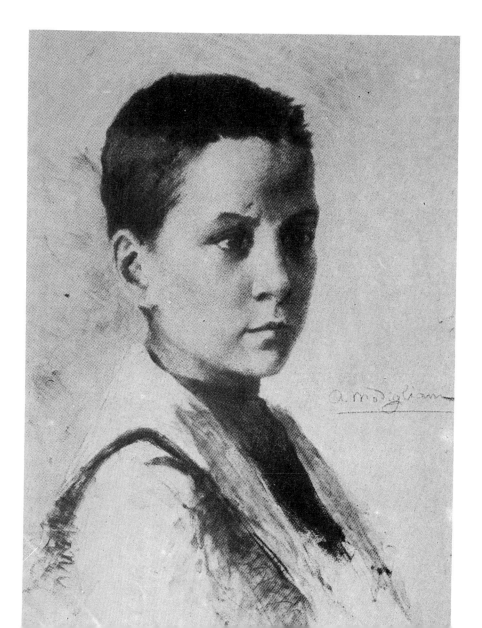

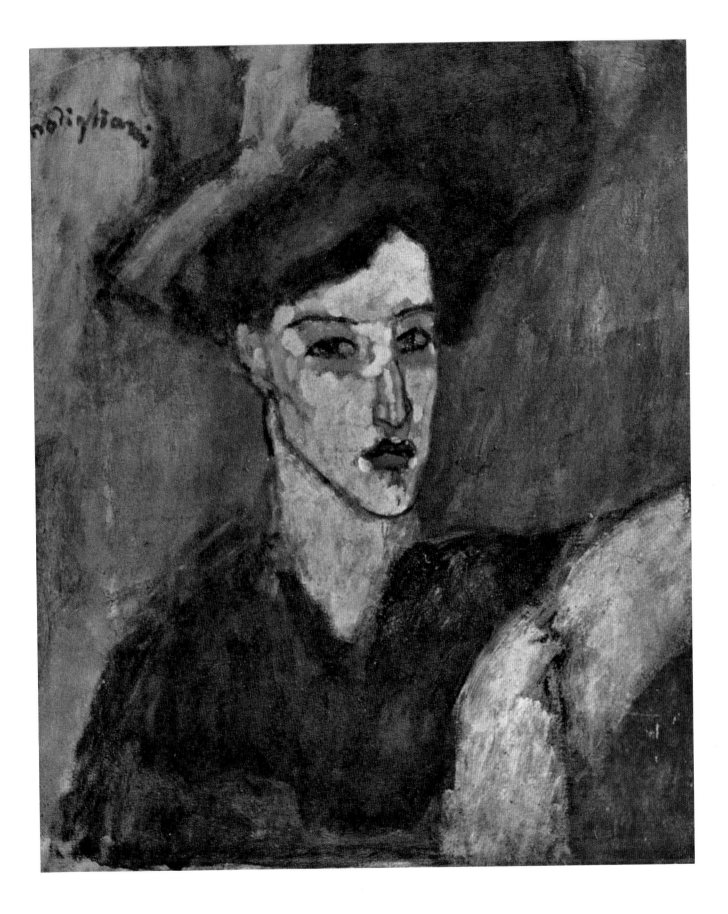

THE JEWESS, 1908.
Oil on canvas, 55 x 46m. Private collection.

suggest form and contain mass, in such a way as to accentuate the feeling of weight.

On returning to Livorno, as can be seen from a letter to Romiti dated 1902, Amedeo left immediately for Pietrasanta at the foot of the Carrara marble quarries. Here he began to sculpt.

On 7 May 1902, the 18 year-old Modigliani, cured of his illness and armed with a mine of culture, passed the entrance exam to the Florence Academy of Art where he joined the *Scuola Libera di Nudo* (life painting school) "in a dilapidated and badly heated garret"*. Here, old Fattori gathered together young artists who wanted to escape from the new representatives of the Macchiaiolian school and work with the master himself.

The following spring, on 19 March 1903, a school register shows that Amedeo enrolled in Life classes at the *Reale Istituto di Belle Arti* in Venice. A note at the foot of his registration form shows that he came from Florence and mentions the date of his enrolment at the Academy there. From then on, Modigliani divided his time between Florence and Venice without forgetting Livorno, where the family, particularly his mother, impatiently awaited his return. A portrait of the wife of his old teacher Micheli dates from this period. It is painted in a new spirit and shows the evolution of his style. During this transitional period, Amedeo broke away from the Macchiaiolian School and concentrated on harmonising colour masses. The face is still

treated in a classical way but the background, hair and shoulders are painted as flat areas of strong tone.

In the years before his move to Paris, Amedeo continued to conduct a Nietzsche-like correspondence with his friend Oscar Ghiglia and began to draw more in cafés than at classes.

Guido Cadorin who, together with Mario Crepet, Guido Marussig, Cesare Mainella, Fabio Mauroner and Umberto Boccioni, shared his Venice days, was later to tell Modigliani's daughter Jeanne that they often visited churches together but also attended séances organised and paid for by an Italian baronet named Cuccolo or Croccolo. A plump man, elegantly dressed in grey, the baronet would pick them up from the Academy in the evening and take them them to the Giudecca quarter where, together with some girls, they were initiated into the joys of occultism and hashish. Jeanne was to remark later that "he had no need to go all the way to Paris to discover drugs". During this period Modigliani painted the portrait of this Venetian friend's mother.

In February 1905, Eugénie Modigliani wrote in her diary: "Dedo, in

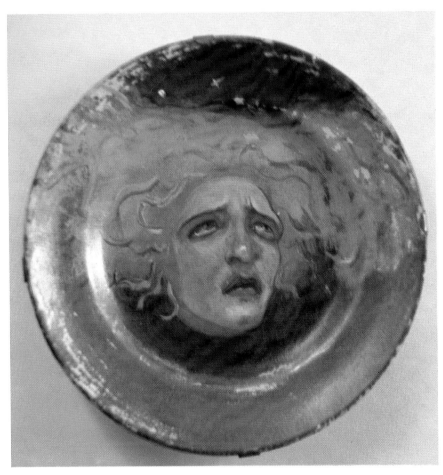

Gorgon, 1902.
Oil on terracotta, 22 cm diameter.
Private collection.

17

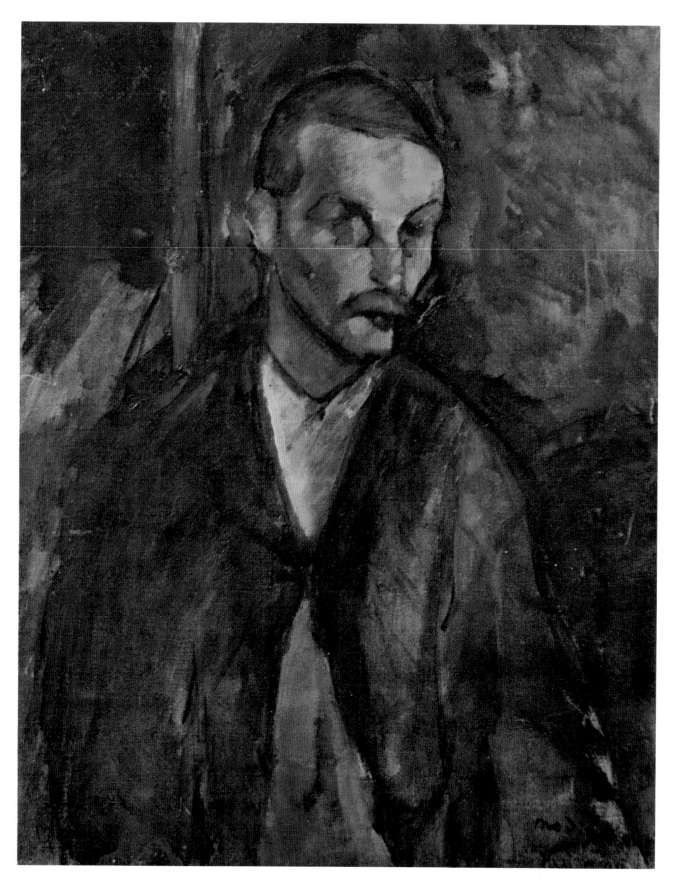

BEGGARMAN, 1909.
Oil on canvas, 65 x 54 cm. Private collection.

PORTRAIT OF SOMMATI, 1908.
Pencil drawing on paper, 22 x 18 cm. Pinacoteca civica G.Fattori, Livorno.

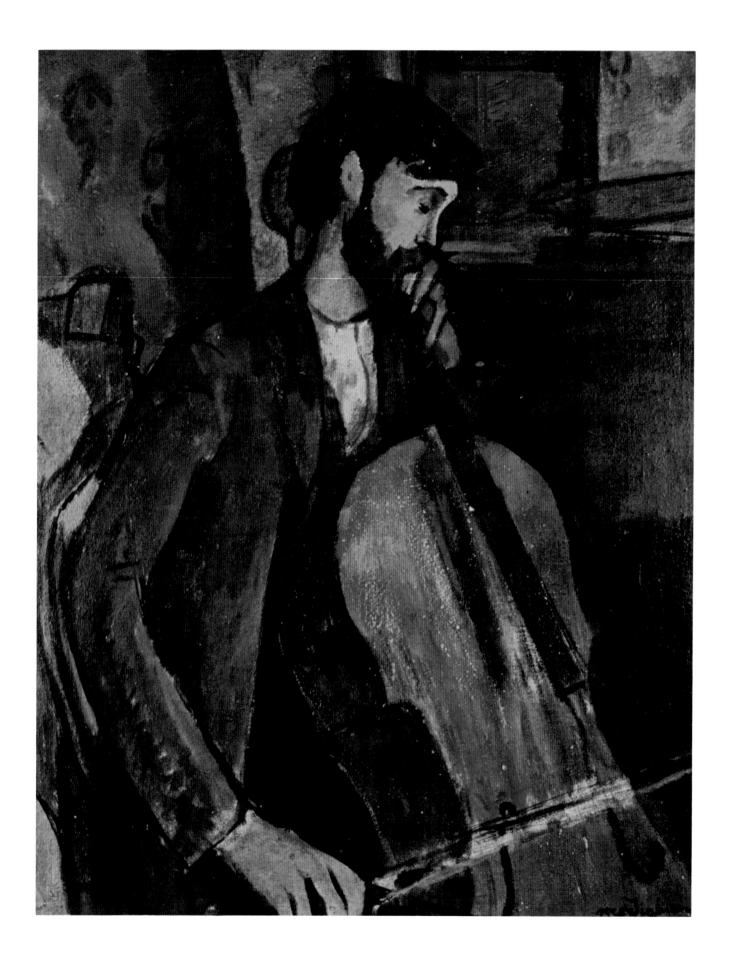

Venice, has finished the portrait of Olper and plans others..." This work has unfortunately disappeared and probably many others with it. There remains a portrait of his friend Fabio Mauroner which dates from this period and was exhibited in Venice in 1930. It is estimated that he could have painted an average of at least one picture a week for each of the weeks he spent as a student at the two schools and during his trips to Livorno. Some are still hidden in private collections in Tuscany, and it is hoped that one day they will come to light. In a letter to Oscar Ghiglia, he sums up what he owes to Venice. "The man who does not understand how to use his energies to continually seek new goals and new figures in his life in order to constantly gain in confidence, who does not reject all that is old and rotten, is not a real man – he is merely a *bourgeois*, a tradesman. True, it means suffering, but might not pain act as a spur to help you find yourself again, to strengthen and raise your aspirations even higher? It would be all right for you to visit Venice this month, but you decide. Don't wear yourself out; learn the habit of putting your aesthetic needs above your day-to-day duties. If you want to get away from Livorno, I'll help as much as I can but I don't know if it is what you need. It would certainly be a pleasure for me. In any case, let me know. I have received the most valuable lessons of my life in Venice: I feel as though I shall leave a bigger man for having worked here..."

There may be some doubt about a trip to London in 1905 that Modigliani claimed to have made to take part in a Pre-Raphaelite Exhibition, but it is certain that he went to Paris at

Right: The artist just before moving to Paris.

Opposite: Study for THE CELLIST, 1909. Oil on canvas, 73 x 60 cm. Private collection.

Opposite: THE AMAZON, 1909.
Oil on canvas, 92 x 65 cm.
Private collection.

Modigliani in his Paris
studio, circa 1909.

the beginning of 1906, where his first lodging was a reasonably good hotel near the Madeleine. The money his mother sent him paid his keep for three weeks in the better part of town, but he still visited Montmartre to see the works of the avant-garde artists who were converging there from every part of Europe, particularly Russia and Hungary. It is probable that he enrolled in a drawing academy at this period, such as that of Colarossi, and that he later returned several times to attend classes.

We know none of the details of his daily life or artistic exploration between 1906 and 1907. We know he moved into the famous *maquis*, a Montmartre slum which was being cleared prior to development. He was soon turned out of his temporary studio, and was forced to move from one hotel room to another, giving as his address the Bateau-Lavoir (a Montmartre tenement where many artists rented studios). He seems to have lived in a studio in rue Caulaincourt, and we know he ended up renting a sublet at 7, Place Jean-Baptiste Clément. It was at the Bateau-Lavoir that he met Picasso, Braque, Salmon, Jacob and many others.

There are many and varied accounts of the 14 years (broken only by two trips to Livorno) that he spent in Paris.

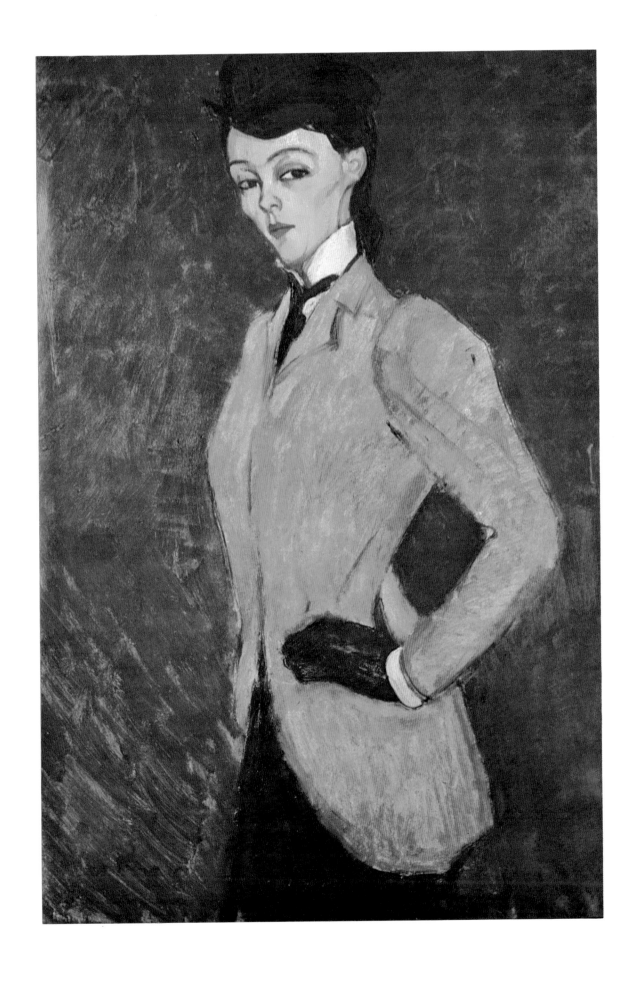

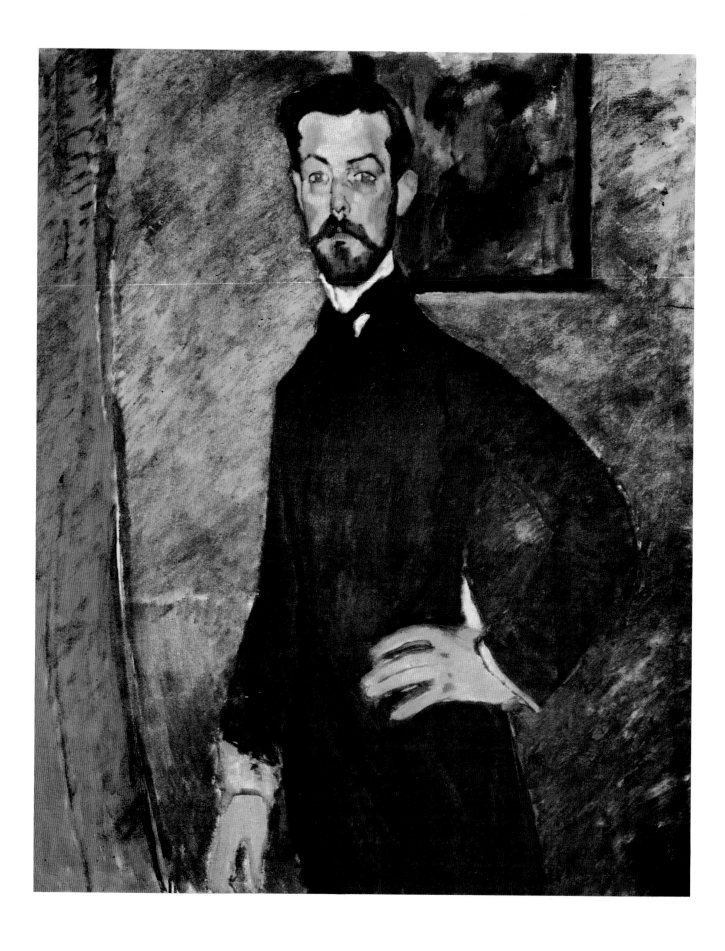

While realising the importance of sifting through the true events of Modigliani's childhood, it is essential to understand, as did Jeanne Modigliani, that "the problem of finding accurate accounts of his life is that actual observers of it tend to fall roughly into three groups: indulgent sentimentalists, sighing over the handsome, elegant and distinguished young man of considerable culture and exquisite manners; intolerant people for whom the fact of being an artist does not excuse the unacceptable *poseur* incapable of holding his drink, the lack of self-control, the weakling and the architect of his own destruction, the drunkard and kill-joy; and lastly the egocentrics for whom talking about Modigliani is only an excuse to relive their own youth."

We shall therefore give only a brief outline here of his life in Paris before going on to analyse his work which developed fully and reached its zenith in the last decade of his short life.

In Montmartre he took as his models Toulouse-Lautrec, Steinlen, Picasso and Van Dongen; but he was aware of copying their styles too closely, with the result that he kept only a few works from this period.

In the autumn he made the acquaintance of Dr Paul Alexandre, who was the first to recognise his potential. A doctor of medicine and an art lover, Paul Alexandre, together with his brother Jean, had established a kind of artist's commune at 7, rue du Delta. Modigliani did not live on the premises but visited often. He had his books and pictures moved there and it was Alexandre who advised him to join the *Société des Indépendants*. On 20 March he exhibited six pictures at the *Salon des Indépendants*, amongst them *The Jewess*, in the room reserved for the Fauves. He was to make a present of this painting to Dr Alexandre.

Evening gatherings in the rue du Delta often turned scandalous. "A fervent believer in hashish, taken in moderation, and in the powerful effect of it on the senses, particularly the visual, Dr Alexandre admitted that Modigliani overdid it a little, but without making the frenetic exhibition of himself which has occasionally been described."* In April, Alexandre introduced Modigliani to his father and persuaded the latter to sit for the painter. This portrait was followed by one of Paul himself and of one of his brothers.

In the summer of 1909, Modigliani visited Livorno for a few months. On his return to Paris he brought with him the *Beggarman*. The portraits of Vera Modigliani, his sister-in-law, and Bice Boralevi, a childhood friend, date from this period. Having re-immersed himself in the family and physically and spiritually rejuvenated himself, the painter returned to Paris and made his home in Montparnasse at La Ruche, 216, Boulevard Raspail and then at 16, rue du Saint Gothard, while keeping a studio at 39, Passage de L'Elysée des Beaux Arts. It was at this time that he asked Dr Alexandre to introduce him to the sculptor Brancusi. On the occasion of their first meeting, he sketched a

PAUL ALEXANDRE, 1909.
Charcoal on paper,
34 x 26 cm.
Private collection.

Opposite:
PAUL ALEXANDRE, 1909.
Oil on canvas, 100 x 81 cm.
Private collection.

Eugénie Garsin, the artist's mother.

Opposite: PORTRAIT OF A YOUNG WOMAN, 1908. Oil on canvas, 56 x 55 cm. Private collection.

portrait of the sculptor on the back of a canvas on which he was to paint *The Cellist*. No art dealers showed any interest in his work, and only Doctor Alexandre and Guillaume Apollinaire, then a bank clerk as well as a poet and art critic, arranged a few sales for him.

At the March 1910 *Salon des Indépendants*, he exhibited six canvases including the *Beggarman*, *The Cellist* and the *Beggarwoman*. He drew a great deal and, under the auspices of Brancusi, took up sculpture again in the form of stone carving. 1910 was perhaps the most significant year in his entire œuvre. The critics at the Salon had been favourable and he began to find new points of reference and influences beyond that of Cézanne: the boldness of the avant-garde school (particularly Severini and Marinetti), Cubism (supported by Braque and Picasso but rejected by him) and, of course, African Art.

In 1931, writing in the review *Aujourd'hui*, his friend Cingria describes Modigliani as: "having a very handsome face, in which slight reserve fought with amusement – in the mobile ever-changing facial expression natural to Italians, even to Italian Jews. His phrases were well-rounded and he spoke beautiful French. His laugh was short and dry. He was a fair and good man who flattered no-one. I have never known anyone so entirely free from snobbery. He was a man of courage (in Montparnasse you often needed to be). Despite his courteousness (and he was very courteous), he was obliged several times to say some hard words. He uttered them without flinching." To Zadkine he was "a young God in disguise, a workman in his Sunday best; he wore corduroy trousers with a checked shirt and a red belt round his waist."

At her nephew's suggestion, Laure organised a trip to Normandy in the summer of 1910, where Modigliani heedlessly got soaked to the skin. Laure feared the worst, so they returned to Paris.

For the whole of that year, Modigliani's fascination for the art of Africa and Oceania and his interminable discussions with Brancusi, Lipchitz, Gargallo, Zadkine and Amedeo de Souza Cardoso gave him all the fuel necessary to fire his enthusiasm for sculpture. In 1911 he exhibited a few gouaches and seven sculptures in the studio of his Portuguese friend Cardoso, as can be seen from photographs taken at this time in which the sculpted *Heads* are visible.

One day in the summer of 1912, worn out by the sheer hard work of carving stone, the effects of stone dust and and his disorganised way of

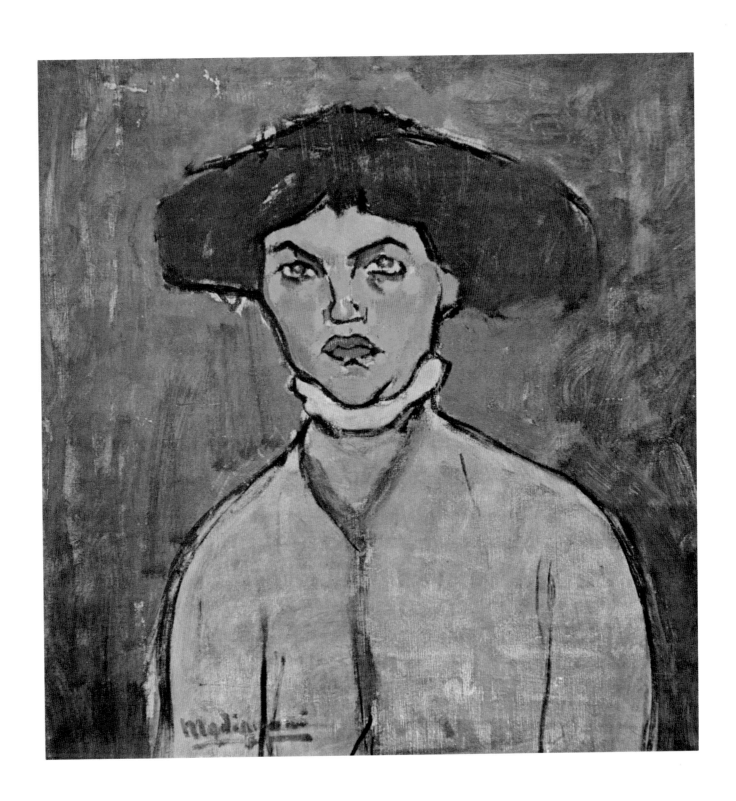

HEAD, 1910.
Pencil drawing on paper,
42.5 X 26.3 cm.
Private collection.

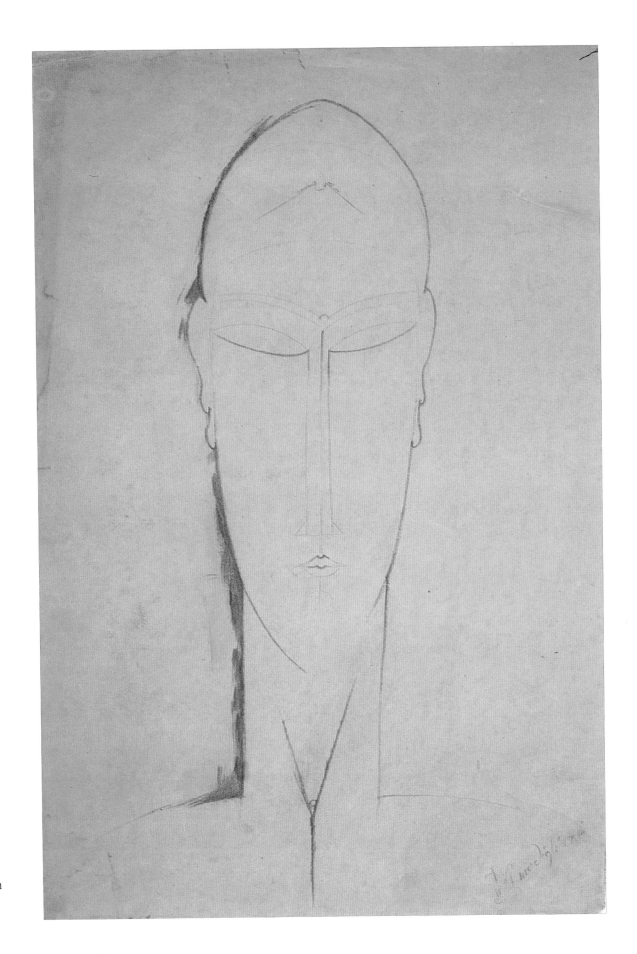

HEAD OF CARYATID, 1910.
Blue crayon drawing on
paper, 53 x 37.5 cm.
Private collection.

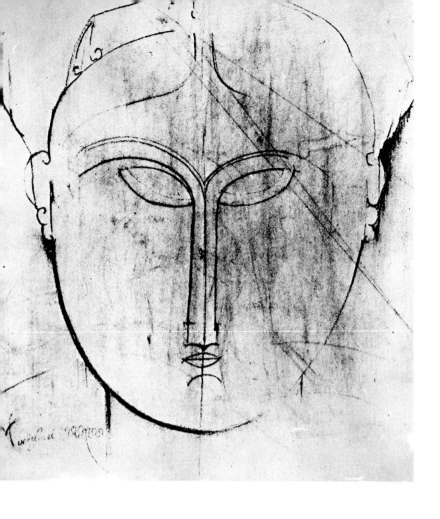

HEAD OF CARYATID, 1910.
Charcoal and graphite
pencil drawing,
29.1 x 26.4 cm.
Private collection.

life, Modigliani passed out. He was found on the floor of his room by
Ortis de Zarate who persuaded him to go home to his mother for a rest.
In Livorno he encountered the incomprehension of his old studio
friends, who wanted to hear about his painting and not about his
sculpture. In the autumn of 1912, Amedeo Modigliani exhibited 8 stone
carvings at the 10th *Salon d'Automne*. He wrote to his brother,
Umberto: "To have such a number accepted *en masse* is pretty rare!"

Since Modigliani had decided to spend the summer in Italy, he had
had his sculptures taken by cart to be stored in the courtyard of Dr
Alexandre's house. According to the doctor they were removed soon
after, giving rise to the belief that the artist did not go to Livorno after
all that year. In the autumn he brought to the clinic where the doctor
worked a head and shoulders portrait, painted from memory. The
elongated head is reminiscent of his sculptures and it was perhaps the
first truly original picture that Modigliani had completed. Probably
influenced by the Expressionism of his new neighbour at the Cité
Falguière, Chaïm Soutine, who came to France in 1912, Modigliani
became interested in the impasto quality of applied paint and the
exaggeration of features, as in Russian portraits, and was tempted once
again to explore the possibilities of painting – which was less
hazardous to the health. A dealer in the rue de la Boétie, called Chéron,
supplied him with models and brandy in a basement studio; the dealer
was frequently obliged to lock the painter in to get him to work.

On 3 August 1914 war was declared. Dr Alexandre was called up and Modigliani was never to see him again. Being declared unfit for service himself, he remained in Paris where he met the English poetess and novelist, Beatrice Hastings (1879-1943), with whom he was to enjoy a stormy relationship lasting two years. During this period the poet Max Jacob introduced Modigliani to the art dealer Paul Guillaume who bought some pictures from him. Guillaume was to write later to his friend Scheiwiller: "From 1914 to 1915 and for part of 1916, I was the only dealer buying Modigliani and it was only in 1917 that Zborowski took him up. Modigliani was introduced to me by Max Jacob. He was living at the time with Beatrice Hastings, working at her place, at the painter Haviland's and in a studio which I rented for him at 13, rue Ravignan. He also worked in a little house in Montmartre where he lived with Beatrice and where he painted my portrait." The relationship between Amedeo and Beatrice was complex, and both indulged in every kind of excess, but depite this Modigliani's output grew. He painted many beautiful portraits of Beatrice between 1914

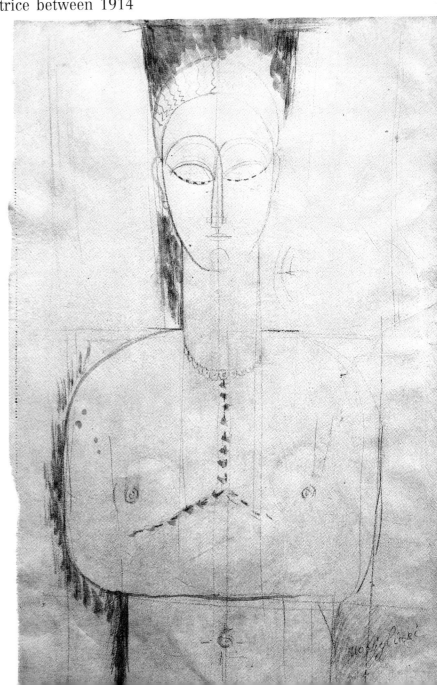

CARYATID, 1910.
Drawing in pencil and
watercolour on paper,
42.5 x 26.5 cm.
Private collection.

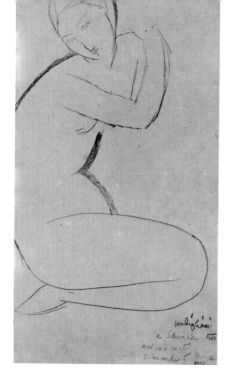

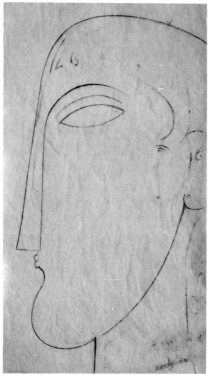

HEAD IN PROFILE, 1911.
Graphite pencil drawing on
paper, 43 x 26 cm.
Private collection.

Top: CARYATID, 1912.
Graphite pencil drawing on
paper, 42.6 x 26.2 cm.
Private collection.

Opposite: HEAD OF CARYATID,
1911. Drawing in pencil and
watercolour,
38 x 26.5 cm.
Private collection.

and 1916, while perhaps leading a more settled life, and his canvases gained in confidence, intensity and serenity. However, the couple's rows were spectacular, and eventually in 1916 the English girl, worn out by them, returned to her own country.

Modigliani took part that year in a group exhibition. The Polish poet Léopold Zborowski (?-1932), Fujita's and Soutine's dealer, invited Modigliani to work in the largest room in his apartment at 3, rue Joseph Bara, on the Left Bank. Anna Zborowska, the poet's wife, was to become one of the painter's favourite models after his break with Beatrice. He made many studies of her, and seven noteworthy drawings in a sketchbook. A friend of the couple, the sweet and refined Lunia Czechowska, posed just as often for Modigliani and was the inspiration for some of his deepest psychological studies.

Introduced to each other by Fernande Barrey, Fujita's wife, Modigliani and Zborowski became inseparable friends; they remained so until Modigliani's tragic death in 1920. For four years, Zborowski devoted himself entirely to promoting Modigliani and would defend him vigorously to critics and collectors alike. He gave in to Modigliani's every whim and encouraged him to work by all means possible. Zborowski posed many times for the painter, who saw the poet in him rather than the art dealer, giving him an elongated ethereal face suggestive of exaggerated romanticism. Portraits of Zborowski can be found today in the most prestigious museums in the world. According to Jacques Lipchitz, "the understanding between Zborowski and Modigliani is a striking example of the almost family ties which, in Paris in this era, united artist and art dealer. Not all picture dealers were exploiters and gaolers."

Modigliani once explained to Léopold Survage, whose famous portrait is in the Helsinki Museum of Art: " In order to work I need a living person before me." Modigliani analysed his friends, dealers, professional models and acquaintances, as often as curiosity or imagination led him to draw or paint them. Many times on canvas and on paper did he explore the face of his pathetic, grubby, hermit-like friend, Chaïm Soutine, from the ghetto of Vilno. His is the face, so openly offered, that is seen transposed and immortalised, notably in the Stuttgart National Museum and the Washington National Gallery.

The Mexican painter, Diego Rivera, inspired Modigliani with his portraits which were at once heavenly in their composition and earthly

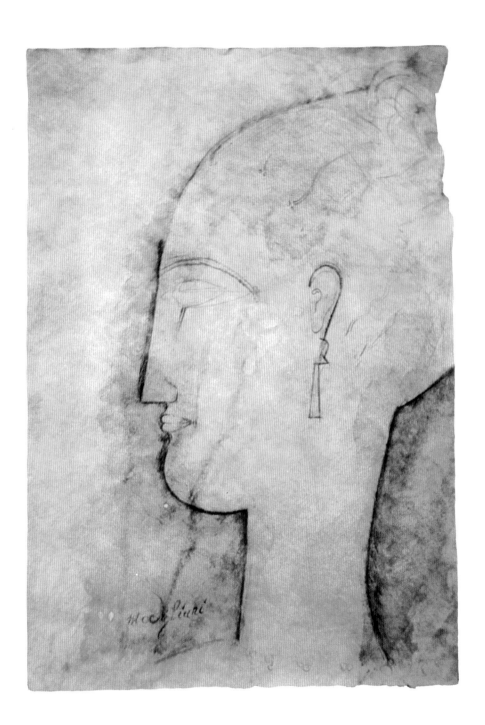

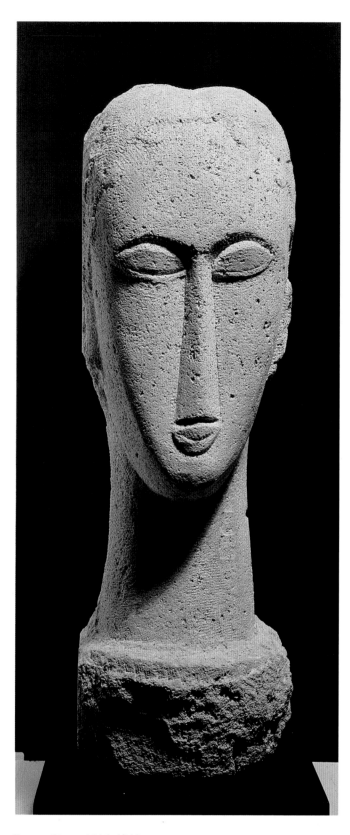

FEMALE HEAD, 1911-1912.
Stone, 50.8 x 16 x 19 cm.
Perls Galleries, New York.

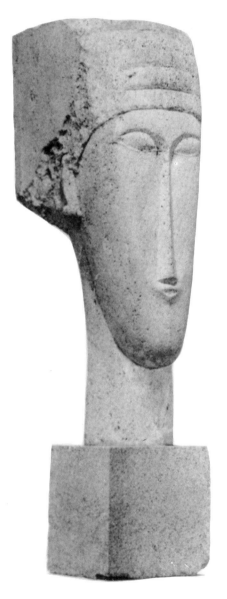

HEAD, 1912.
Limestone, 63 cm high.
The Solomon
R. Guggenheim
Museum, New York.

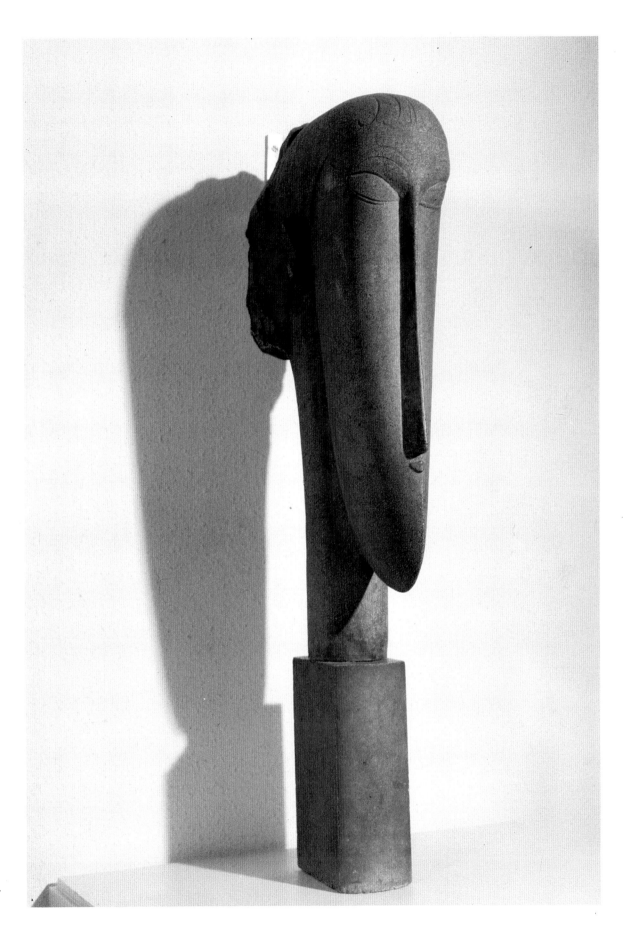

HEAD, 1911-1912.
Stone, 63.5 x 12.5 x 35 cm.
Tate Gallery, London.

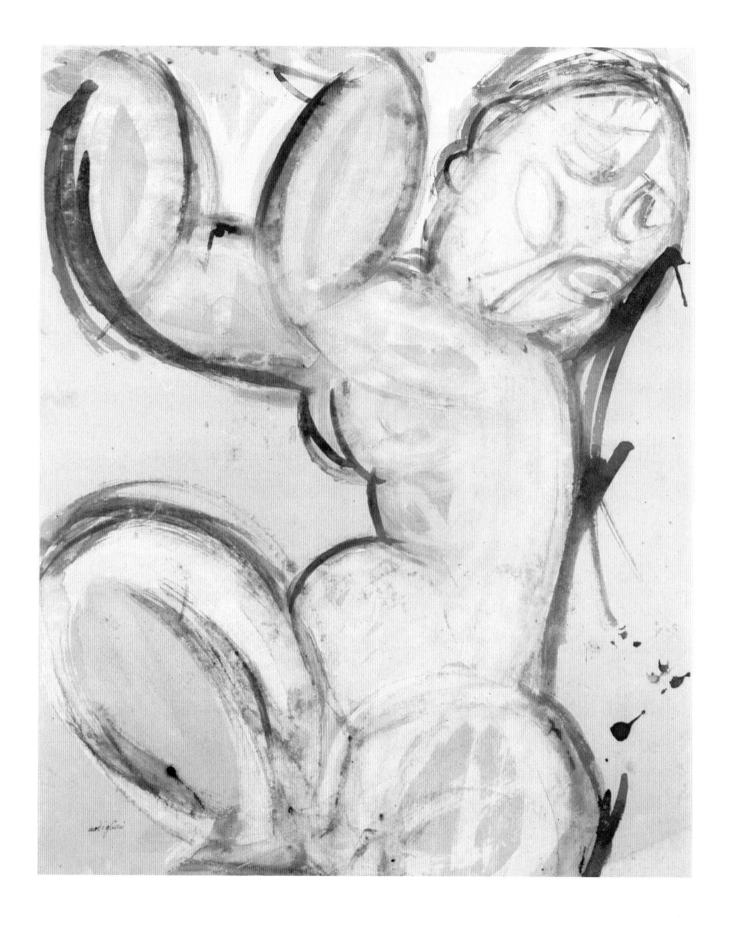

in their fragmented, dazzling and vibrating colour. These drawings and canvases, one of which is in the São Paolo Museum, spoke directly to Modigliani as did this friend and confidant with whom he shared Homeric discussion and argument, as well as the sufferings and pleasures of Montparnasse. To Rivera's studio, a gathering place for artists and intellectuals, there came a young Russian girl, also a painter. Modigliani was to paint her portrait dressed as a young boy, her blond curls hidden by a hat and her figure flattened by a man's jacket. Later, remembering Modigliani, Marevna was to write: "he had a fine head, totally Italian in its beauty with curly, untidy hair but giving the overall impression of a classical statue... with the temperament of a poet. He was educated, cultivated, extremely objective and looking for neither fame nor fortune."

The poet Max Jacob, probably Modigliani's closest friend, whom he had known since his Bateau-Lavoir days, was the inspiration for the portrait embellished with esoteric inscriptions now in the Nordrhein-Westfalen Collection in Düsseldorf. The rapport between the painter and Max Jacob was founded on verbal sparring matches of a mystical nature, which took place in an atmosphere of learned poetry and hallucination. One of the few poems which Max Jacob dedicated to a friend is dedicated to Modigliani who, in return, gave him a number of portraits – all fascinating on account of their secret meaning.

Modigliani also painted many pictures of Moïse Kisling, one of which may be found in the Pinacoteca di Brera in Milan, and of his wife Renée, who treated Modigliani like a brother. This couple shared his studio and went with him to parties at the Carrefour Vavin.

Amongst Modigliani's studio neighbours, Pinchus Krémegne at La Ruche and Oscar Mietschaninoff at the Cité Falguière also sat for him in 1916 – seated in attitudes of static repose, peaceful, calm, hands resting on slightly open knees.

As we have seen, Paul Guillaume, Chéron, Jean Cocteau, Blaise Cendrars, and artists like Marcel Humbert and the Spaniard Celso Lagar also sat for Modigliani, who analysed each of them in his own intensely personal way. He executed their portraits with originality, always finding something new to say in the structure of form, the style and the harmony of colour.

1916, a very productive year, is also marked by the first great elongated nudes, a theme which Modigliani was to develop further the following year. This series formed part of the famous exhibition at the Berthe Weill gallery in the rue Taitbout, Paris, which had been planned to run from 3 to 30 December. The catalogue cover consisted of a nude painting of Beatrice with a short poem by Blaise Cendrars. In fact, the show was cut short by the police seizing the two nudes in the window of the gallery – they had caused public outrage.

Opposite: CARYATID, 1913.
Watercolour on paper,
53 x 42 cm.
Private collection.

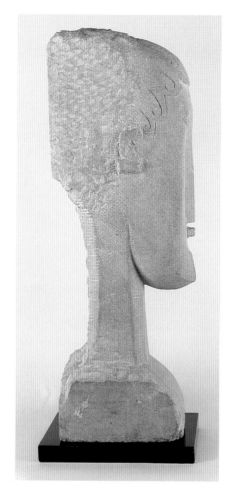

Head, 1911.
Musée National d'Art
Moderne, Paris.

Top: Head, circa 1913.
76 cm high.
Perls Galleries, New York.

In the spring, during carnival time, Modigliani met the 19-year-old Jeanne Hébuterne, then a pupil at the Colarossi Academy, who became his companion. With the help of Zborowski and in the teeth of opposition from her family, they moved into 8, rue de la Grande Chaumière. Jeanne's friends nicknamed her "Coconut" on account of her pale complexion and chestnut hair with red lights, which she sometimes wore wrapped around her head in a coronet style. Jeanne had a certain talent for drawing. She and Modigliani made several sketches together which are to be found in a sketchbook next to those of Max Jacob. She painted a self-portrait in watercolour, a painting of quality, now in the Petit-Palais in Geneva. She appears to have had surprising individuality for such a young artist. Apart from the 16 pictures Modigliani painted of her, there is only one photograph – taken of her dressed in a poncho she had decorated herself – and one sculpture by her friend Chana Orloff, modelled when she was pregnant. A few still lifes and one moving drawing of Amedeo in bed, reading by candlelight – which has been dated to January 1920 – are also credited to her.

In March 1918, Modigliani's health began to worsen. As Jeanne was expecting a child and Paris was under fire, Zborowski helped them to get away to the Côte d'Azur, where they resided between Nice and Cagnes. On 29 November 1918, their daughter Giovanna was born in Nice and the painter acknowledged her immediately as his own. The light of the Midi inspired him to lighten his palette, as can be seen in *Young Man in a Blue Jacket* and four landscapes. In a short essay entitled *Modigliani the Seer*, Frans Hellens describes how in 1919 he posed for a portrait in Nice, for which Modigliani charged 20 francs. His wife, who did not think it like him at all, forced him to sell it – only to discover 15 years later that she had been wrong: the picture looked exactly like one of his daughters.

At this point, truth and legend seem to become entangled. On the one hand we have the man, aware of the progression of his tuberculosis and alcoholism, torn between metaphysical anguish and the

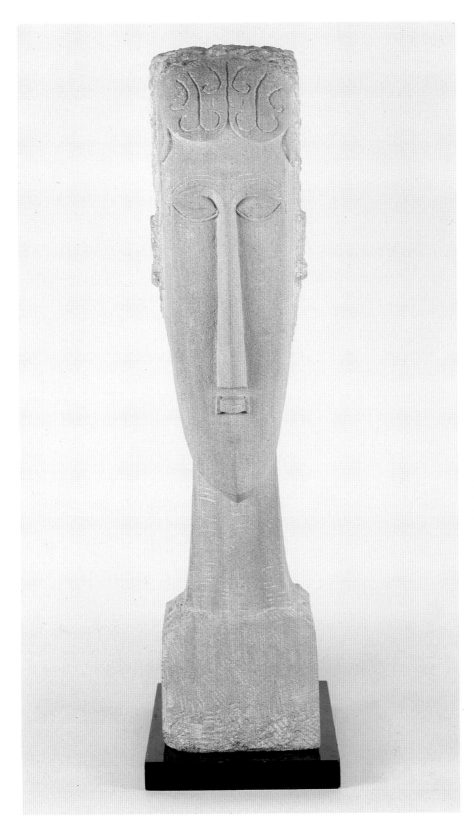

HEAD, circa 1913.
76 cm high.
Perls Galleries, New York

Amedeo Modigliani at the
end of his life.

Opposite: HEAD, 1911-1912.
Stone, 47 cm high.
Musée National d'Art
Moderne, Centre Georges
Pompidou, Paris.

desire for recognition as an artist, and on the other a young woman, full of life, la *donna angelo* (angelic woman), source of all inspiration, a mother expecting a second child. During these last months Modigliani painted excellent portraits of his friends. His last work was the *Portrait of Mario Varvogli.* On the preparatory sketch he wrote: "Incipit vita nova/Il novo anno!"

Worn out by illness and excess, Modigliani died on 24 January 1920. Jeanne Hébuterne committed suicide the following day. His daughter reported that on the way to the hospital Amedeo was heard to murmur: "Italia. Cara Italia".

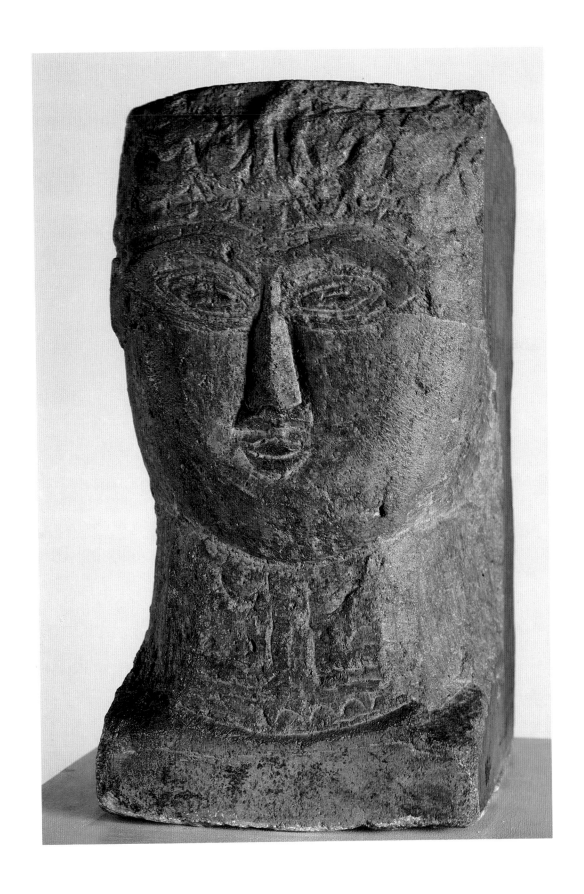

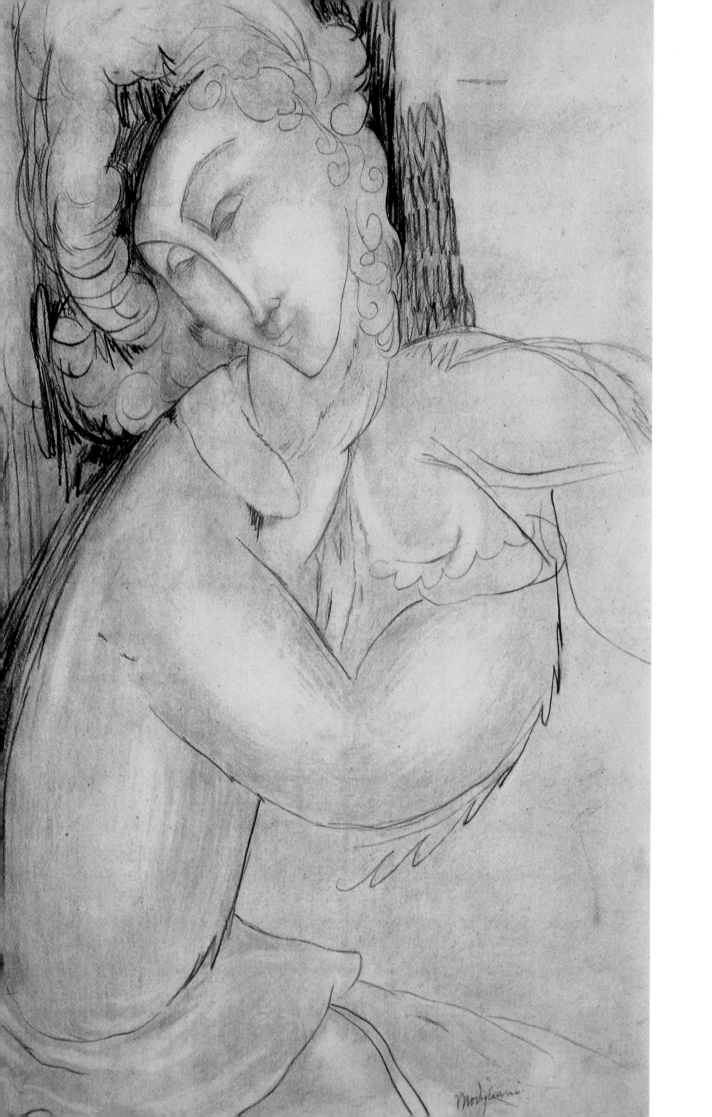

An analysis of the art of Modigliani

Christian Parisot

Having taken a brief look at the life of Amedeo Modigliani, we now come to his work, the bulk of which was created in France over a period of some 15 years. Today a number of very important drawings, stone and wood carvings, bronze sculptures, portraits in oil (of friends, acquaintances, women he loved and professional models), five landscapes and around 30 life paintings are known.

Until recently, art critics and biographers have been preoccupied with linking these shifts in media and style with different episodes in his ever-changing and often insecure life. Jeanne Modigliani, his daughter, has emphasised that the mystery with which the painter's œuvre is surrounded makes a nonsense of the superficial perception, based on his life style, that is generally held of him as a person.

Let us take a more positive and comprehensive look at the œuvre of this Italian painter who was working alongside the avant-garde artists of the early 20th century. No-one who has seen his work will ever forget the perfection of line and the poetic atmosphere with which he imbued the men and women who sat for him. We will look in more depth at these two elements and seek out from among the symbols, with which his pictures are strewn, those which are linked to his past and origins and which give to everything he created its unique character.

We shall first consider the way in which Modigliani made use of the academic art education which he had received in Italy (and which would have been much the same in all the art academies of Europe at the time), having analysed, and to a great extent rejected, the various new directions which his artistic contemporaries were exploring.

We shall then review the different pagan and religious influences which mark his work. The role of religion and its symbolism is

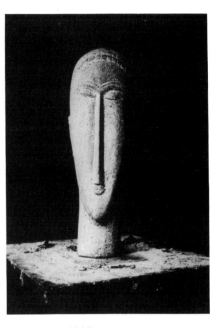

HEAD, circa 1911.
Limestone, 65 cm high.
Private collection.

Left-hand page :
WOMAN WITH HAT, 1914.
Pastel on board,
70 x 39.4 cm.
Private collection.

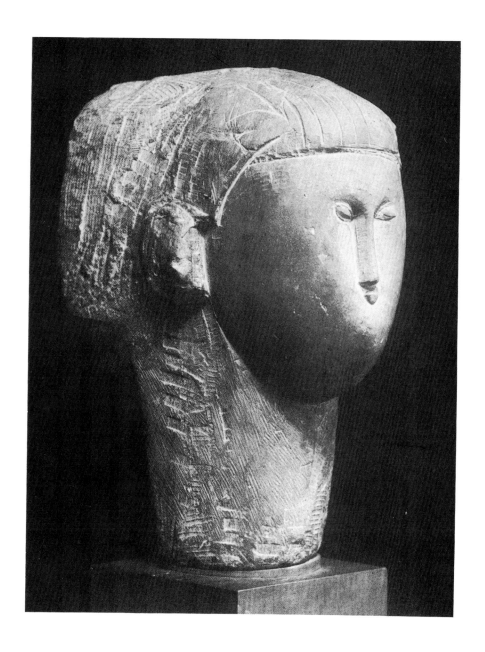

HEAD, 1911-1912.
Stone, 51 cm high.
Hirshorn Museum,
Washington.

perceptible in all the forms of expression he chose: sun gods; African, Oceanian, Cycladic and Oriental idols; Egyptian and Etruscan souvenirs; Byzantine icons; gothic capitals and reredos madonnas; and in particular those cabalistic signs which link him strongly to the Hebraic tradition and which are authentic marks of his own culture.

Lastly, we shall examine the way in which relations between painter and model were established and evolved. He started with a probing analysis of the sitter's character, and then made a careful study of the individual's particular beauty and gentler qualities.

An ever closer rapport was created between the artist and his sitter (male or female): they reflected each other as in a mirror. The elongated, idealised nudes invite even greater speculation. After the intense psychological analysis and the rigorous striving to obtain a satisfactory resemblance, came the search for serenity.

44

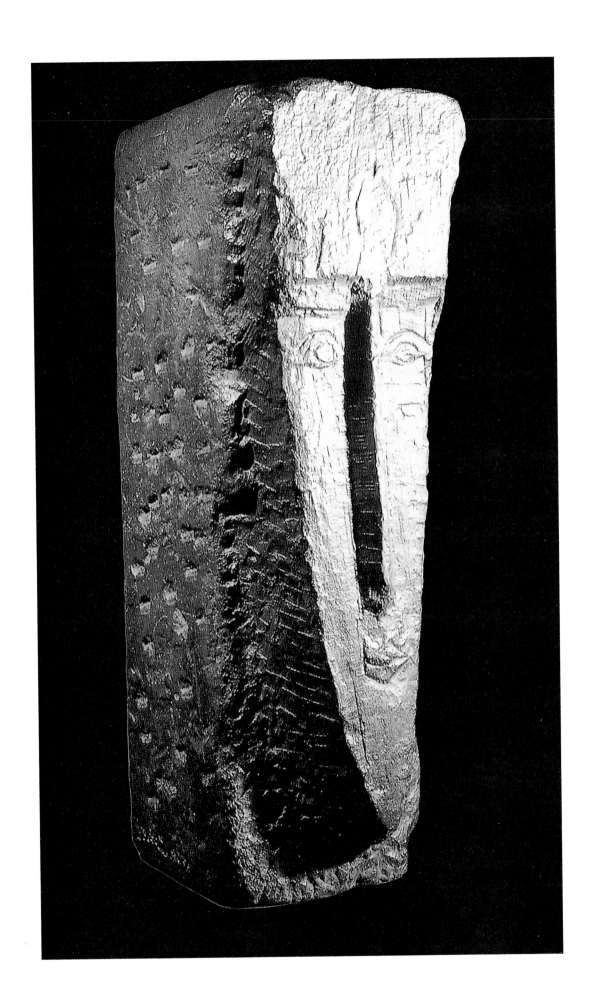

H<small>EAD OF</small> C<small>ARYATID</small>.
Bronze, 71 cm high.
Private collection.

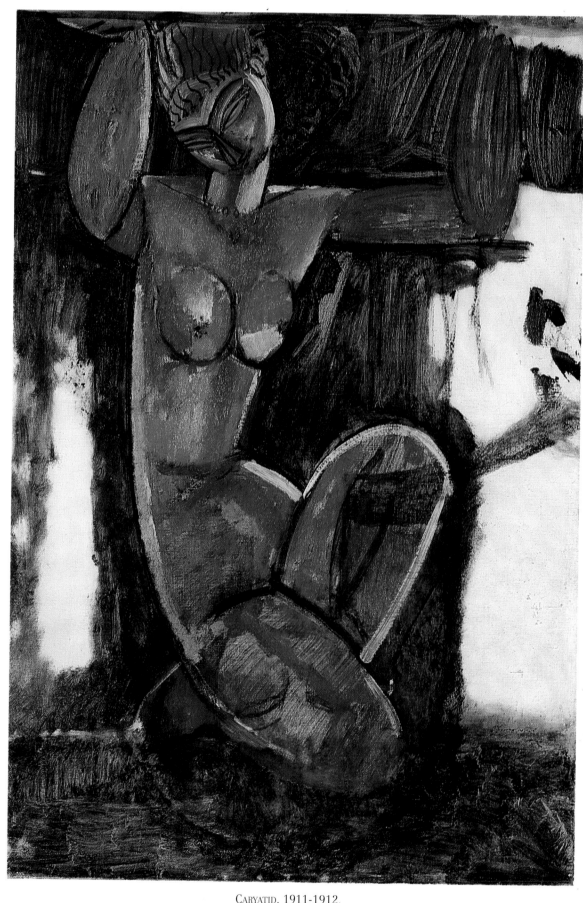

CARYATID, 1911-1912.
Oil on canvas, 73 x 50 cm. Kunstsammlung Nordrhein-Westfalen, Düsseldorf.

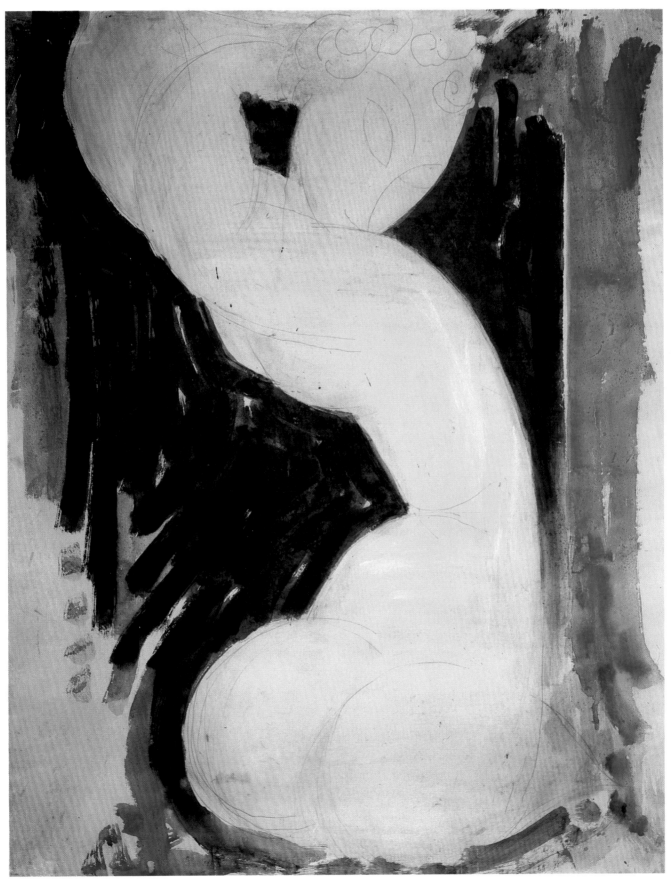

CARYATID, 1914.
Pencil and tempera drawing on paper, 90 x 70 cm. Private collection.

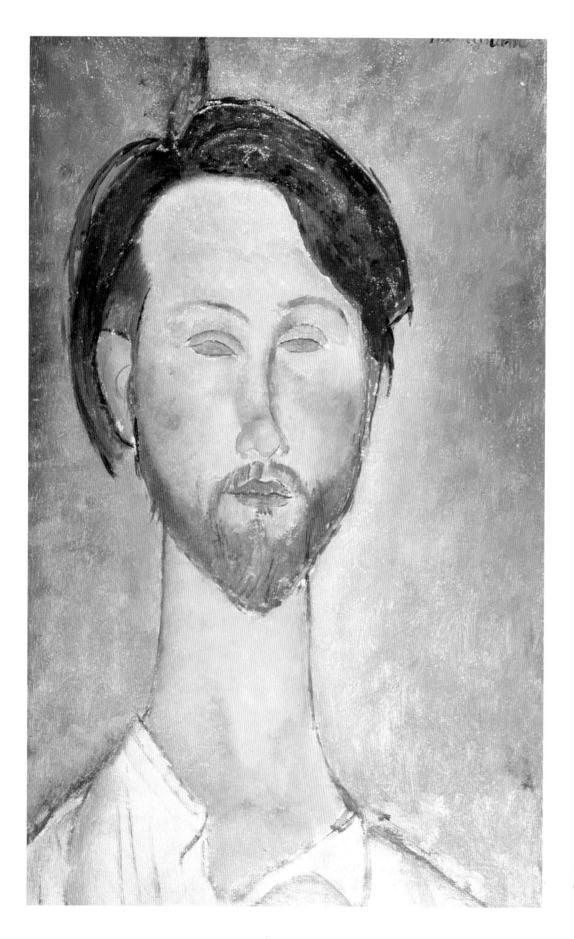

LÉOPOLD ZBOROWSKI, 1918.
Oil on canvas, 46 x 28 cm.
Private collection.

When Modigliani arrived in Paris in 1906, several new art movements were rocking Europe. The importance given to different *Salons*, the new-found affluence of the middle classes after the Second Empire, the interest shown by American buyers in the landscape painting of the Fontainebleau School and in the works of the Impressionists – all this made Paris the art capital of the world. Painters and sculptors flocked to Paris from everywhere, particularly from Eastern countries, looking for peace, recognition and patrons. The prime importance accorded to science, the rapid growth of industry, the desire to shatter established conventions – these were all reflected in art through a rapid series of trends. After the Neo-Impressionists came the Fauves and the Nabis, then the Cubists and the Futurists, the Secession Movement in Austria and the Expressionists, closely followed by the exponents of Abstract art. Many artists working in Paris were strong personalities who sometimes expressed their loves and hates violently. Perhaps Modigliani was aware from the start of the creative volatility engendered by these impatient seekers after truth in Montmartre and Montparnasse.

Some painters, such as Soutine, had insufficient skill in technique and immediately enrolled at one of the academies. Others had received a full education in the arts, as had Picasso and Modigliani, whose cultured knowledge of poetry and philosophy impressed all who met him.

At the beginning of the 20th century, students at the *Beaux-Arts* received an education whose pattern had hardly changed since the Romantic era. They drew casts of classical statues, then moved on to living models. The teacher used objects lying around in the studio to teach technique and knowledge, then made the students copy portraits and compositions from the past, the works of Raphael in particular. He would recommend reading 15th and 16th century treatises on painting by Cennini, Alberti or Leonardo da Vinci, or Humbert de Superville's work on expression in Greek and Chinese Art and the search for ideal beauty, the *Essay on the Immutable Proofs of Art*, published in 1830. A few innovative teachers took pupils and models out into the open air to study light and shade in nature. Modigliani had been receiving such *plein airiste* instruction since he was an adolescent in Livorno. Others advised students to put their faith in theories that laid down the rules of artistic creation such as *A Grammar of the Art of Drawing* published in 1867, by Delacroix's friend, Charles Blanc, or *The Law of Simultaneously Contrasting Colours* by the chemist Chevreul, which appeared in 1839, as well as the works of various German and American opticians. All student painters were encouraged to resolve the problems posed by the science of colour, the psychological

PORTRAIT OF DIEGO RIVERA.
Drawing, 34.5 x 22.5 cm.
Private collection.

Opposite: Study for the
PORTRAIT OF DIEGO RIVERA,
1914.
Oil on canvas, 100 x 79 cm.
Museu de Arte, São Paulo.

implications of drawing and the rules of perspective, particularly those who were tempted by the large-scale compositions and frescoes brought back into fashion by Puvis de Chavannes.

Modigliani had at first enthusiastically accepted this method of teaching both in Florence and in Venice, but the poetry reading and philosophical discussion encouraged by his family and his innate gift of questioning everything led him finally to see its limitations. The young artist was also distinguished from his fellow disciples by his in-depth knowledge of the museums of Italy, with their wide-ranging collections; knowledge gained during his long trip while convalescing in the south of Italy. This journey could be compared to that of the 15th-century Neapolitans who travelled into the Netherlands and brought back the secret of the Flemish artists: oil painting.

In Sienna, he admired the enigmatic and austere figures found on early altar screens such as those of Sassetta and Simone Martini. In Florence, he loved the sculpture of Tino da Camaino, carved in 1320, in which the delicate, regularly-featured ovals of women's and angels' heads incline gently onto one shoulder. He was often to re-use this in his own models. He retained the intensity and feverish analysis of Leonardo da Vinci, and the fine, regular outlines and refined form obtained by Lorenzo Credi working in silverpoint on *carta tinta*, a pre-dyed paper of a brownish pink colour which gave a ready-made flesh tint. From the following generation, that of Michelangelo, who believed that the perfect style had been found in great examples from the past, he learned and retained the Neo-Platonic philosophy of the inward idea and image, in direct opposition to the realism of the era. This *Maniera Italiana*, or Mannerism, full of an affectation which tended to carry with it a certain elegance of bearing, was that which 16th-century painters such as Pontormo, Rosso, Andrea del Sarto and Bronzini took with them to the court of Versailles. It is to them that we owe the ladies with exaggeratedly long necks and the elongated nudes - the first modern nude paintings.

Taking his inspiration from more Southern lands, Modigliani harked back to the first centuries of our era: after the statues of ancient Greece, the Kuros, Cycladic idols and the statuettes from Samos and other Aegean islands with their hollowed out eyes, he saw the great examples of classical sculpture. The head outlined as an oval, the realistic portrait with the symmetrical, almond-shaped eyes: these he

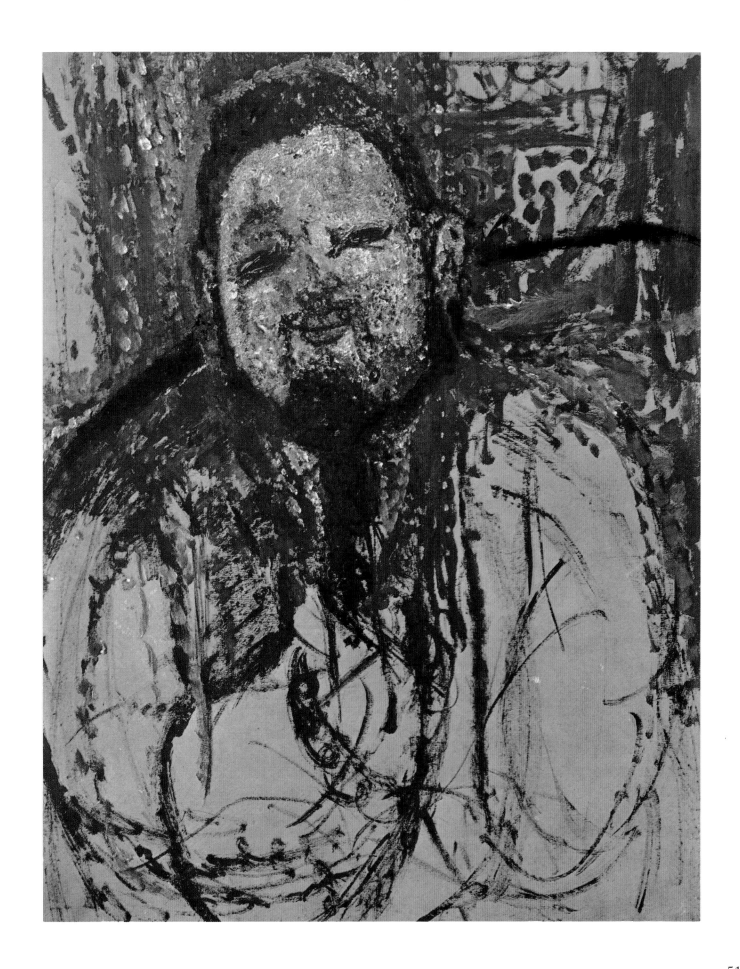

found in Roman effigies, in portraits from Pompeii and the sarcophagi of Fayum, all inspired in their turn by the vanished art of Greece.

Modigliani saw in Venice the triumph of the portable portrait which owed its fame to Bellini and ended the ascendancy of the religious picture. This period also saw the accession to painting of a middle class which was practically to monopolise it for as long as art remained figurative. Venice had attracted Dürer, and Modigliani learned a lesson from engraving: the use of elongated and uncluttered outline.

And lastly, of course, Venice was synonymous with the great colourists Tintoretto and Titian. Although Modigliani was to prefer the juxtaposition of duller tones to their blazing palettes, he was not to forget their mastery of colour.

However, as he did not intend to spend his whole life producing variations on the great works of the old masters, and as his ambition was to develop a more modern style of his own, he worked relentlessly at drawing, sketching daily life around him in the cafés of Venice more often than he attended classes. Eventually he decided to move to Paris, where recent events and the competition seemed more rewarding.

In France, 30 years earlier, the last school of painting which can truly be called coherent and disciplined had become established in a reaction against academic tradition: this was the school of Impressionism. Its principal aim was to discard the traditional or figurative representation of space, and was in direct opposition to the representative painting of the 19th century. It prepared the ground for a change in attitude to realism. In attempting to eradicate the constraints of perspective, handed down from the Renaissance, its exponents gave a new optical dimension to graphic art. On the surface, a representative painting or drawing was still all there – it was the means by which it was achieved that was changed and interpreted as something different.

Between 1875 and 1910 there was a great deal of interest in so-called Primitive art, in pagan and magic art from the past. This resulted from an increase in the number of archaeological digs, expeditions to colonise primitive peoples and from the undertaking of major building works. This taste for mysticism and for distant lands was due in part to the Symbolists. They made possible the transition from the chromatic explorations of Gauguin to the Cubists' synthesis with Primitive art. Many artists were interested in exploring this: Max Jacob, Modigliani, Chana Orloff and Picasso, the last two in a way that was disguised by their geometric forms. Modigliani was certainly interested in ethnography and had been a regular at the Bateau-Lavoir in 1907

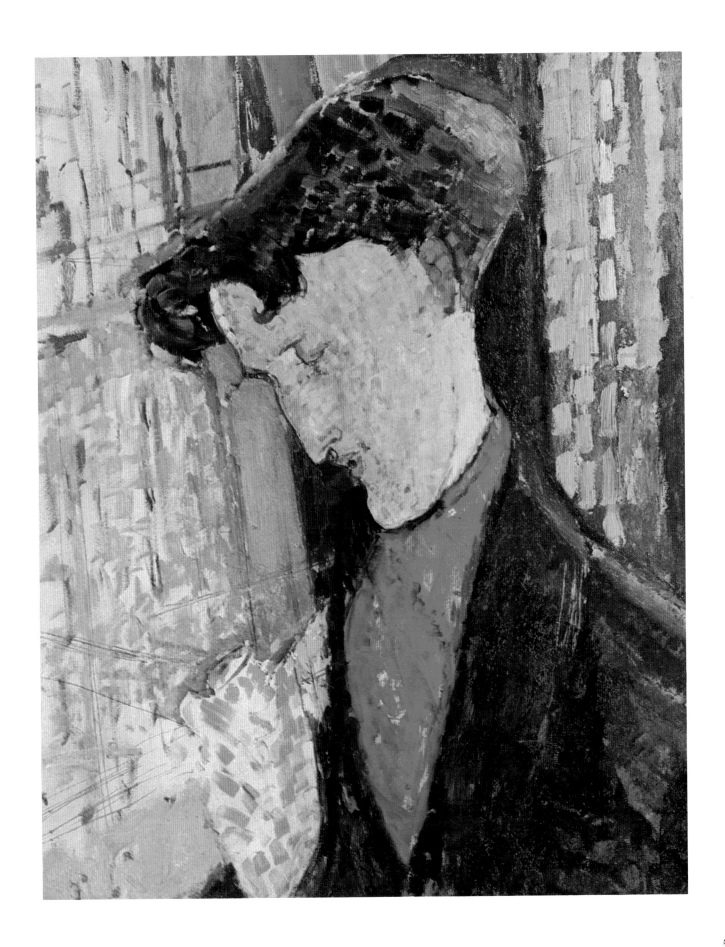

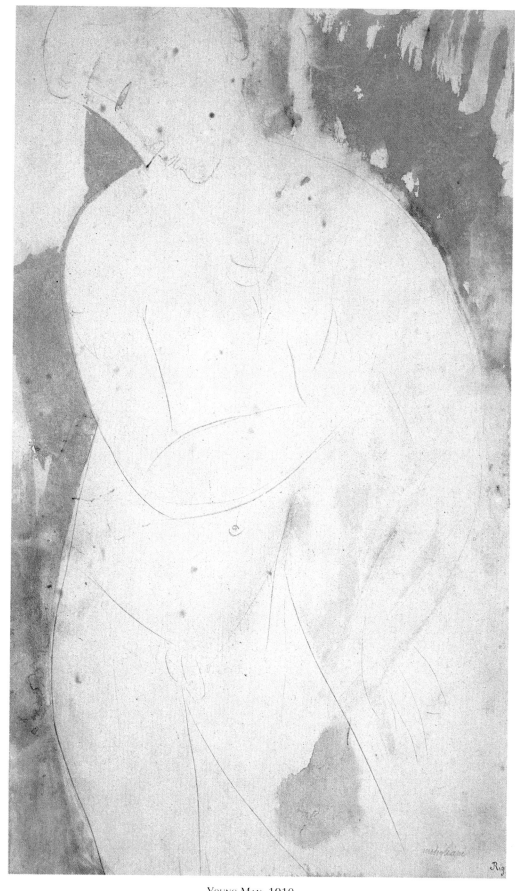

YOUNG MAN, 1910.
Blue watercolour and pencil drawing, 44 x 26 cm. Private collection.

WOMAN WITH HER HAIR IN A BUN, 1915.
Oil and Indian ink on board, 37 x 28,6 cm. Private collection.

when Picasso painted the *Demoiselles d'Avignon*. The influence of
Gauguin and Oceania can be seen in some of his sculptures based on
the Easter Island statues.

Indeed, like many of the artists and art lovers around him,
Modigliani knew that this desire for change was nothing new. For 20
years or so it had been realised that the surface of the canvas, the
painting on the easel, was too limited. All experimentation had so far
consisted in attempts to release the picture mentally from this pre-set
dimension by trying to incorporate and use the ambient space around
it. The Pointillists had tried covering white frames with complementary
colours in order to create a link between the canvas and its
surroundings. The Nabis went back to the hinged form of the reredos
and Chinese and Japanese screens. But the Cubists found none of these
devices satisfying. The rules which had hitherto been the norm in
depicting beauty had to be forgotten and the move made away from
representation of the image of man. The artist was now seeking to
portray the intimate structure of the sitter's personality. For the first
time too, technique and methods, it seems, were released from the
constraints of rules and prohibitions.

At the turn of the century, two trends in art ran concurrently. The
first was the official attitude to art, which perpetuated the tradition of
representative painting so dear to the middle classes. Exponents of this
art received medals at the *Salon* and had a ready-made and almost
instant market for their work. The *Indépendants*, to whom Modigliani
belonged, formed the second. They included several groups seeking to
make the spectator aware of a new set of problems, ideologies and
beliefs. These were artists interested in social preoccupations,
including those foreigners who had made Montmartre or Mont-
parnasse their headquarters and who were subject to no constraints.
Modigliani counted himself as one of this camp.

Once freed from the classical rules of art, he tried a variety of
different drawing media: Conté pencil, pen and wash, charcoal, blue
crayon, graphite pencil on pre-dyed paper, ink and watercolour on
paper. The results were still impersonal in the sense that they lacked
any identity distinctive to the artist. The influence of the line of
Toulouse-Lautrec and of Steinlen can be seen in these, as well as their
social overtones. In painting he was tempted by Expressionism as is
evidenced by *The Jewess*, exhibited at the *Salon des Indépendants* in

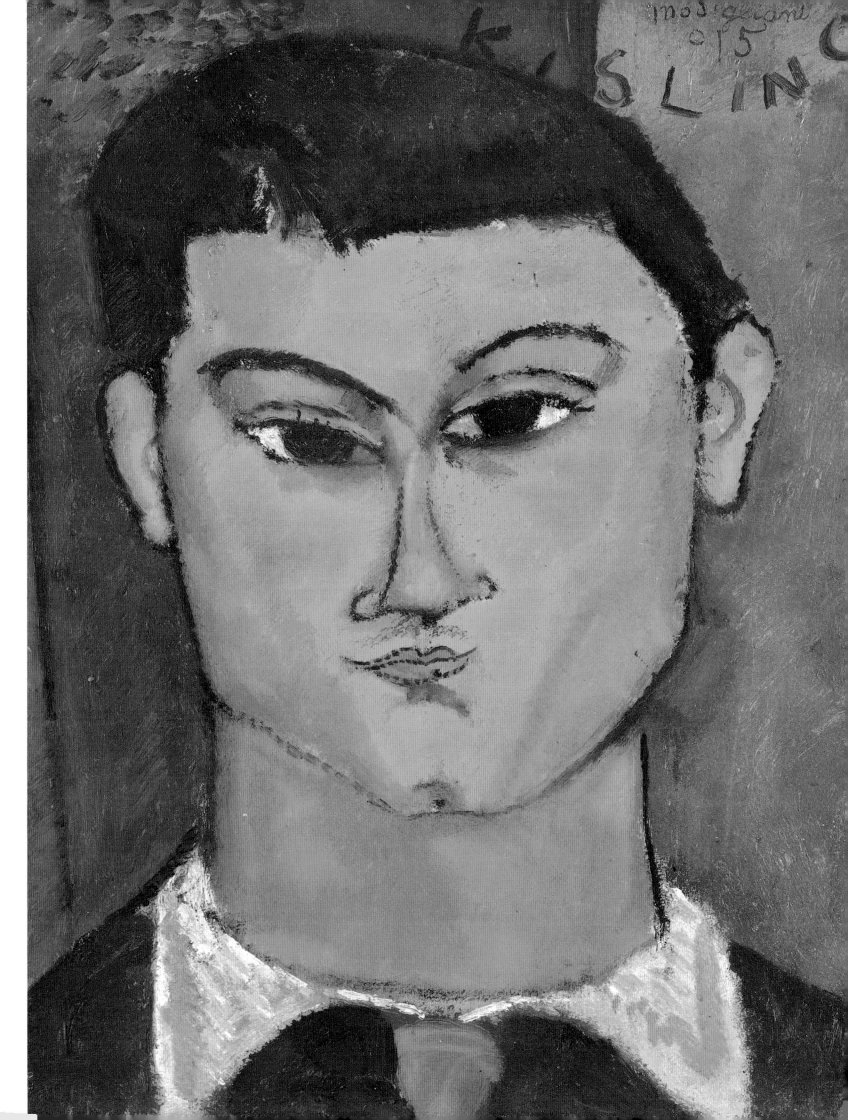

SEATED WOMAN WITH A GLASS,
1915.
Oil panel, 102 x 51 cm.
Private collection.

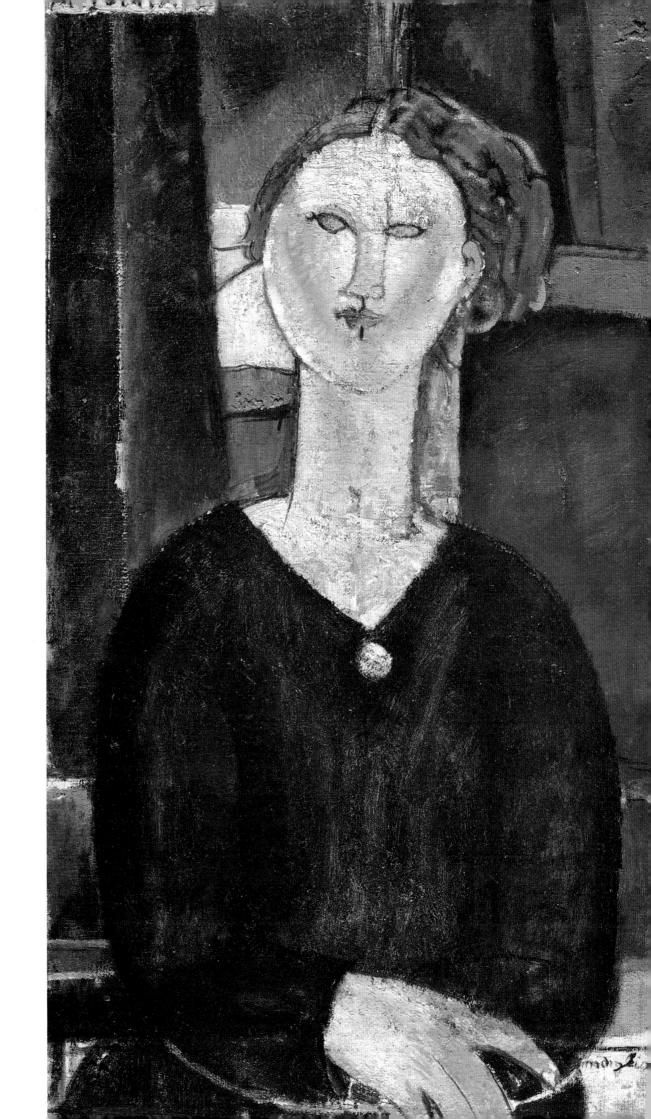

ANTONIA, 1915.
Oil on canvas, 82 x 46 cm.
Musée de l'Orangerie, Paris.
(Walter Guillaume
collection).

MADAME POMPADOUR, 1915.
Oil on canvas, 61 x 50 cm.
The Art Institute of Chicago.
(Joseph Winterbotham Collection).

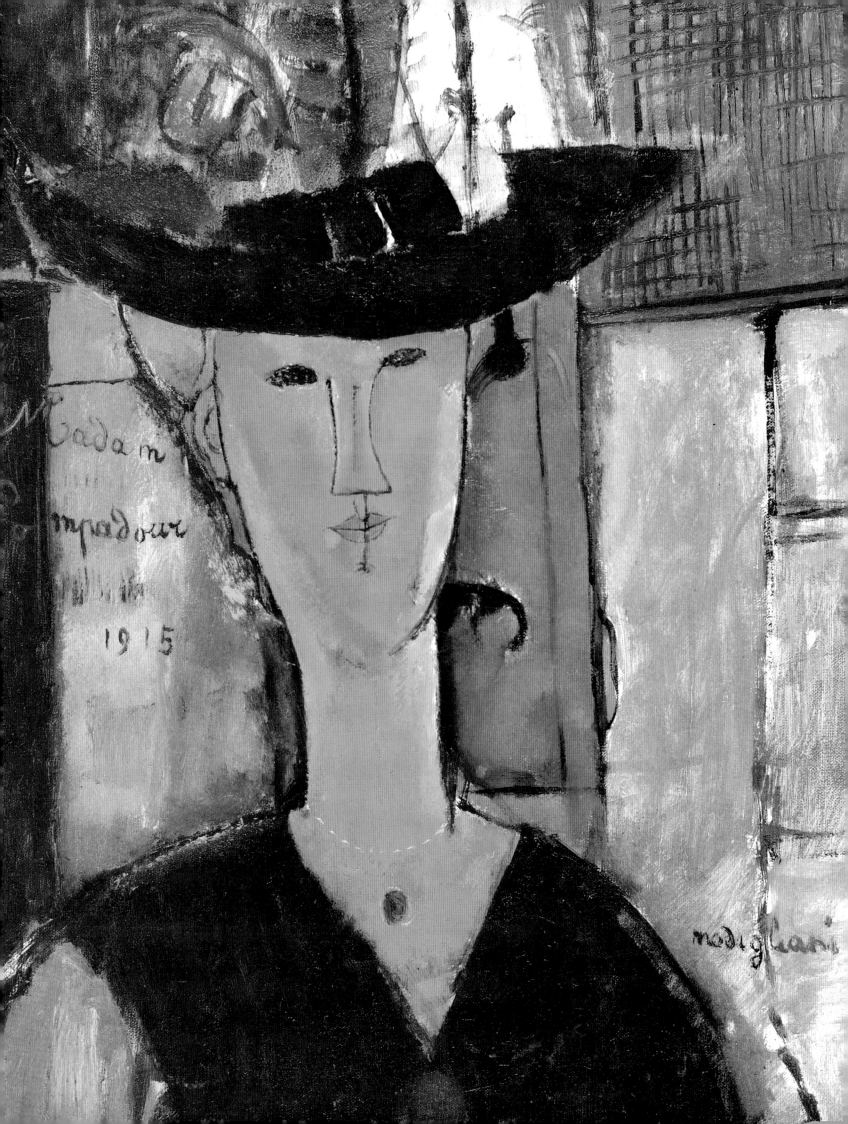

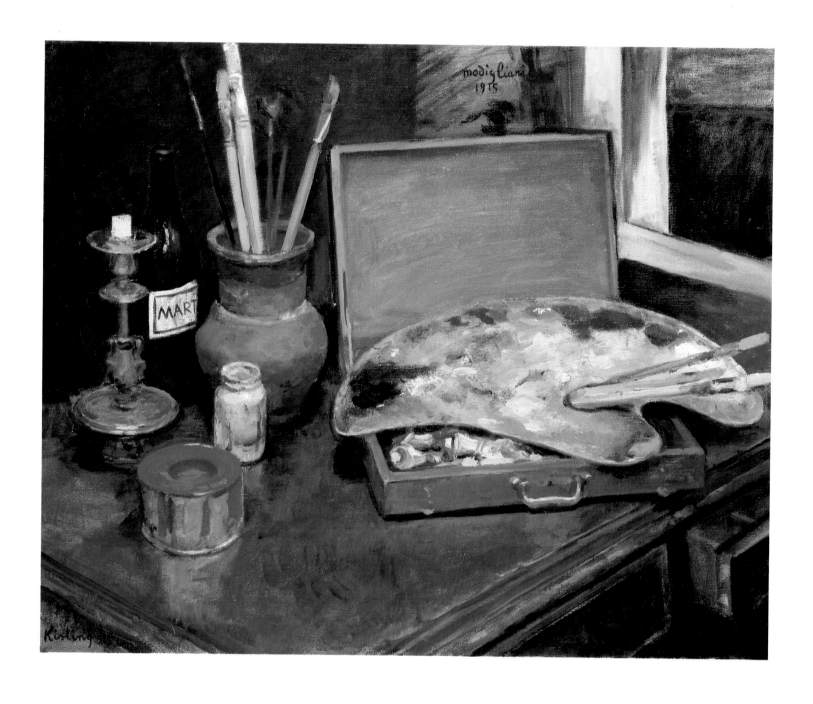

This canvas was painted in Moïse Kisling's studio, shared by Modigliani for some time with his close friend.

As stated by Jean Kisling, Moïse Kisling's son, this painting testifies to the fact that both used, for several years, the same brushes, colors and canvases but it is also a token of their friendship and all the work that they did.

Trace of this painting can be found at Galerie Zac in Paris. It was sold to Edgar Arosta in Beverly Hills and was recently incorporated into the collection of actor Charles Boyer.

1908, and *The Amazon*, painted in 1909, where the contrast of vivid yellow on a dark background is also reminiscent of the boldness of the Fauves. *The Cellist*, which is extremely reminiscent of Cézanne, dates from these beginnings. Other later works, such as the *Boy in Blue Jacket*, painted in 1919, return to the influence of Cézanne. Some portraits, such as those of *Frank Burty Haviland* and *Diego Rivera*, painted in 1914, include elements of Pointillism. Finally, in order to get away from classical perspective, he tried breaking up the areas around the figure in the Cubist manner, using volumetric shapes with defined edges, as can be seen in the 1915 *Henri Laurens* portrait. Echoes of these contemporary modern trends resound throughout his work. But just as he had detached himself from his classical education, he also refused to let himself be dragged into the arguments of the day and would not align himself with one movement rather than another.

That Modigliani pursued a lone course towards a personal form of expression is due to sculpture. Brancusi became interested in the series of drawings of Caryatids executed by the Italian around 1910 and encouraged him to go on to sculpt under his teaching. Without going through the usual preliminaries of learning to model in clay, Modigliani went straight to stone carving. In Greece, the Caryatids were female figures who supported the roofs of temples. Brancusi, who admired African art, also knew about the female figures which held up the thrones of tribal chiefs in the Ivory Coast, and Dr Alexandre collected works of art from this region. Modigliani simplified his designs, inspired by the rounded sculptures of the Indies and the crowned *Devetas* of Khmer art, with their elongated ear lobes, which had been brought to public notice by the explorations at the temple of Angkor that had been proceeding since 1898.

Much has been said about the gracefulness of Modigliani's Caryatids and the skill with which he managed the empty areas of space between raised arms and head. His sculptor friends were to pursue decisive explorations in this direction. But today our interest is mostly drawn to their relationship to primitive goddess/earth mother figures. We notice the blind eyes, the long, triangular-shaped nose, the smallness of the mouth and the expression of inner meditation.

Modigliani sculpted some remarkable heads, of great purity, but never tried to put into stone whole figures with the sinuousness of his drawings and canvases.

After this, he went back to painting. The influence of solar divinities could now be seen in his oil sketches and portraits, notably in those of *Diego Rivera* and *Pablo Picasso*.

His drawings often carried signs of the tradition which most directly concerned him. In the empty spaces of a picture can often be seen cabalistic signs and hieroglyphics. For example: a spiral mark like that

Left-hand page :
Kisling-Modigliani
THE WORKSHOP, 1915.
Oils on canvas,
62.5 x 77.5 cm.
Private collection.

which is sometimes found in Celtic art (see illustration p.176), a small star of David (p.170), cross marks (pp.179, 188, 190), a crescent moon and the figure 7 (p.164) and a form of lyre, which may also be a variation on the signature (p.164), often repeated and accompanied by a dedication. Jeanne Modigliani has pointed out that: "If you remove them you see that they are in fact essential elements in the balance of the composition." On the back of his friend Cingria's portrait is a whole poem written by him, "From the Top of the Black Mountain", and below a drawing of an athlete's torso he inscribed a prophecy of Nostradamus, beginning with the verse "The old lion will defeat the young lion". This tendency towards mysticism drew him and his friend Max Jacob closer together.

Modigliani dedicated a portrait to the poet as follows: "To my brother, on the night of 7 March. The crescent moon." Max Jacob was a convert to Christianity and Modigliani had never been a practising Christian. Nevertheless, the one probably inspired the other to make the three drawings of persons at prayer, simple monks or supplicants, dated about 1916. The painter may have gone through some kind of spiritual crisis, as evidenced by the title of one drawing: *Estatico* (Ecstasy). Max Jacob's inner searchings had probably made him feel insecure in his own beliefs. Not outwardly at first, but subconsciously; the artist was being tormented by his own anguish and fear of death. These signs and designs are dictated by almost resonant impulses, emitted at low frequency and mostly at random, and seem almost to contradict the romantic prejudice that "Where there is order, there is no art". Paradoxically, Modigliani also returned to the ancient origins of the Hebrew language to renew his acquaintance with the hieratic form and the sacredness of the human face.

In parallel with this crisis of identity we also need to look for references in his art to the Italy of the painter's childhood. We know that, lacking stone to carve, he had gathered railway sleepers from Metro building works, and that in this dark wood he sculpted very elongated figures, reminiscent of 18th-century statues of the Padua School or the carvings found on the pillars of Chartres cathedral. He used his friend Zborowski as the model for a Saint John the Baptist, now lost or destroyed, and was inspired by the themes of the Virgin and Child and the Crucifixion. Jeanne Hébuterne was the model for several mother and child paintings, a theme into which the *Gypsy with a Child*, painted in 1918, also falls.

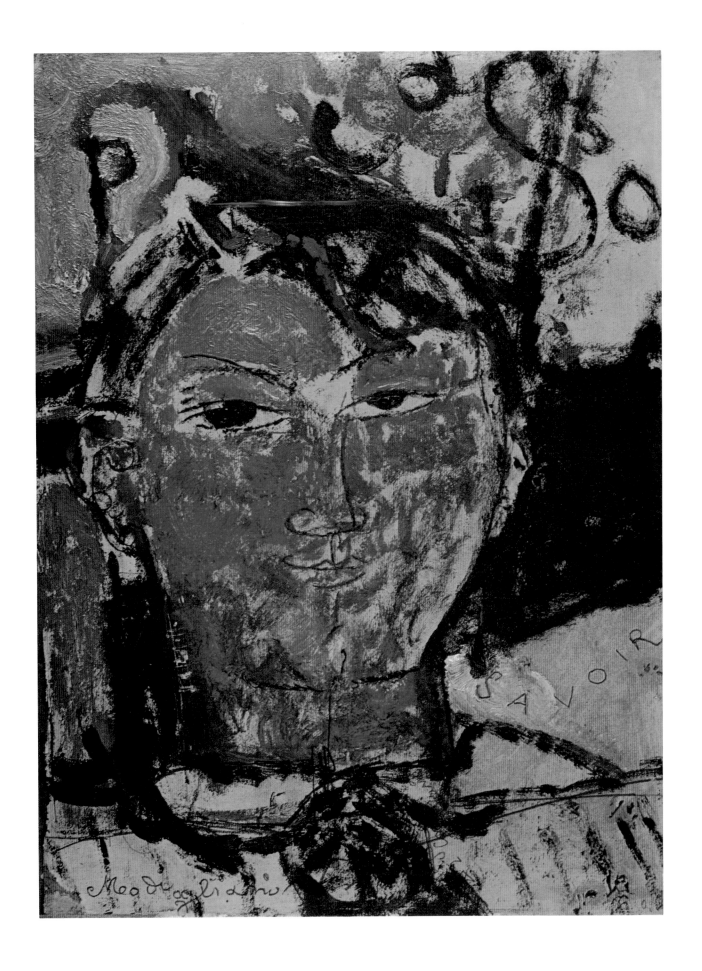

All this production can be viewed as a reaction against the Expressionists' and Cubists' distortion of the human figure, and may have been intended to restore respect for God's creations.

The metaphysical importance of the face had been demonstrated to the Italians by Byzantine artists. In ancient Rome, portraits were regarded as talismans of a person's survival, and if a man was assassinated, the face was obliterated. To prolong the lives of those around him would have been for Modigliani a kind of assurance of immortality for himself. The women he loved became objects of veneration. He gave Beatrice Hastings the title of *Beata Beatrix* and draped Jeanne Hébuterne, carrying his child, in the colours of an Andrei Rublev fresco.

Primitive art used abstract forms to indicate certain powers, to give concrete substance to dream material and to transmit precise indications as to the physical and psychological attributes of the subject.

References to Byzantine art indicate another approach to understanding Modigliani's essential and schematic type of representation. Byzantine art was considered backward-looking compared to other schools of representational art in that it could even forbid the depiction of the human face. Life on earth was considered as transient, while the spirit was what really mattered. By eliminating volume and perspective, by reducing the number of chromatic schemes and symbols, by simplifying attitude and gesture, they succeeded in de-materialising man and the physical world. The symmetry of the composition represented the hierarchical order of the Church. The elimination of any individual element which might occur by chance gave an intense significance to hieratic and intemporal gesture.

A gouache on paper of a woman, *Teresa*, treated in a Pointillist manner, is painted in this tradition. It is reminiscent of Ravenna mosaics and of a picture of Empress Theodora of Byzantium. The sitter feels very distant from the viewer. Modigliani was probably already distancing himself from daily life and feeling rejected by a society in which he refused to carve a place for himself. He could have become a fashionable painter like Van Dongen, or gone back to Italy, but he would not give in, considering Paris to be his place of work. He would try to realise his dream of linking art more closely to life.

Since his first visit to France, Modigliani's relationship with his models had greatly changed.

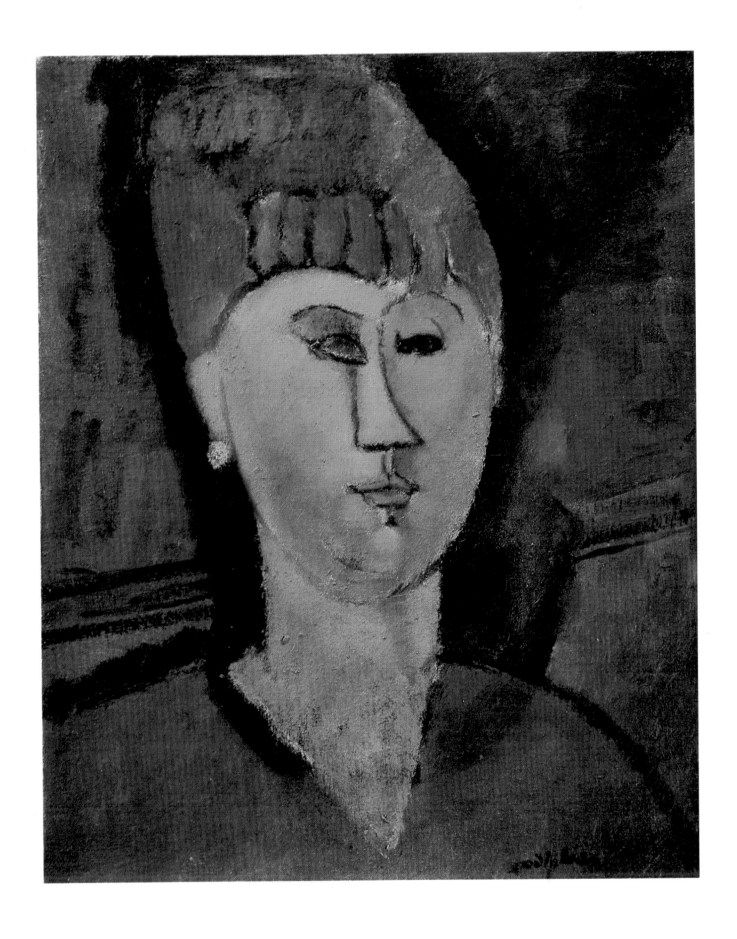

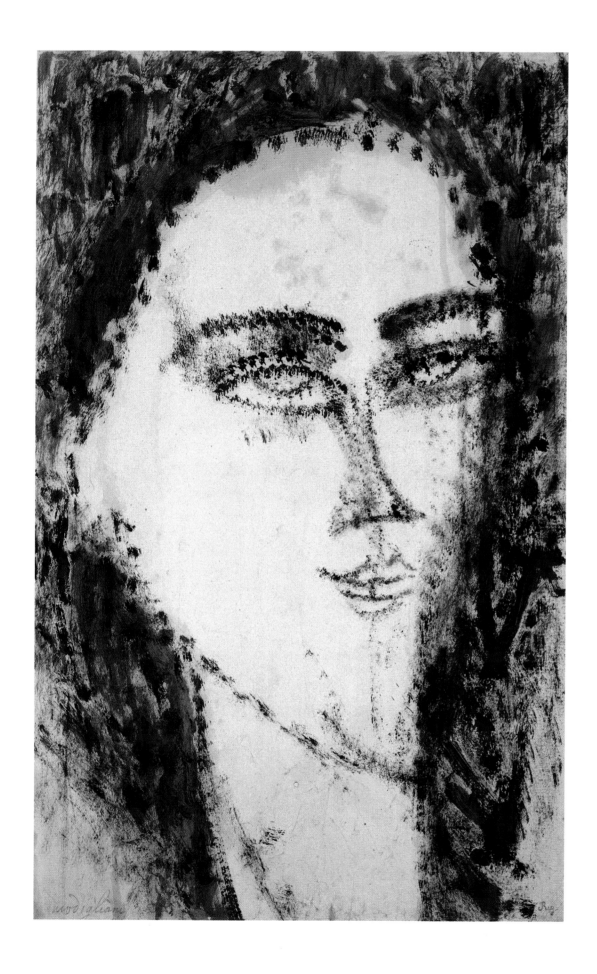

HEAD, 1915.
Oil on paper, 42 x 27 cm.
Musée Calvet, Avignon.

From the beginning, he nearly always chose to draw or paint single figures, seated in an interior setting. The composition was vertical. Women had their hands comfortably crossed, while men's hands were rarely shown. Virtually no models' feet ever appeared, even in life paintings. Profiles are rare. The artist preferred three-quarter or full-face views.

There is an extreme economy of props. Generally, the subject is seated in front of a window casement or in the corner of a room, to leave plenty of space around the figure. Occasionally the model is placed in front of a wall or a door and only the curve of the shoulders separates them from the background, as in the sad, mournful portrait of Chaïm Soutine, dressed in brown, which was painted in 1916. Women often have little fringes, collars, coronets, earrings, occasionally another single item of jewellery: a brooch, a cross or a medallion, making them look like pagan divinities. *Madame Pompadour* wears a proud hat trimmed with feathers. Some small imaginative point lightens the apparel of the most humble sitter: a white collar, lace trimming or asymmetric and outlined lapels. The men's names are often written on the picture and the size of the lettering is perhaps of significance: Picasso's name is in huge letters, and on his shoulder can be read the word *Savoir*, indicating his position as leader. Those of Kisling and Zborowski leap to the eye. Paul Guillaume rates capital letters, Max Jacob lower case letters which stand out and the name of Lipchitz melts into the background. Chana Orloff displays her Christian name on a pendant and her head is crowned with Hebraic script.

The rapport between painter and model became almost hypnotic. Eyes slightly crossed, sometimes blind or half-closed, give the impression of two wills in opposition: that of the painter determined to probe the model's character and that of the person in front of him, appearing to resist the capture of some part of their personality. It is wasted effort – a few strokes later they will have to submit. For Jean Cocteau, Modigliani's portraits, even his self-portraits, reflected only the painter's inner vision rather than an outward objective view of the sitter, as gracious, noble, precise and lethal as the fabled horn of the unicorn.

During the course of this confrontation, aggressive or passive, the sitter absorbs and reflects a certain image of the artist. Modigliani painted himself at the same time as he painted his model. The sitter acts also as a mirror. It is this which increases the symbolic power of his plastic expression. The faces of the men or women who find them-selves in front of him often remain immobile. Smiles are rare. Nevertheless the painter succeeds in suggesting several possible expressions. The spacing of the eyes plays an important part in this: a wide space gives the model a vague, meditative look, a narrow space gives them the appearance of incipient animation.

BRIDE AND GROOM, 1915-1916.
Oil on canvas, 55.2 x 46,3 cm.
Museum of Modern Art, New York.
(The F. Clay Bartlett Bequest).

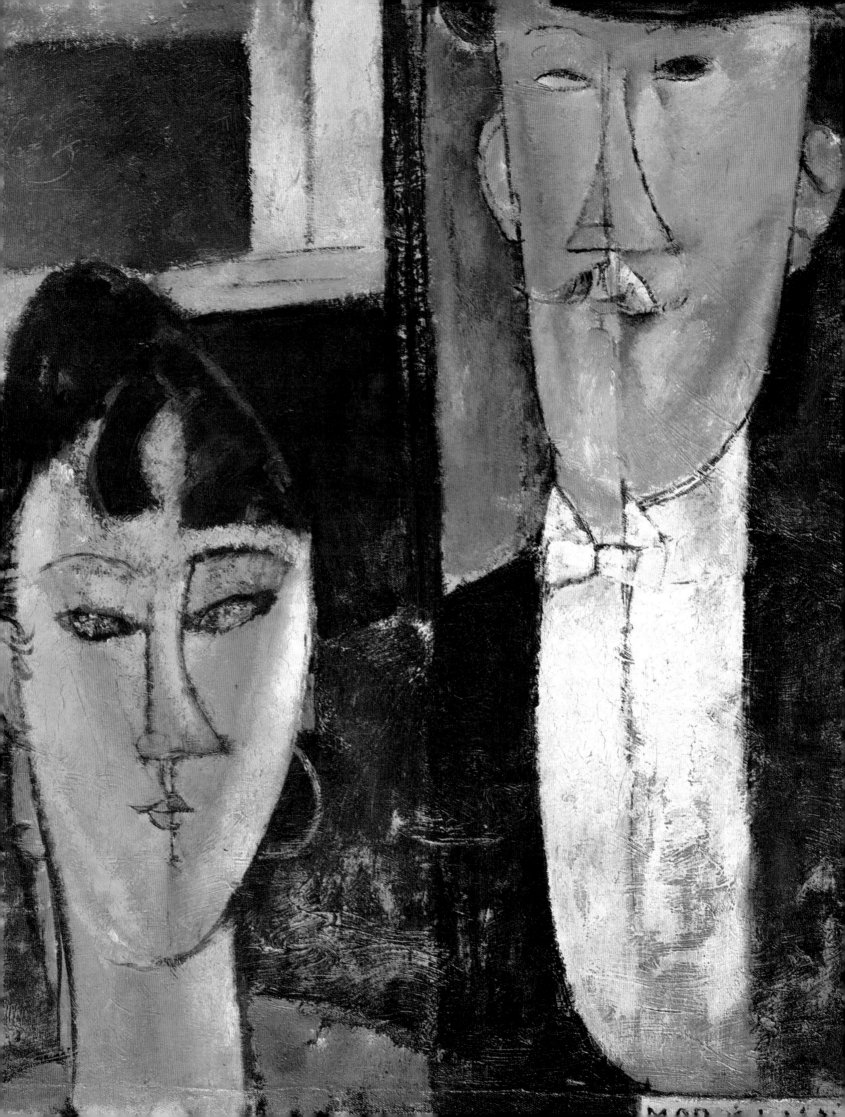

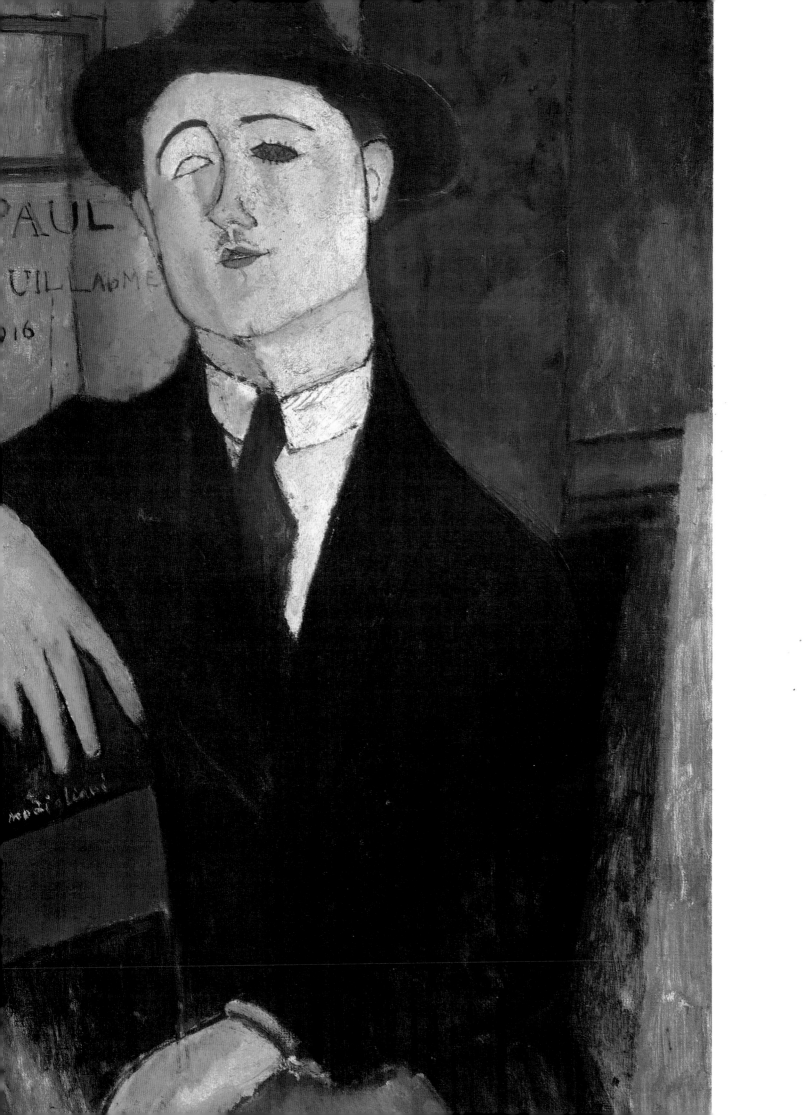

Modigliani drew and painted many female acquaintances and professional models, without much personality, who look bored.

It was quite different with the women he knew well. In painting Beatrice Hastings he returned to the pure lines of his sculpted heads, noted the determination of the eyes and the obstinacy of the mouth, the wilfulness of the chin and the proud carriage of the head. The backgrounds of stuck-on painted paper with silver arabesques and the extravagant hats show ease and a taste for elegance. *The Woman in a Black Tie* also follows fashion. Anna the wife of his friend Zborowski, and their friend Lunia Czechowska, inspired beautifully composed portraits which reveal the affection in which he held them.

Modigliani painted several portraits which were almost caricatures and were not without humour. The best known are those of Jean Cocteau and Paul Guillaume, in whom he brought out the ambitious side and, perhaps out of snobbery, the latent nervousness. Amongst these is the double portrait, which he must have done from memory, of the bride and bridegroom, a couple of *parvenus* he met in the street. Both composition and colour are extremely expressive.

To his close friends he gave the best of himself. Thanks to Modigliani's portraits we can better understand Soutine, the young man full of gaiety from the Vilno ghetto, meditating by a fireplace or on his feet, stupefied by drink. We recognise the solidity of Henri Laurens in the Cézanne-influenced portrait, the slightly precious side of Kisling, Jacques Lipchitz's affection for his wife, the reserve of Léopold Survage, the intelligence of Picasso, and the finesse and friendliness of Dr Alexandre and Zborowski. In each case the viewer also perceives the compassion, amusement and understanding of the artist. Modigliani's psychological approach, his perfection of line, and the interchange of feeling which comes through make him one of the great portrait painters, in a class with those who have left behind them an unforgettable picture of their times, such as Dürer or Holbein.

For a long time he had preferred subdued tones, greenish blues to browns, only rarely lightening the surroundings or the profile left in shadow. However, his stay in the Midi was to give greater transparency to the canvases painted at the end of his life. Modigliani adopted the lighter blues of Cézanne and his sensitive probing drove even deeper. In painting Jeanne Hébuterne, he simplified volume even further, elongated the form and rounded the shoulders. He had a great deal of

Opposite: PORTRAIT OF PAUL GUILLAUME, 1916. Oil on canvas, 81 x 54 cm. Galleria civica d'Arte Moderna, Milan.

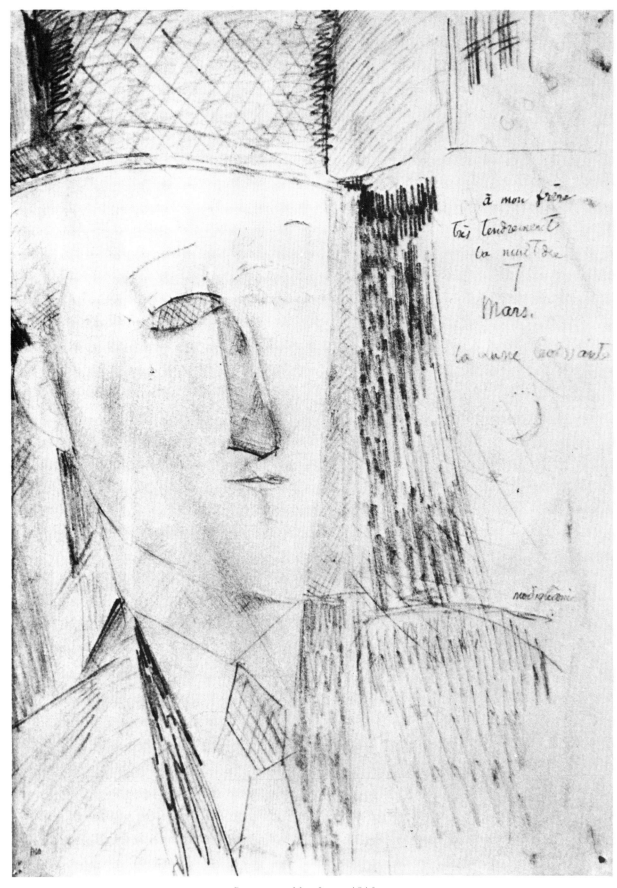

PORTRAIT OF MAX JACOB, 1916.
Graphite pencil drawing on paper, 34.5 x 26.5 cm. Private collection.

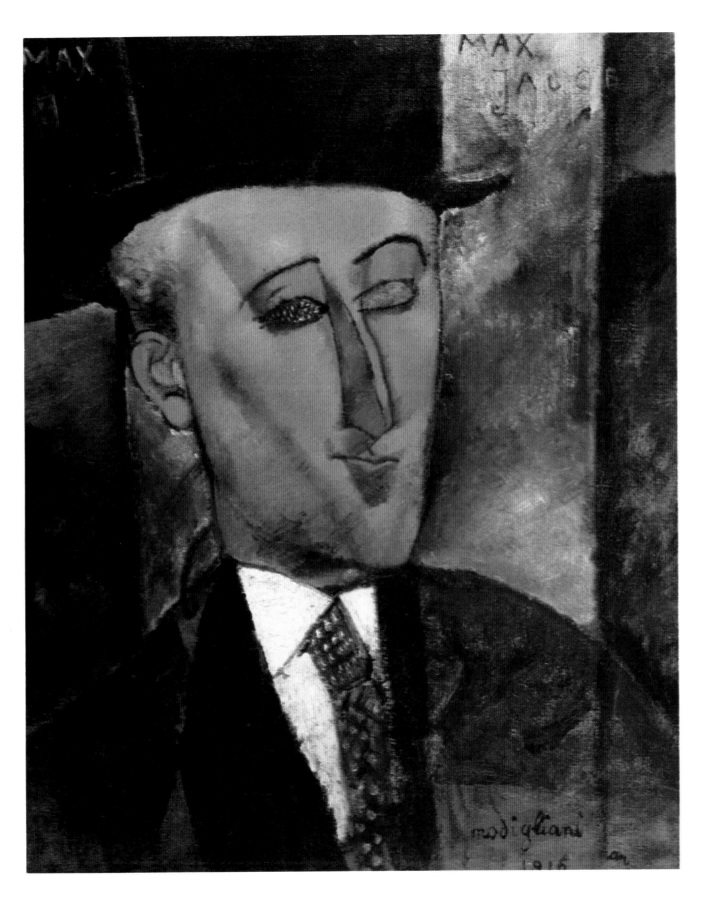

PORTRAIT OF MAX JACOB, 1916.
Oil on canvas, 73 x 60 cm. Kunstsammlung Nordrhein-Westfalen, Düsseldorf.

NUDE, 1916.
Pencil drawing on paper,
29.3 x 45.4 cm.
Private collection.

Opposite: SEATED FEMALE
NUDE, 1916.
Oil on canvas, 92 x 60 cm.
Courtauld Institute, London.

affection for this young girl whom he watched turn into a woman. He has made us free of all her expressions: frowning, pensive, proud of looking elegant, meditative carrying her child, happy to be loved, letting a smile filter through, serious as she presents her daughter. The expression invented by Restive de la Bretonne, to describe the elongated creatures with which the engraver Binet illustrated his books might well be used of Jeanne: *femme féique* (the fey woman).

Modigliani reserved sensuality for his nudes. These professional models and acquaintances have a melancholy air which haunts the observer. Some crouch down like Gauguin's Tahitian women, whose warm skin tones they also approach. Others are stretched out provocatively, or with a distant air, in the pose of Goya's *Maja Desnuda* or Manet's *Olympia*. The construction of forms and the beauty of colour are reminiscent of his early small caryatids, who in his opinion ought to have been "columns of tenderness supporting a temple of beauty".

Despite the fact that they offer themselves, these nudes also give a feeling of calm and stability, thanks to the simplicity of the setting, the better technique and the feeling that the artist has arrived at a long sought-after mastery. In the contemporary portraits of Jeanne Hébuterne and Anna Zborowski it can be seen that he gives more importance to emotion. This is brought out by more *recherché* nuances, by exaggeration and distortion and a nobility of bearing which testifies to greater spiritual refinement, as can also be seen in the one self-portrait which he left us, dated 1919.

In his last works, he renounces all accessories and inscriptions, and

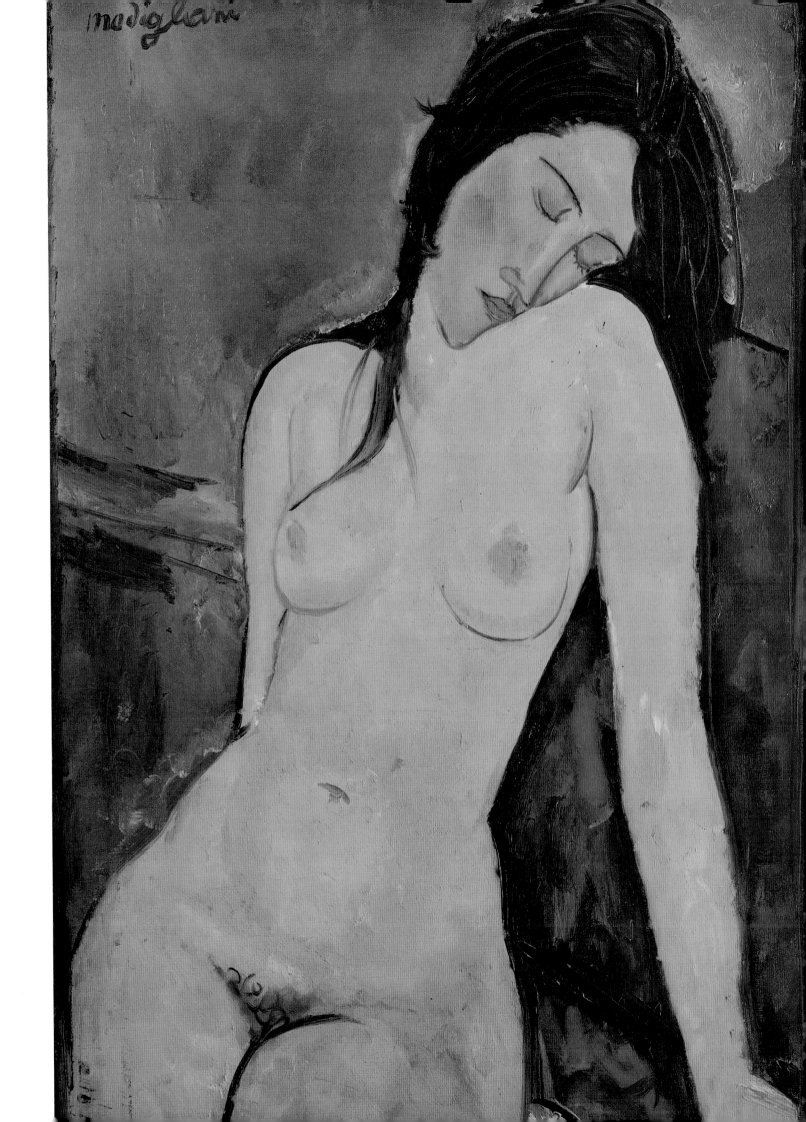

THE SERVANT, 1916.
Oil on canvas, 73 x 54 cm.
Kunsthaus Museum,
Zürich.

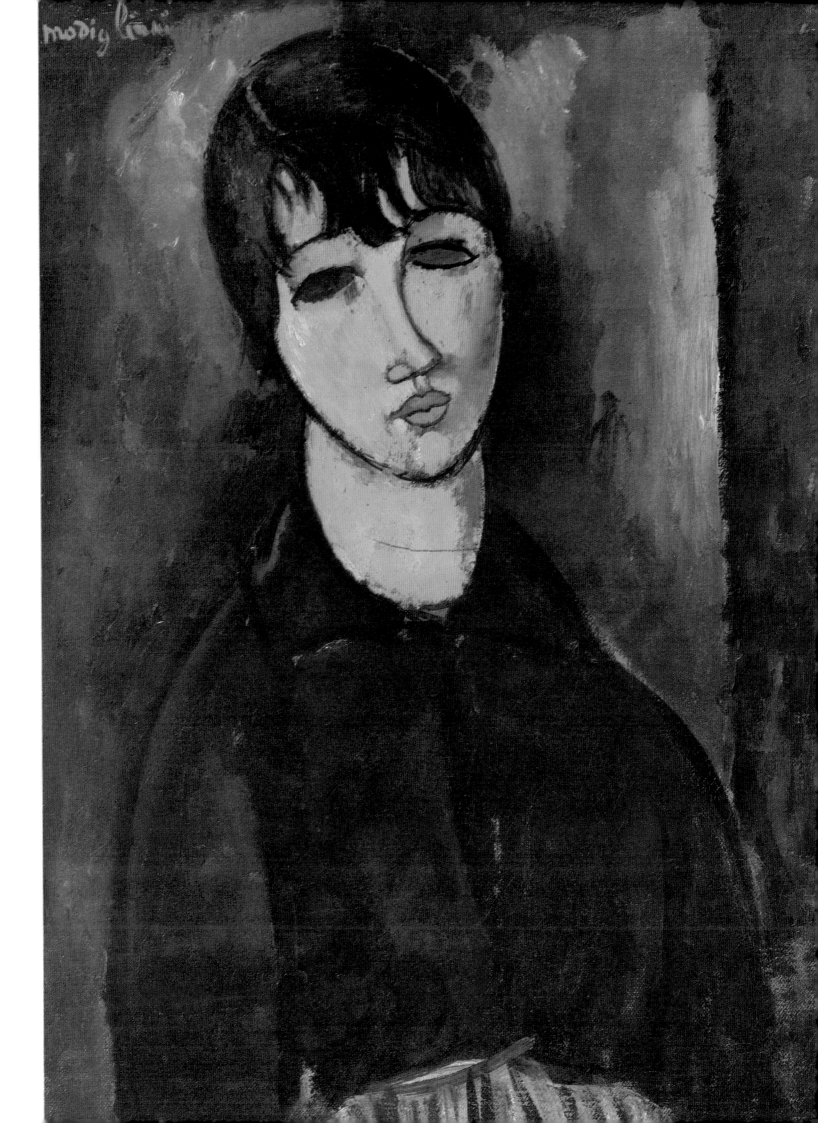

PORTRAIT OF CHAIM SOUTINE,
1916.
Oil on canvas, 92 x 60 cm.
National Gallery of Art,
Washington.

transforms the sinuously outlined women of his world into icons worthy of his worship.

Modigliani knew how to use the love of elegance inherited from his Italian background, his culture and his ever-open mind about the civilisations which had left their mark on all Mediterranean art forms, his ever-unsatisfied curiosity about the human being and his hunger for metaphysical speculation.

In Paris, despite all the problems, he had done what he set out to do, without giving in to the easy option and commercial tempations – for he could easily have just become a fashionable painter.

On the other hand, the constant work he put into his *métier*, and his determination to eliminate the superfluously decorative in his art, very early on brought him the recognition of learned dealers such as Paul Guillaume and Zborowski who, quite rightly, saw the true value of his work.

The numerous portraits he painted of friends and of the women in his life show that he strove continuously to learn about their inner selves and their motivations.

He tried to leave the most perfect image possible of those he loved and respected. This blend of sensitivity and mastery of technique is what makes his works truly original. His is a rich, subtle, exacting and much more diverse œuvre than it is generally thought to be: the impressive number of exhibitions – all around the world – of his paintings, drawings and sculptures testifies to this.

Amedeo Modigliani belongs by right in the canon of great painters.

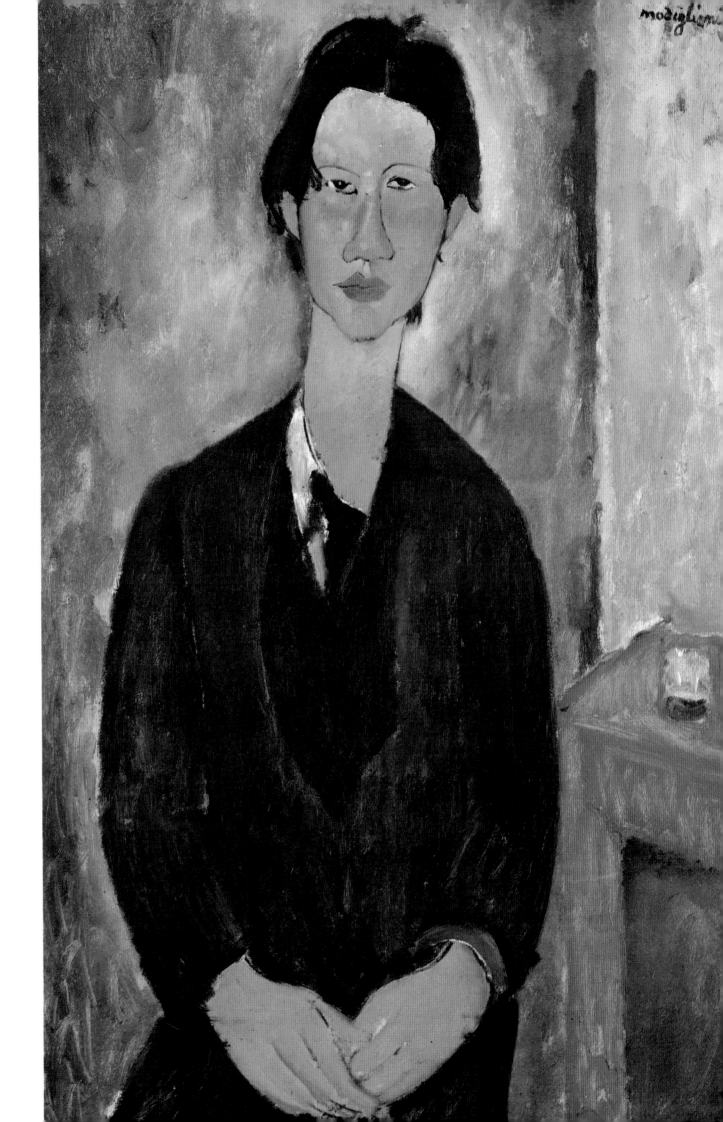

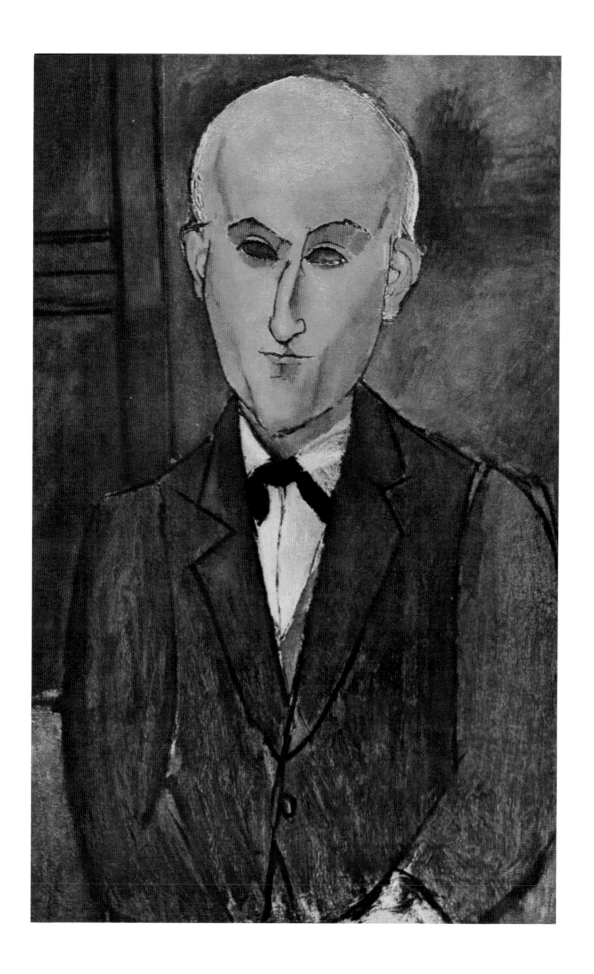

The critics on Modigliani, or the Dual Nature of his Art

Sylvie Buisson

"I would like my life to be like a river, rich in plenty, flowing joyously over the world..."

So wrote Amedeo Modigliani in a letter to his friend Oscar Ghiglia in 1901. Reading the many *critiques* of the Livorno painter from 1919 onwards, when the first article about him was published in the Geneva *Eventail*, it does not seem· as though this heavenly vision, offered by Modigliani as the leading force of his life, was reflected in the ideas that run through the pages written about him...

Nevertheless, had Modigliani been asked, like Soutine, if his life had not sometimes been a great disappointment to him, he would probably have replied: "No. Who told you to ask me that? I have always been a happy man".

The existential truths about Modigliani are already outside the norm even before his artistic life is touched on. They consisted of the happiness he carried within himself, the determination never to be unhappy and the inevitable anguish of all creative people. The first paradox is in the way he lived his 36 short years. Even if they were not all fun, as would appear to be the case from contemporary witnesses, they were like the "river rich in plenty", which was to cause many tears and much ink to flow in its wake.

It seems particularly apposite to choose from among the judgements of contemporary French critics a number of texts published in the ten years which followed his death. They are sufficiently probing and contradictory to show us the real man, as well as the basis for the legend about him, which we should approach with caution.

Extracts from Francis Carco, Florent Fels, Lamberto Vitali, André Salmon, G. Scheiwiller, Waldemar George, André Warnod, Gustave

Opposite:
PORTRAIT OF MAX JACOB,
1916.
Oil on canvas, 92 x 60 cm.
Cincinnati Art Museum.

Coquiot, Adolphe Basler, Maurice de Vlaminck, etc. give us the extremes of opposing views, and show the position they allot to Modigliani the artist and to Modigliani the man.

Both subconsciously and consciously, their writings navigate the discrepant though apparently logical conclusions elicited by the paradox of Modigliani's work and the way in which he lived his life.

These writings, rich in the content of their era, provide us with valuable insight, because of their prophetic quality and their immediacy to the events they describe. They also make us pause and reflect, since they are interpretative and in all cases subjective: so much so that the fiery spirit and passion of the writing causes facts to be distorted, particularly by the legend which, however exciting it might be, is nonetheless subject to imaginative interpretation.

Thanks to this collective imagination, the life of Amedeo Modigliani takes on a theatrical quality which we may enjoy, but which must also be taken at its true value.

What, for instance, is one to make of a biographical portrait of Modigliani by G.Coquiot, written only four years after the death of the young painter, in which he appears to resemble a hero of legend. It opens in the manner of a Grimm's fairytale:

"Once upon a time, in Livorno in Italy, there lived a little Jewish boy who was loved by his parents. His name was Amadée, Amedeo Modigliani..."

When Jeanne Modigliani was editing a life of her father she read the *critiques* and literature about him very carefully. She was wary of the fictional elements which had crept into the rather too literary language of her father's friends, who were often more concerned with the impact of their publication than with the simple truth. All had known him, some had shared his daily life, but very few contented themselves with the facts, at least where his way of life was concerned. On the other hand their judgements regarding his art were authentic, fascinating and committed. As was the case with most of his friends, who were later grouped under the heading of the School of Paris, the critics did not lionise him in his lifetime, nor did he even receive a great deal of encouragement. André Warnod in his book *The Painters of Montmartre*, published in 1928, clearly demonstrates that the discovery of painting

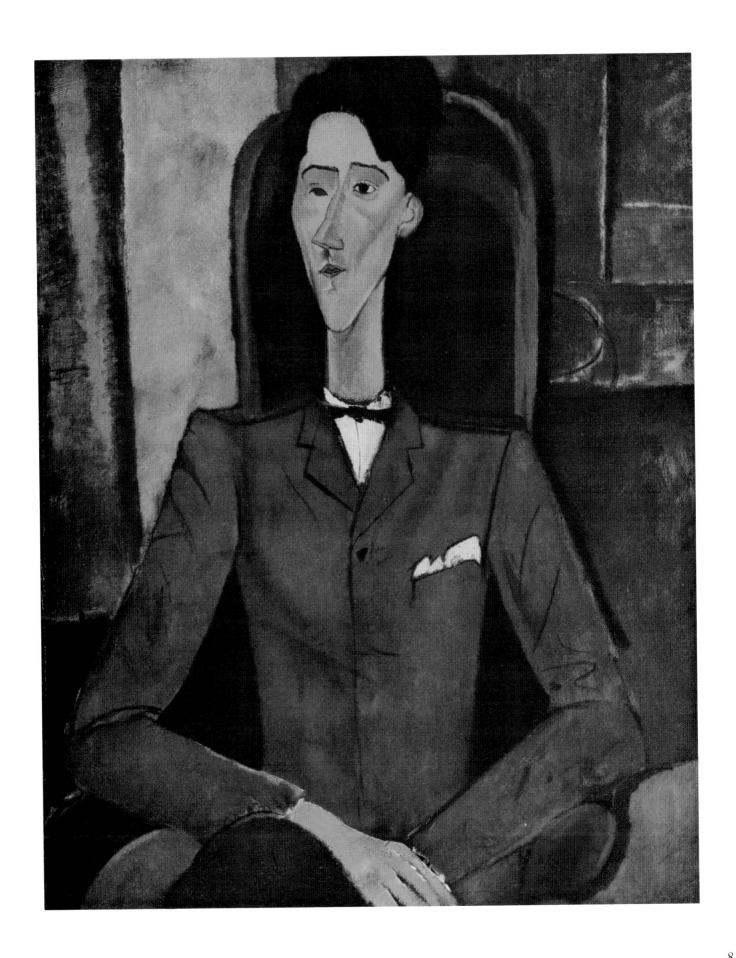

85

as a social phenomenon did not take place until after 1920, with the first commercial success of Utrillo and the death of Modigliani. According to him these two events were key factors.

"The discovery of Utrillo", wrote Warnod, "the inclusion of his paintings in the 'stock exchange' of pictures and the small fortunes made by people who dealt in this newly-quoted asset, troubled many. A similar event, and one which was to have the same immediate results, occurred as soon as Modigliani died."

These two events, coming so close together, made a great impression on many people who up until then had barely noticed painting. The fact that a canvas which had been bought for a few francs could a short while later be worth several hundreds and then several thousands, and continue to increase in value to prices counted in tens of thousands of francs, whetted the appetite of all kinds of speculators. Patrons of art burned with the fever of prospectors in the Alaskan gold rush. Each discovered in himself the soul of a collector, whether he was from the world of trade or finance, or from the middle classes.

"New, youthful, painting became a popular subject of conversation, and what had up to now been the prerogative of picture dealers fell into the public domain."

"Apollo and Mercury had formed an alliance and Mercury was the senior partner."

"This new state of affairs completely changed the position of painters just starting their careers. Some people, in despair at not having known that masterpieces could be bought for a few francs in the days when Utrillo was leading his life of the damned in the bistros of the Butte Montmartre, wanted their revenge and, so as not to miss the boat a second time, they subjected everything that saw the light of day in the art world to a minute scrutiny."

"Talent was bought while still in the egg. What would emerge from the shell? A rare bird perhaps? But how many chickens were to sit on eggs which were to hatch out into ugly ducklings!"

With the development of the market in paintings, the number of art critics proliferated, as did their readers and the impact of their writings. Modigliani, like Utrillo, aroused the interest of all. However, before this passion for art had arisen, and while he was still alive, a six page article by Francis Carco on Modigliani, illustrated by three reproductions of his paintings, had been published in a Swiss review on 15 July 1919. A few lines written by an anonymous author in *Les Écoutes*, following the exhibition at the Paul Guillaume gallery from 15 to 23 December 1918, must also be mentioned.

"M. Paul Guillaume has in his stable – if one is permitted to call it such – two front runners. One is M. Modigliani, an Italian living in Batignolle; and the other Giorgio de Chirico*, a Spaniard living in Montparnasse. Modigliani is a reformed humorist (...) who has been 'Cubing' for a while so as not to draw attention to himself and who is now distorting, stretching out and elongating his faces under the dual influence of Maori fetishism and André Derain."

Apart from this amusing review, the *critiques* of his work which appeared between 1919 and 1934 are interesting because they help us to pin down the complex character of the artist. On reading them we are led to believe that this was a personality fused in the blinding flash which unites extremes and plays with contrast, contradictions and opposing ideas. The Italian painter never proves to be what we think we have worked out when trying to classify him logically.

Modigliani was not just a sculptor. He was not just a painter. Even less was he just a draughtsman or a colourist. He was all these things at once. He was Modigliani: above periods or styles.

He can only really be defined by the evocation of opposites, placing him and his work with suffering on one side and perfection on the other, between realism and expressionism, between painting and sculpture, between colour and line, between the straight line and the curve, between voluptuousness and purity, between France and Italy... and all at the same time.

The contrasts in his personality, the tribulations of his life, and also his generosity and his hunger for the absolute, place him between suffering and perfection. As Henri Lormian expressed it:

"And this man, whose friends thought he looked like a fairy tale prince, with his Roman profile and well bred air of an aristocrat, (all the photographs of him are evidence of this)... had a dripping nose and the eyes of a drunkard. Women never noticed this or, if it was pointed out to them, would say in a tone of voice which admitted no argument, 'Perhaps, but he is such a wonderful conversationalist'."

To help him cope with the constant battle of daily life and with his dissatisfaction at the impossibility of finding purity on earth, Modigliani took refuge in drugs and alcohol. It seems quite clear that the critics were prepared to pardon, understand and even respect the weaknesses which were eventually to carry off this exceptional man. Florence Fels recalls epic sessions at La Rotonde:

"...Libion, the *patron*, intervened at closing time, to the slight concern of a number of people with whom he was drinking and arguing, but whom he adored. 'Modigliano, you've had enough... Modi

(*) Giorgio de Chirico (1888-1978) was an Italian.

88

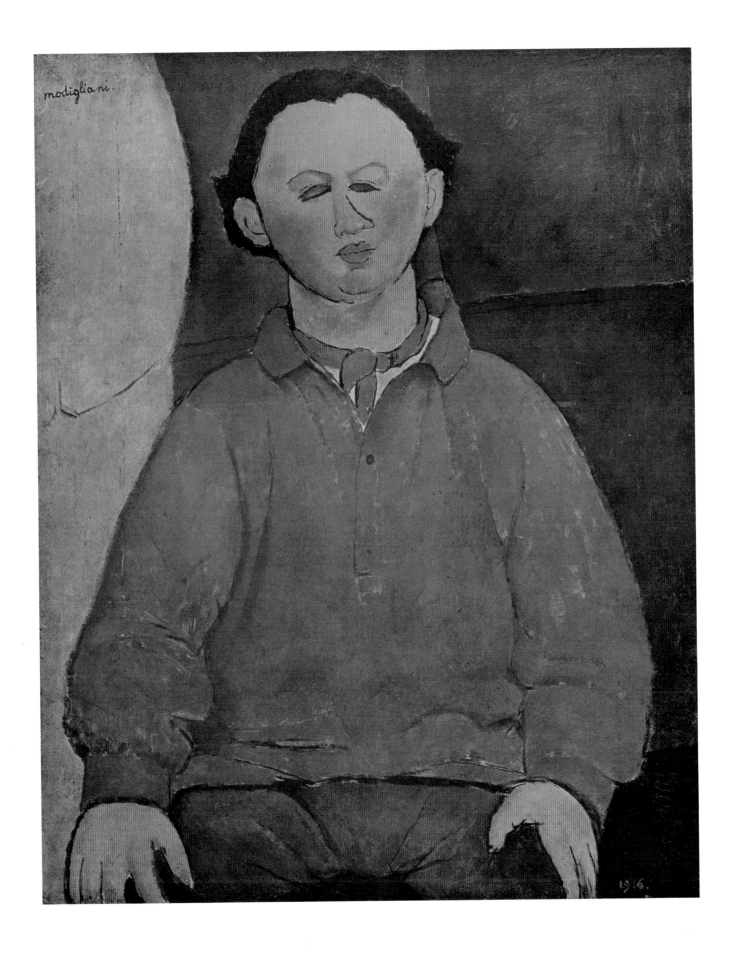

89

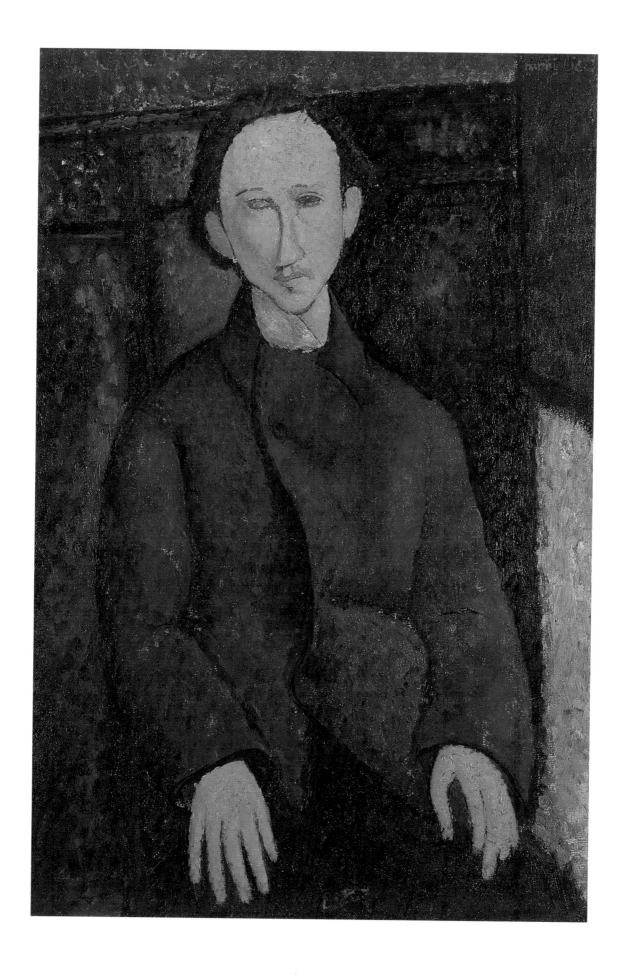

it's time for bed now", he said to Modigliani who was standing up against the bar, arms crossed. The painter did not give Libion a mouthful but patiently nodded to him and carried on drinking.

"Madame H...gs (Beatrice Hastings) who was his favourite at the time, hardly less drunk than he and carrying on her arm a small basket of flowers, begged him to come 'home', to the square, cold, undecorated, plaster-walled garret furnished with a sofa, a frying pan, and a pitcher and ewer, which I never visited without a shudder.

"Piss off, Madame', was the reply.

"And Modigliani stood his ground, in a sense still master of himself, indifferent to his surroundings, lost in an alcoholic dream. Much later, having wandered around and seen the last of his friends home, Modigliani, staggering but still dignified, returned to his lodgings. In the middle of the night a bawling sound could be heard, like the cries of a sinner condemned to eternal torment."

Adolphe Basler remembers how, from 1914 onwards, "the sight of a sober Modigliani became increasingly rare. To make a living he painted the portraits of any who would sit for him; but no sooner had he earned a franc than he drank it. He drank cheap wine and often became unmanageable. He was the despair of the bistros. His friends, used to his excesses, forgave him, but the café owners and waiters, who got no tips from artists and writers, treated him as a common drunk."

"But everyone loved him," the critic continued, "his landlord, his barber, the bistros, every one of them had paintings or some souvenir from him. Talk to the Russian painter Wassilieff, she fed him at her canteen during the war! Talk to the locals, to X..., the little sculptor from Burgundy, or Z..., the painter, or to the communist philosopher Rappoport with whom Modigliani often enjoyed an argument; talk to the policemen who locked him up when he was drunk. He was even popular at police headquarters where a number of senior officials eagerly collected his work. Poor Modi could not have wished for a better public than he had during the war. People from all over the world, Americans, Swedes, Norwegians, Poles, Russians and Mexicans all had their own seat at La Rotonde."

The painter Maurice de Vlaminck, eight years older than Modigliani, was a great admirer of the young Italian, as can be seen from this article published five years after his death:

"I knew Modigliani well.

"I saw him hungry, I saw him drunk, I saw him rich with a little money, but I never saw Modigliani lack magnanimity or generosity."

Opposite:
PORTRAIT OF PINCHUS KRÉMEGNE, 1916.
Oil on canvas, 82 x 55.5 cm.
Kunstmuseum, Berne.

"I never saw in him the suggestion of a mean sentiment. I saw him angry, irritated at having to admit that money, which he despised, was sometimes more important than pride or what he really wanted to achieve."

"Today when everything is highly coloured, dressed up, when we believe we can outdo life itself, when it is all surcharge, surfeit and Surrealism, some words lose their true meaning. I no longer know how to use the word art or artist."

"Today the word artist could perfectly well replace the word tradesman. It can be seen on everything, from the fire station to the cocaine dealer, via the hairdresser and the hardware shop and all round the big stores: the art of home economics, the art of cooking, the decorative arts, the art of hairdressing, etc."

"But let us suppose for a minute that the word had not been thus debased, but had regained its own colour and true meaning, then I would say:

"Modigliani was a great artist."

It is clear that Modigliani's honesty found an echo in the sensitive, upright and strong character of Vlaminck.

"Modigliani", he continues, "was an aristocrat. His entire œuvre bears witness to that fact. His canvases all bear the imprint of great distinction. Grossness, banality and vulgarity have no place in them."

"I can see Modigliani now, seated at a table in the Café de la Rotonde. I can see his classical Roman profile, his authoritative look; I can see his fine, well-bred hands with nervous fingers, unfalteringly drawing in an unbroken line."

Some six months after the painter's death, Francis Carco recalled the smell of sulphur which hung about his first notorious exhibition at the Berthe Weill gallery.

"At a recent exhibition of his work in the rue Taitbout, Modigliani found himself forced by the police to take down certain nude paintings which were shocking passers-by. But", Carco continued, revolting against this piece of imbecile prudery, "the remaining portraits, which he had distributed haphazardly around, were in themselves enough to show the nobility of his art. Even if you do not like his cynicism or the

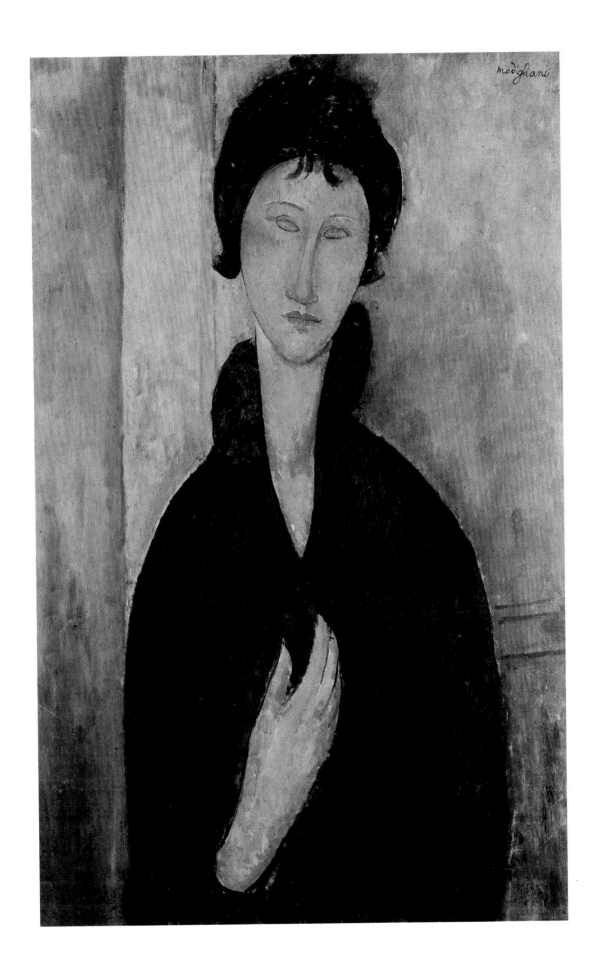

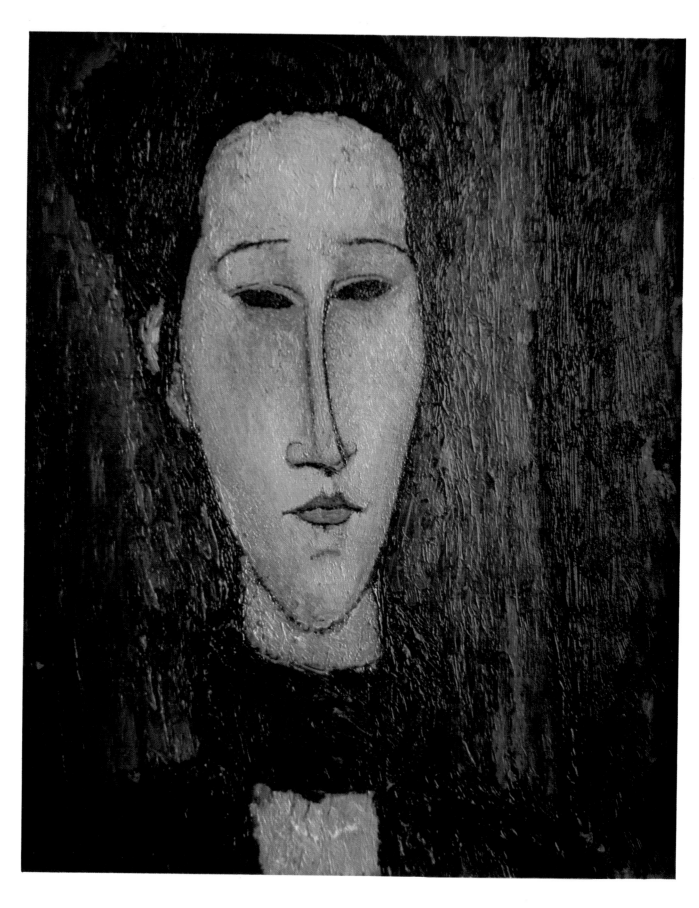

PORTRAIT OF ANNA ZBOROWSKA, 1917.
Oil on canvas, 41 x 33 cm. Private collection.

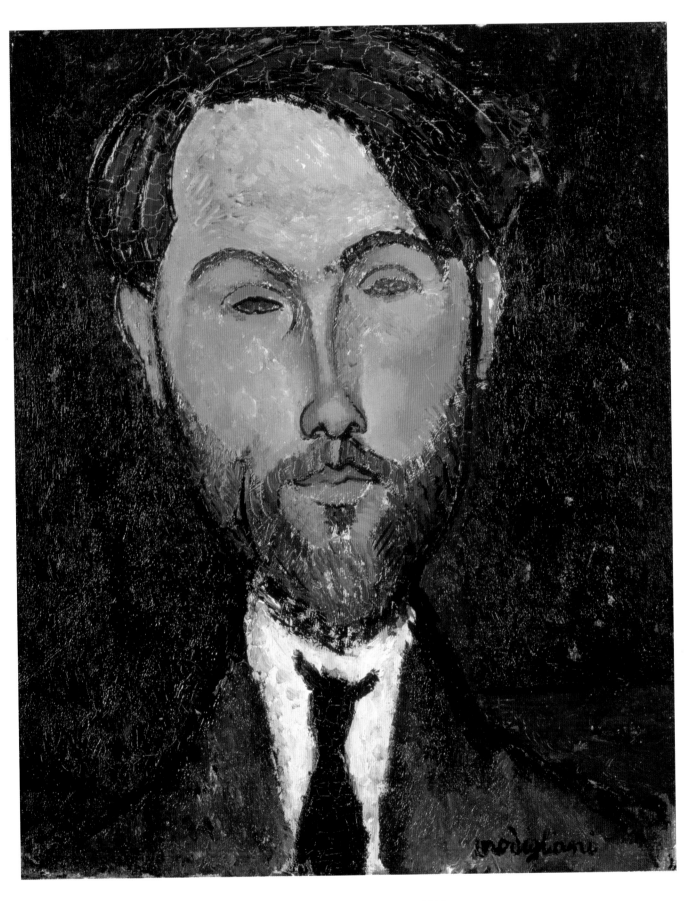

PORTRAIT OF LÉOPOLD ZBOROWSKI, 1917.
Oil on canvas, 40 x 32 cm. Private collection.

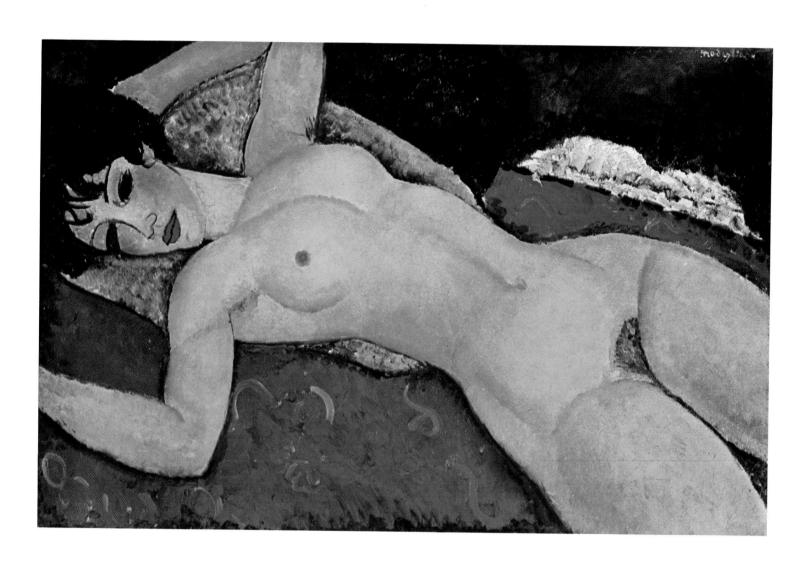

repeated use of a palette in which two or three tones are blindly cherished; or the fact that he distorts in an attempt to define grace; or sacrifices much to creativity, nuance alone interesting him (after rhythm, that secret construction of movement "which displaces line"), are you not shocked at your own slowness in understanding the subtle rapport between the painter and the object of his cult?"

If one describes his life as being somewhere between suffering and purity, it seems even more right to position his work between voluptuousness and purity, as I shall now attempt to show.

Some critics get carried away by the magnificent sensuality of the nudes and their voluptuous appeal to the senses, while others see in them only the quest for a redeeming perfection.

Francis Carco pays homage to the painter's daring:

"He approaches these astonishing studies quite frankly on canvas. Their nudity seems to consist only in uncovering the modelling of the stomach, the breasts and a mouth which is more ambiguous than the actual sex. Animal suppleness, sometimes immobilised, abandonment and happy frailty have never had a painter more carefully interpret them. Look at the clasped hands, or the hands seeking each other, the movement of the face, the eyes, one already half closed in anticipation of the pleasure to come, the finger... the thighs, more inviting than the appeal of two arms held out, and the delicate fold which hides the 'moist retreat of love'..."

In his book, *Amedeo Modigliani*, published between 1925 and 1927, Giovanni Scheiwiller distinguishes between the two types of Modigliani nude (Carco does the same, as we will see):

"This artist painted nudes of great quality", he wrote, "which can be separated into two categories:

"Models, in all the splendour of their youth, who must have given the painter not just spiritual feelings but also passionately carnal ones. These form the first category.

"The second is made up of works with a quality of singing contentment, which would not trouble even the dreams of a good bourgeois. I know of no other nudes which testify like Modigliani's to perfect spiritual communion between model and painter. It is not just a question of normal beauty which would animate animal sensuality; the artist has transmitted his own aesthetic feelings to the picture, and as the mystic bows down before the mystery, so Modigliani deifies woman. Through the exquisitely careful drawing and the refinement of touch, Modigliani reveals all the fragile sadness of the subject.

Opposite:
NUDE, 1917.
Oil on canvas, 60 x 92 cm.
Private collection.

JACQUES LIPCHITZ AND HIS WIFE, 1917.
Oil on canvas, 80.2 x 53.5 cm.
The Art Institute of Chicago.
(Helen Birch Bartlett Memorial).

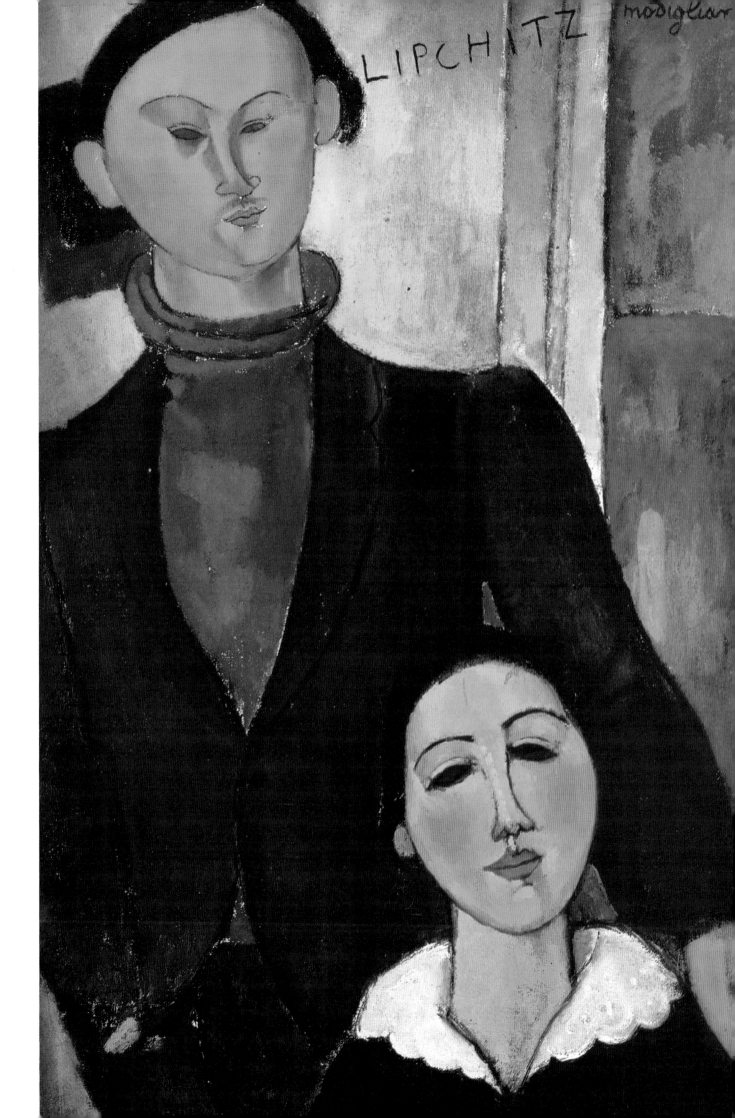

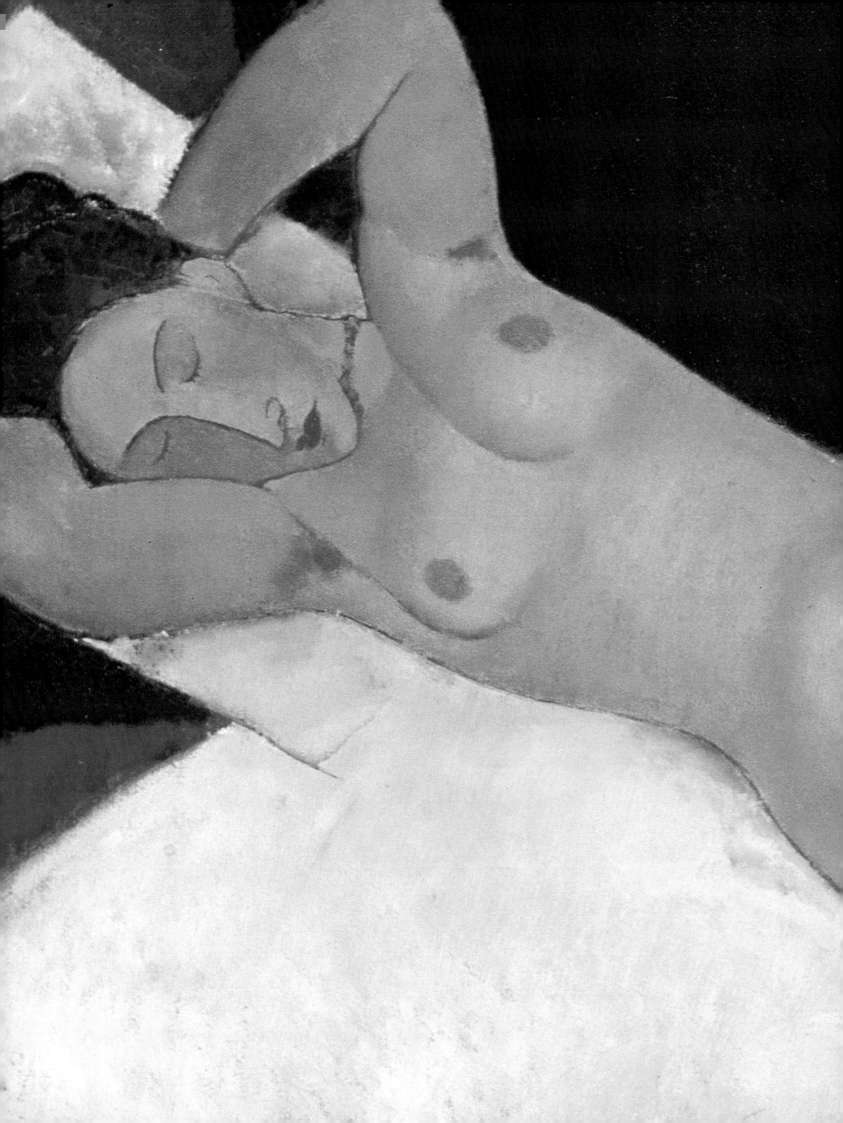

"Some of this painter's nudes (for example, *The Pink Nude*) have an almost religious feeling about them, more ecstatic in fact than many of the famous Buddhas of Angkor, Ceylon or Java."

In his book *The Nude in Modern Painting*, published a year before the above, Francis Carco developed this theory of two classes of nude:

"Modigliani differs from other masters of life painting in having no particular 'method' for painting skin. In the roundness of the forms, in the warmth, full-bloodedness and tones of the skin, we recognise a Rubens or a Renoir. The overall style alone makes it instantly recognisable as Modigliani. Here the young girl is standing up, smiling, her shift has slid halfway down her thighs and the most delicious skin tones mingle together and are given solid form by an exquisite lightness of touch, which froths up pearl and rose, rubs in amber, and flecks with pale gold, to give a downy quality to the triumphant freshness which the exquisite light of an April morning caresses rather than outlines. Between the light and the skin there is an impalpable veil which gives a velvety finish, like translucent frost on a flower, sparkling in the light..."

"In another picture the interpretation is quite different. A woman with firm, healthy but rather ripe flesh, is seated, clearly drawn, against a hard background. The body no longer shimmers. It is painted in wide, long, matt, almost uniform strokes as though the painter were using whitewash instead of employing subtle areas linking one nuance to another. It is worked in single tones that come in sections with smooth regularity. Nothing in the use of colour or visual devices relieves this. The carnal lyricism of the young girl in her shift has turned into a direct statement. What was smiling and ornate sensuality has taken on a wholly human emphasis. After the invitation engendered by charm comes the authority of desire."

Francis Carco also put forward the idea that in between these two extremes lay an infinite variety of feelings, an idea which seems to me to be particularly judicious and enlightened:

"Between these two interpretations there lies an infinite range of feelings and sentiments which suggests the nakedness of woman. It

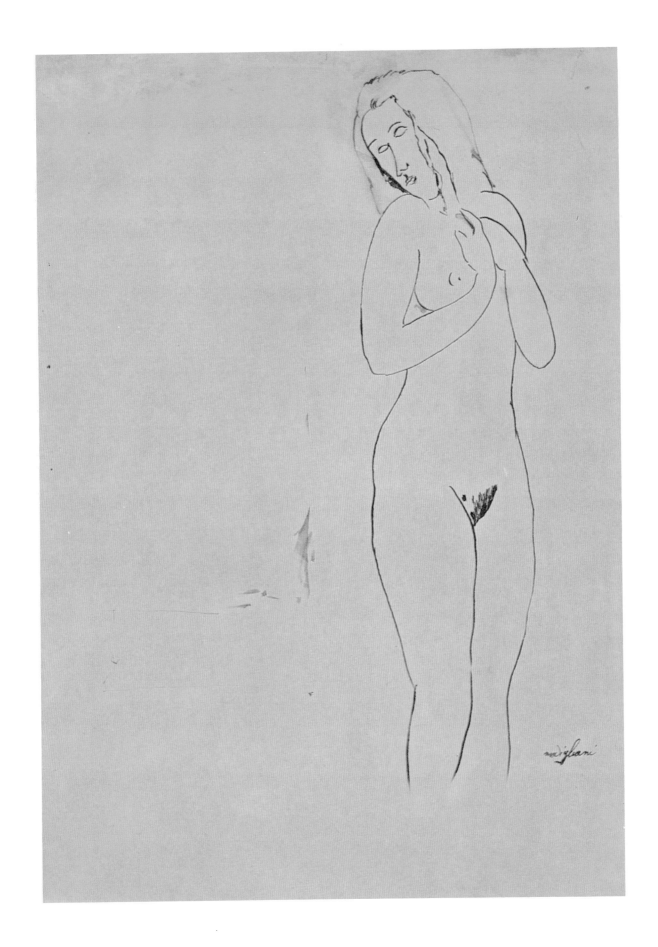

would be impious to single out the shimmering creations for hypocritical reasons and ridiculous to compare idiotic 'modest nudes' with these piercingly voluptuous ones, which are not in the least gross. Whether they are partially lost in the atmosphere of the picture or whether their proud integrity shines out, needing no illumination other than itself, bathed in their own mysterious, impenetrable glow, Modigliani's nudes give us everything except vulgarity. In turn we find a lively alacrity or a heavy animal quality; an ardour which may be unconscious or deliberate; a tranquil innocence and aggressive depravity; all under the most unlikely forms and colours and without the use of a single facile device. Woman yields to us that which is essential and eternal in her. Objects may date them but true art renders them truly timeless."

"Having looked at and appreciated a Modigliani nude for any length of time, it is impossible not to laugh at the cold, highly polished academic schools of painting – even at some of the works in museums which it is still fashionable to praise: the hollow bodies, with elaborately constructed breasts and thighs of trembling jelly. Here is an artist who, immersed in the warm mists of his work, brings to life all the intoxicating mysteries: the flavours, the thrills, the moistness and undulations. These nudes breathe the breath of life.'

To Florent Fels, Jeanne Hébuterne seemed to be the woman he deified and purified, the one who inspired him to seek grace and nobility:

"He had found in his young, slim girl with the widely set eyes and slow gestures a madonna worthy of his brush. He immortalised her in fresh colours, in various outfits, her face a pure oval, her naked shoulders a tender line, lying down or seated, naked and adorably pure, with her orange skin tones against a background of a perfect blue – and I thought what a noble character Modigliani must have."

As though he attributed certain magical powers to his friend, André Salmon, in an article written in 1922, in the review *Amour de l'Art*, had already gone much further on the question of Modigliani's ability to purify in his art:

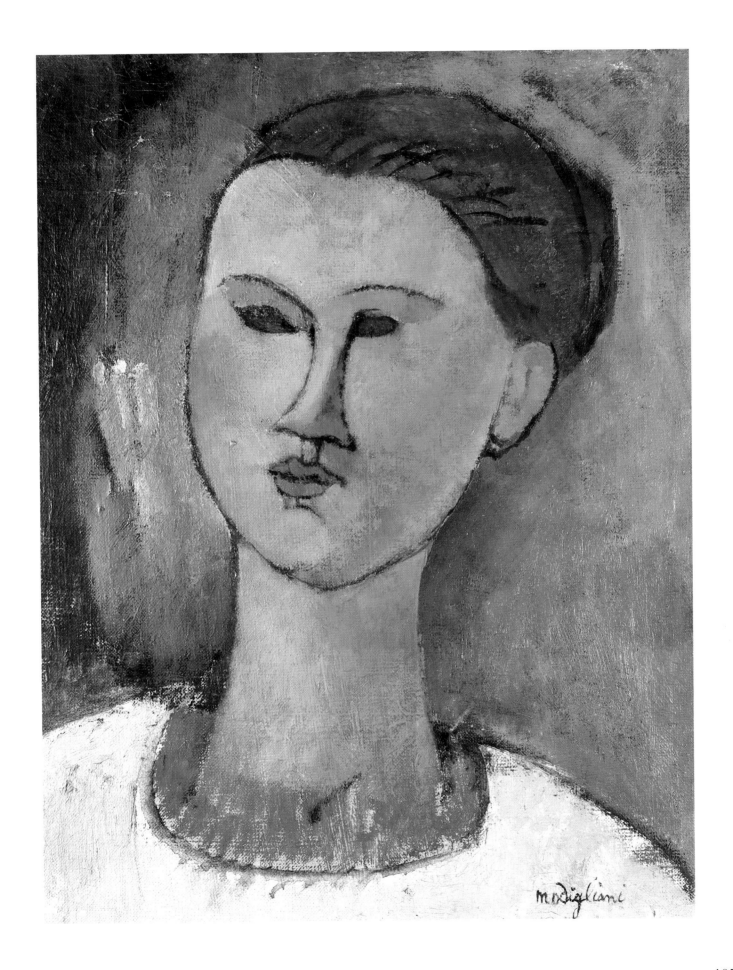

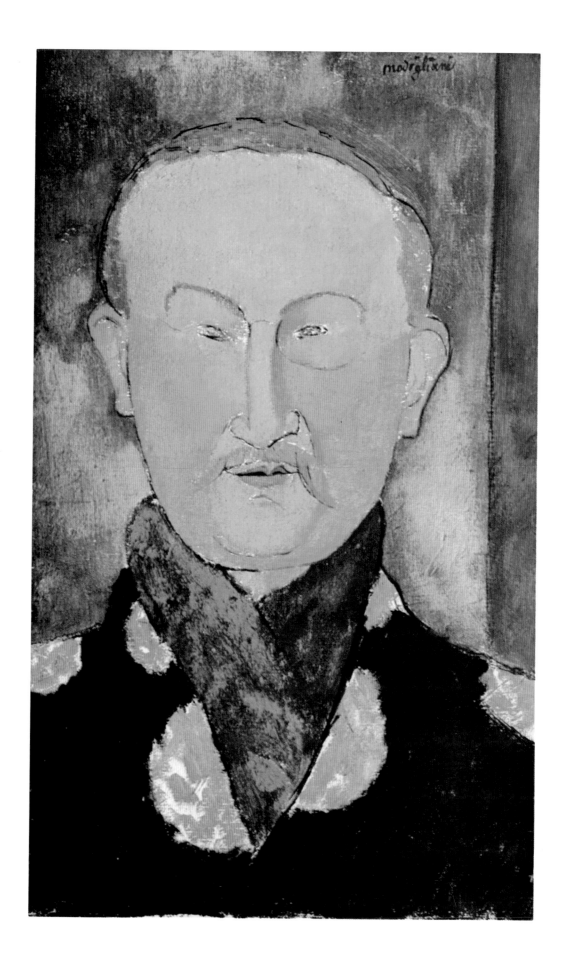

106

"His fever was essentially divine. He haunted the accursed places, purifying with his inscriptions the delapidated walls, which oozed fever and dripped death. He re-clothed them in infinite purity, the young girls smiling out from their frames of torn dirty paper on the attic wall of some child-killer maid! The breath of virgins mysteriously touched the hovel of the lowest prostitute, and on the worn steps where the verminous beggar crouched, marched in procession, ever upward, the purest human qualities of kindness and charity. Naked courtesy blazoned the walls where blood ran like cheap, watered wine. He lit the black dungeon of the deserter with a fiancée's face, the image of the True Homeland..."

"I do not know whether Modigliani is inimitable – that is not what interests me. I do know that through his work the problems of painting have been increased by the painful value of purification."

One can even state that purification and pain run in parallel with death and purification in the artist's life as in his work. These are the two vital threads which underlie his work and without which it would not have existed.

A third factor of a dual nature seems essential to Modigliani's art: the balance of importance between sculpture and painting.

Modigliani really only wanted to be a sculptor – it was his precarious health which sent him along the road of painting. In his painting and drawing, the sculptural quality of the construction is always present. For his art fuses sculpture and painting, normally quite separate disciplines.

Sculpture is a material, three-dimensional discipline and drawing the mastery of space. It is the same with painting and sculpture, the former implying design on a single plane, the latter, volume. Critics have often overemphasised this difference, seeing the artist as a specialist in one technique and forgetting that in the past an artist had to be a scholar, mathematician, astronomer, architect, painter and sculptor. Academic art, too long pursued and practised, had forgotten the lesson of Leonardo da Vinci. In its enthusiasm, Impressionism had for the moment renounced three-dimensionality, even figurative three-dimensionality, and was satisfied with colour and rhythm. Too many incredulous people ridiculed the Cubists, those troubled practitioners of an art which distorted, disorientated and tortured form in order to reach a natural truth which was usually clothed in a certain realism.

Modigliani is one of the latter without belonging to their school in any other way. He has no need to draw closer to the Renaissance artist, nor to carve violins and guitars in order to choose whether to become a sculptor, draughtsman or painter, before he can combine all of the researches pertaining to these on canvas.

Opposite:
PORTRAIT OF LÉON BAKST,
1917.
Oil on canvas, 55.3 x 33 cm.
National Gallery of Art,
Washington.
(Chester Dale Collection).

PORTRAIT OF ANNA ZBOROWSKA, 1917.
Oil on canvas, 55 x 33 cm.
Galleria Nazionale d'Arte Moderna,
Rome.

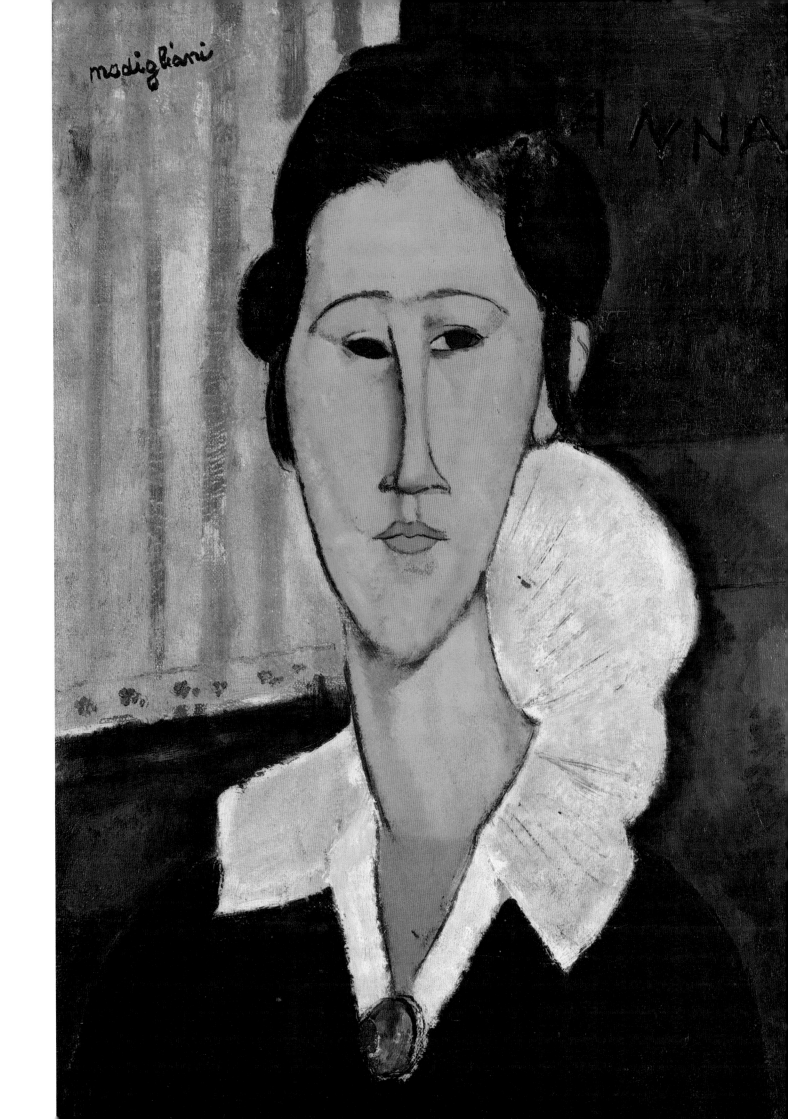

Painter or sculptor? Critics who have tried to make him out to be one or the other will go on arguing as they have in the past.

"… He started as a sculptor," remembers Florent Fels in the *Nouvelles Littéraires et Artistiques* of October 1925, "modelling blind fetish-like figures, with long funereal faces mounted on delicate, slender necks…"

Adolphe Basler, in a work entitled *Modigliani*, published in Paris in 1931, goes back to the artist's beginnings in Paris:

"He was haunted by African sculpture and tormented by the work of Picasso. This was at the time when the Polish sculptor, Nadelmann, was exhibiting at the gallery Druet…"

"The principles of composition in the round in Nadelmann's drawings and sculptures preceded Picasso's subsequent explorations in Cubism. Nadelmann's early sculptures, which Modigliani marvelled at, were a stimulus to him. Curiosity led him in the direction of the figures created by the ancient Greeks and towards Khmer sculpture now becoming known in the circles frequented by painters and sculptors; and he assimilated much, reserving his admiration for the refined art of the Far East and the simplified proportions of African sculpture."

"For several years Modigliani did nothing but draw, tracing round and supple *arabesques* – stylistic ornaments – delicately highlighting with bluish or pinkish tint the elegant contours of the numerous caryatids which he promised himself he would one day carve in stone. And his drawing became confident and rhythmic with a sensitive, personal touch of great charm and freshness. Then one day he took up stone carving, sculpting figures and heads. He only continued to use a chisel until the outbreak of war, but the few sculptures that survive give us more than a glimpse of his great aspirations. He favoured simplicity of form but not when it was so concise as to be abstract."

"The period when Modigliani was following his vocation as a sculptor was a happy one for him. A small allowance from his brother permitted him to work without financial cares. If he drank too much or often fell into a disquieting state, it did not matter. He quickly got back to work for he loved his job. Sculpture was his one ideal and on it he founded great hopes. I never admired him more than at this period in his life…"

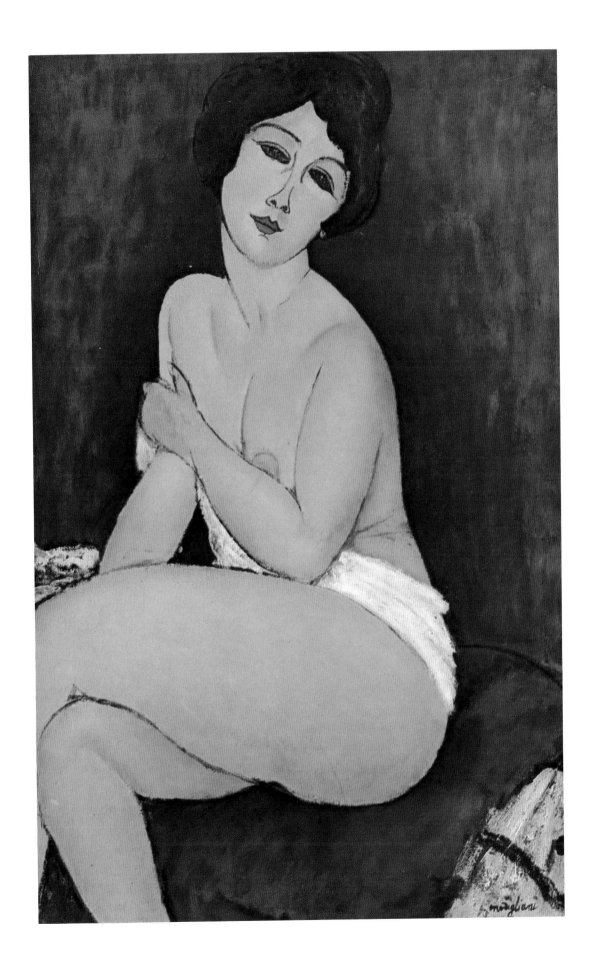

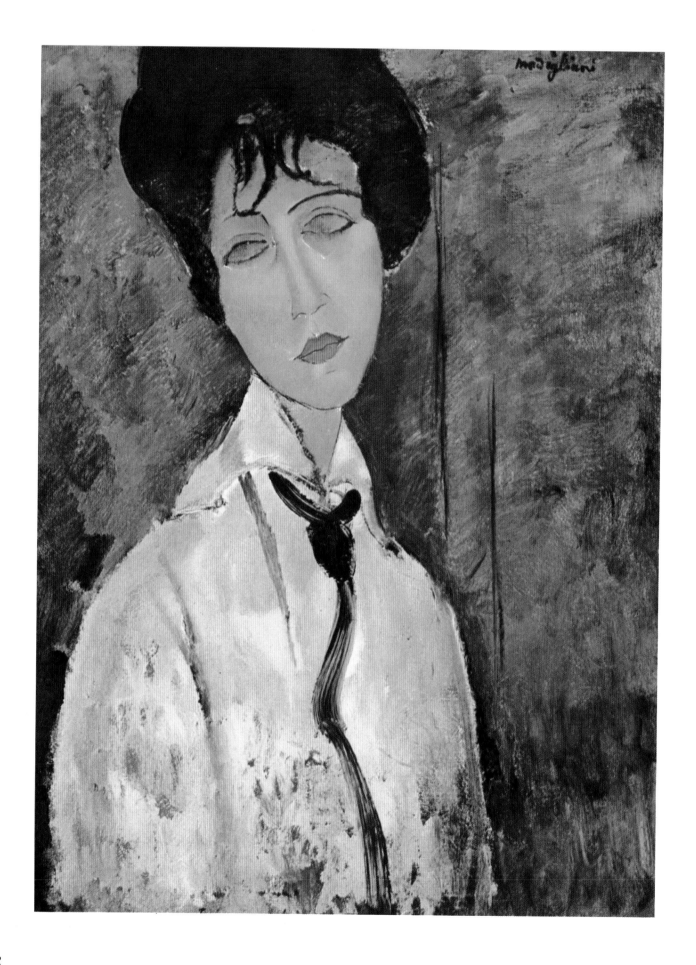

112

Primitive and Ancient art first influenced his sculpture but were later to have a direct effect on his pictorial art, as is recounted by Adolphe Basler:

"The war came, changing everything. Modigliani came under the spell of the English poetess. He was surrounded by an increasing number of admirers of all nationalities. Everyone wanted him to draw them. He was becoming famous! One day he decided to paint. He went to Frank Burty Haviland, the painter and collector who lived next door to Picasso at rue Schœlcher. Frank lent him paints, brushes and canvas. Modigliani tried to put on canvas what he had learnt as a sculptor. The limitations of life occasioned by the war also constrained him to practise a less complicated and expensive form of art than sculpture and one which was physically easier to achieve. It was at Haviland's house that he saw the most beautiful collection of African sculptures. He was fascinated by their attractions and never stopped admiring them. He saw nothing else but their form and proportions. Obsessed by the entirely constructive simplicity of fetish figures from Gabon or the Congo, by the amplification of this in the elegant stylisation of figurines and masks from the Ivory Coast, Modigliani gradually moved towards figures with elongated lines and tastefully exaggerated proportions, whose detail bears the imprint of his admiration for African sculpture. Oval shaped heads and uniformly geometrical noses, taken from Black African figures of worship, began to dominate his portraits, giving them a very piquant air. An exquisite draughtsman, more draughtsman than painter, Modigliani accentuated the gentle curves, destroyed the monotony of too symmetrical forms by extremely refined distortion and, by enhancing them with very flattering colour, made them extremely attractive. A mixture of sweetness and strangeness, saved from being too sweet by the acuteness of his expression, a kind of morbid charm, exuded from the male and female models of this pattern. The exceptions are a few portraits and three or four nudes. On the whole, Modigliani's works resemble each other. His art appears to be confined by a mannerism which is irresistibly attractive to the art lover who is looking only for facile thrills. But for the unfortunate Modigliani painting was his second choice. From 1915 to 1920, the year he died, hard times forced him to abandon the chisel that was his vocation for the paintbrush..."

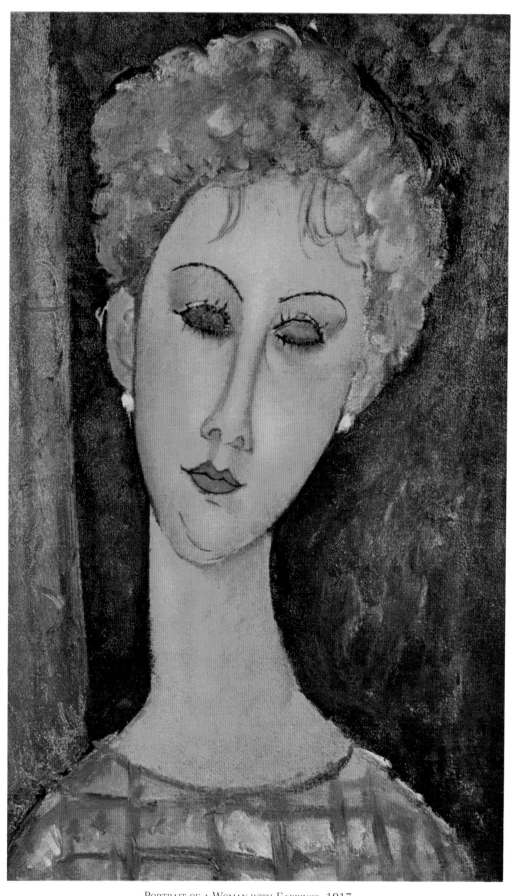

PORTRAIT OF A WOMAN WITH EARRINGS, 1917.
Oil on canvas, 46 x 30 cm. Private collection.

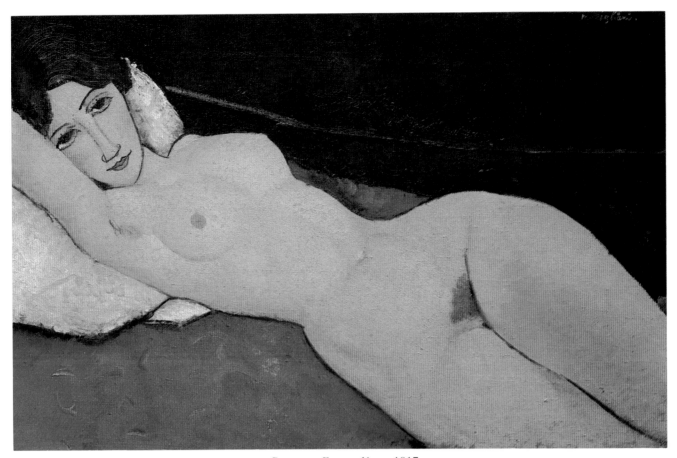

RECLINING FEMALE NUDE, 1917.
Oil on canvas, 60 x 92 cm. Staatsgalerie, Stuttgart.

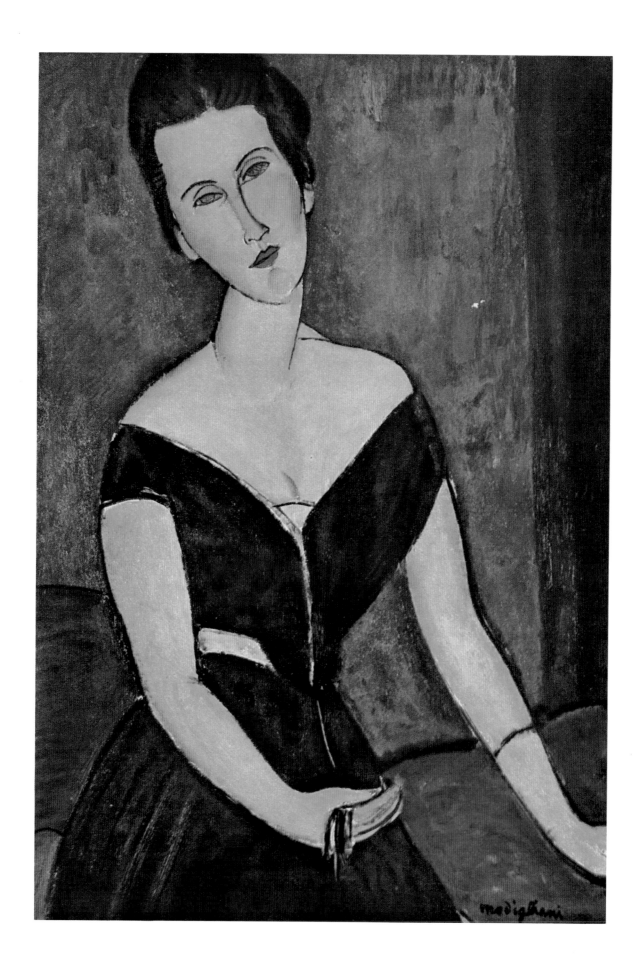

The critic panned his painting and glorified his sculpture. In allowing words like "oversweetness" and "facile devices" to slip from his pen, he opposes the judgement of Waldemar George:

"The crude realism of his portraits, whose geometric framework gives way under the pressure of such dramatic colour, reminds one of the masks from Gabon which conceal, under a strictly prismatic construction, so much mystery!"

And, talking about Modigliani's stone carvings of heads, he adds:

"These sculptures with their markedly protruding profiles sometimes have certain analogies to Negro masks. Their hieratic qualities, the geometric aspect of their composition, designate them as works of priceless learning.

"It is at this time – that of the African-influenced sculptures – that Modigliani moves down from the Butte Montmartre to Montparnasse."

And so Modigliani moved to the Left Bank to join his friends in what was to become the Paris School. Picasso already reigned as master of the quartier and Waldemar George seemed to feel that the influence of Cubism on Modigliani was now greater than that of Primitive art. But is Cubism not derived from the same idols?

"Like a sculptor, he carved a rudimentary head and mentally drew his lines within the whole block of stone, which in turn decided the proportions. It seems that in the interests of harmonious rhythm, Modigliani at this time moved away from the laws of anatomy..."

"The starting point was the block; the cubic or cylindrical form of sculptural origin."

"The artist then proceeded to carve out the form."

"He would put a figure or a head out of true to express volume. Like the Cubists he would thus give a frontal view and, if not actually a profile, at least a suggestion of profile."

In his turn, Francis Carco emphasises the extent to which the sculpture produced in Livorno from 1902 onwards affected the structure, line and composition of Modigliani's paintings:

"The deliberate use of curved lines, the points at which they cross, their position in relation to each other, the fields which they unite or separate, certain extensions of the line, and above all the integrity of the distortion and the establishment of volume remind us of Livorno days, when Modigliani's career began and where he carved some figures of great beauty in stone."

"The critics", wrote Jeanne Modigliani in *Modigliani without the Legend*, "were to notice in Modigliani's work a continual balancing act – apart from a few happy moments of harmony – between the needs of linear rhythm and the love of full, round, heavy, volumetric form."

Indeed, Modigliani's sculpted heads – stamped with the trademark of the artist – remain a delight, and represent both the resumption of his ambition and its source.

Adolphe Basler admires the sculptor:

"Modigliani was quick to call attention to himself. Did he believe his life would be cut short or was he, as a Jew, just in a hurry to enjoy it? I saw him always looking for something new; he showed me some pieces of sculpture, modelled entirely under the influence of African art which he had seen in certain studios and in the homes of certain art critics turned picture gallery employees."

Waldemar George states unequivocally that Modigliani, whatever periods his art went through, was always himself before any other influence:

"...Today I limit myself to pointing out the analogies which exist between Modigliani's sculpted works and his drawings and early paintings."

"As a painter," wrote Francis Carco, "he never forgets the necessity he is under to respect the conditions which rule the arts and are common to them. The visual, plastic feeling for form, which he determines by the weight given to it, balanced by the design rather than the tone, manifests itself in Modigliani's work the moment we consider his œuvre, and is so obvious that even his style of painting was able to change without endangering in the slightest the character of his work."

"...Modigliani approached the world of painting with rough tools," concludes Waldemar George, "... but whatever role they (the sculptures) played in the artist's subsequent development, it is in his paintings that he has given the full measure of his talent... The greatest and most moving works, if not the most complex, date from this first period."

Foretelling that Modigliani's sculpture could have had a life of its own, instead of being merely an adjunct to his painting, Carco regrets that Modigliani did not take it further.

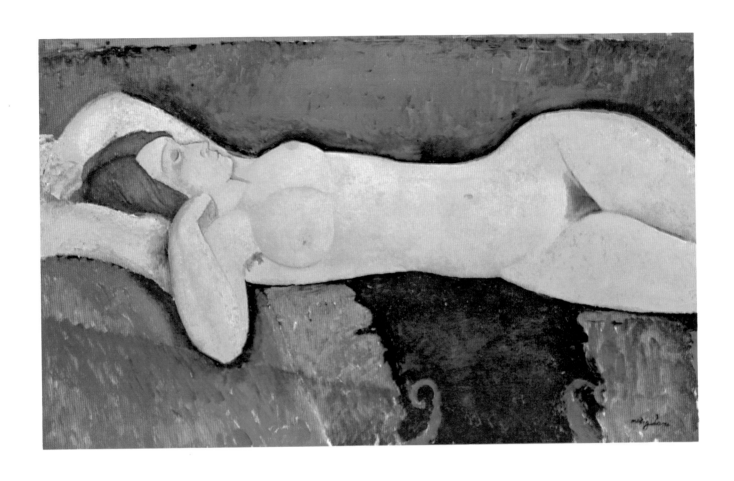

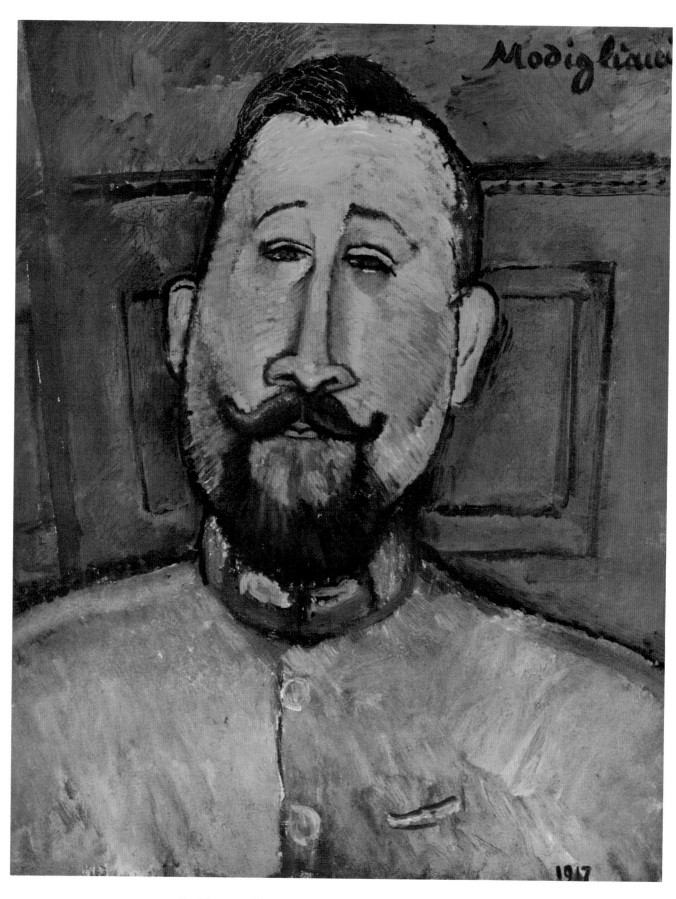

THE HANDSOME MAJOR – PORTRAIT OF DOCTOR DEVARAIGNE, 1917.
Oil on canvas, 55 x 46 cm. The Evergreen House collection, Baltimore.

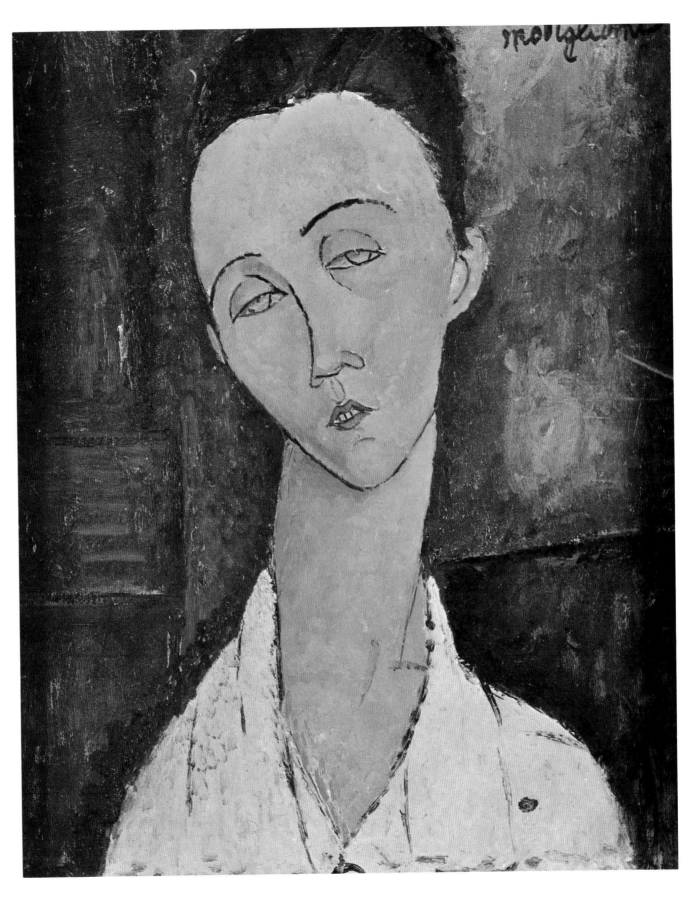

Portrait of Lunia Czechowska, 1917.
Oil on canvas, 46 x 38 cm. Private collection.

"When he was haunted by the Caryatid theme and engrossed in sculpture, he made hundreds of drawings and watercolours of this subject, but the interpretations of them in stone, now in the Museum of Modern Art in New York, demonstrate that he never carried out all his intentions in this respect."

He goes on to reaffirm the essentially pictorial quality of Modigliani's work, sometimes entirely free of any depiction of volume. It is probably Adolphe Basler who best summed up the dual nature of Modigliani's work when he painted masterpieces under the influence of sculpture:

"Modigliani is an attractive, unique figure. Living the most disorganised life ever, this painter/sculptor and sculptor/painter was still able to produce wonderful nudes and equally choice portraits."

Apparently these "wonderful nudes and equally choice portraits" appeared to be more figurative, more realistic and less distorted than the subjects of Manolo, Sabartés, Diego Rivera, Braque, Gris, Picasso or in fact any of the Cubists or followers of that pictorial style. Yet it is only on the surface, as Christian Parisot would suggest much later, that the hidden language and certain unobtrusive deviations give the work of Modigliani all its meaning. He tried to achieve a form of expression which would interpret his subconscious rather than smash mirrors and frames or thrash the beliefs of the academic world. I too would position his work between Realism and Expressionism.

Nothing would have been more foreign to Modigliani than to be labelled as belonging to a School. Even though his was a unique character with a unique way of looking at things, he must certainly be considered to be part of the great artistic movement of his time. As the following article by M.J.G.Lemoine in *L'Intransigeant* shows, he was defended in the arts press as a Modern artist and nothing less.

Paul Guillaume, setting up the 1918 exhibition, felt it was a matter of making the public understand that there existed a pictorial world with a great future in which the frontiers of ordinary reality would be pushed further and further back in the cause of the individual's struggle to find his own truth.

Modigliani was one of the earliest examples of this.

"There is a misunderstanding between the painters of today and the public," wrote Lemoine. "The public comes to exhibitions already so prejudiced that they are completely blocked from taking any interest in what the artist is trying to achieve. Art today has renounced the idea, which went the rounds of the studios when Realism was paramount, that you painted what was in front of you. The public stopped there.

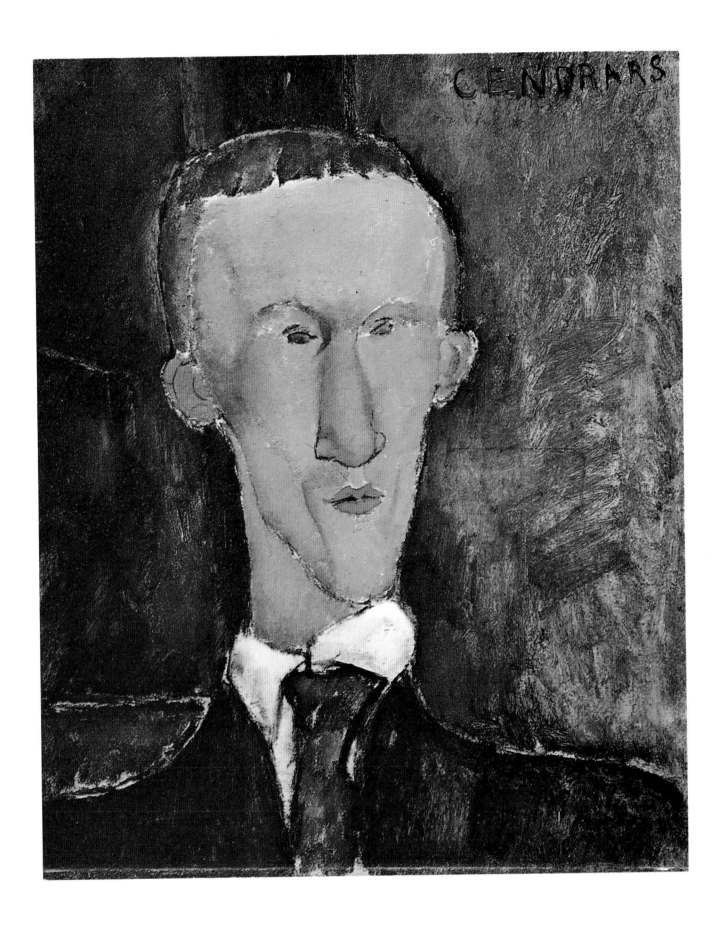

They should make themselves try to understand more. Although the styles of Henri Matisse, Picasso, André Derain, Roger de la Fresnaye, Modigliani, Chirico, Utrillo, and Vlaminck are certainly diverse, they are sufficiently representative of the spirit of those members of the present generation who are trying to escape the conventions of Realism in order to attain and retain only the truths which it harbours."

"This appears to be a subtle distinction, as indeed it is, which is why our idealists should not be surprised if the public takes a long time to catch up with their beliefs. It also makes one wonder why these same Idealists adopt such a haughty attitude (off-putting to the best intentioned) *vis-à-vis* the public."

It would not have occurred to Modigliani to make the slightest concession to potential buyers of his works. He was interested only in the perfection of the relationship between the form he created and the feeling he wanted to express. He made no compromises for a public which wanted only reassuring, pretty likenesses.

However, it must be remembered that Adolphe Basler saw in Modigliani's painting "a mannerism which is irresistibly attractive to the art lover who is looking only for facile thrills..."

Francis Carco concludes that: "This is absolutely not Realism, in the sense of the technical painting term."

"When he distorts," adds Waldemar George, "it is not in a Cubist sense. When he stylises form he does so totally within that form's own character. The feeling of form in Modigliani's work is never interrupted by anatomical detail. No distingushing mark on the model is allowed to interrupt the course or break the rhythm of his visual poetry. Moreover, his nudes, the most beautiful painted by any artist since Ingres, are neither arbitrary nor abstract: on the contrary they remain concrete and true to life."

"I do not know that anyone, before Modigliani, succeeded in putting more intense expressions on the face of a woman," enthuses Francis Carco, "Art today only needs to make meticulous copies. Modigliani makes a mockery of its practitioners' reluctance to analyse their own consciences."

124

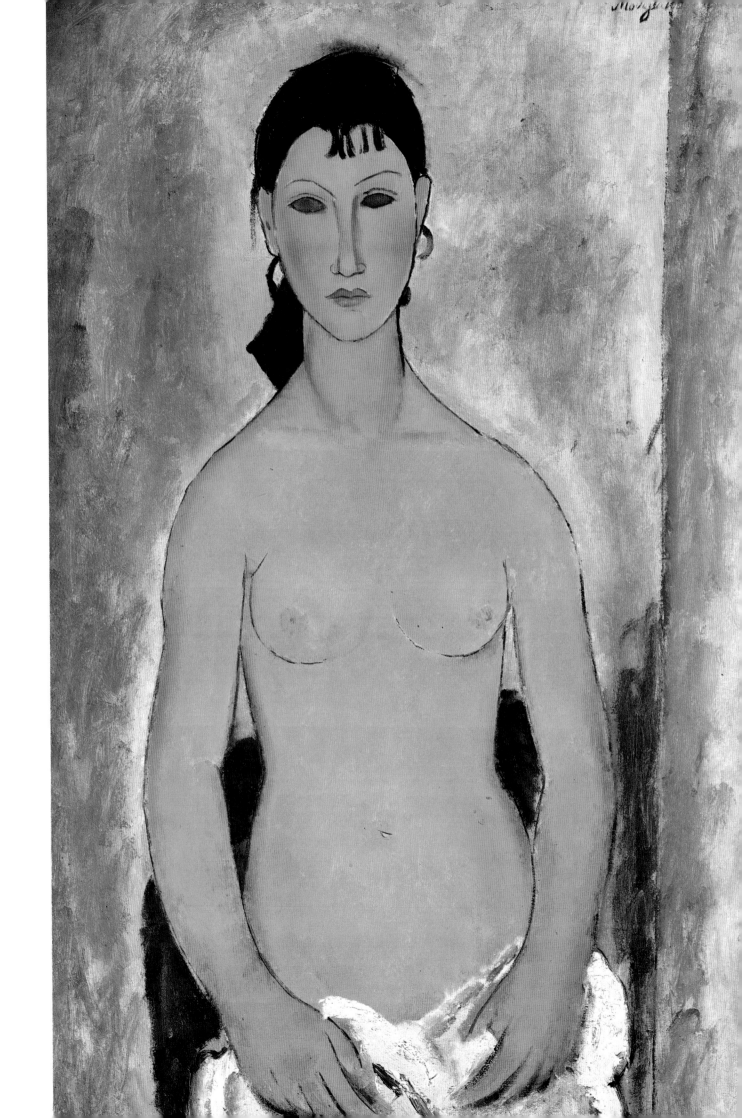

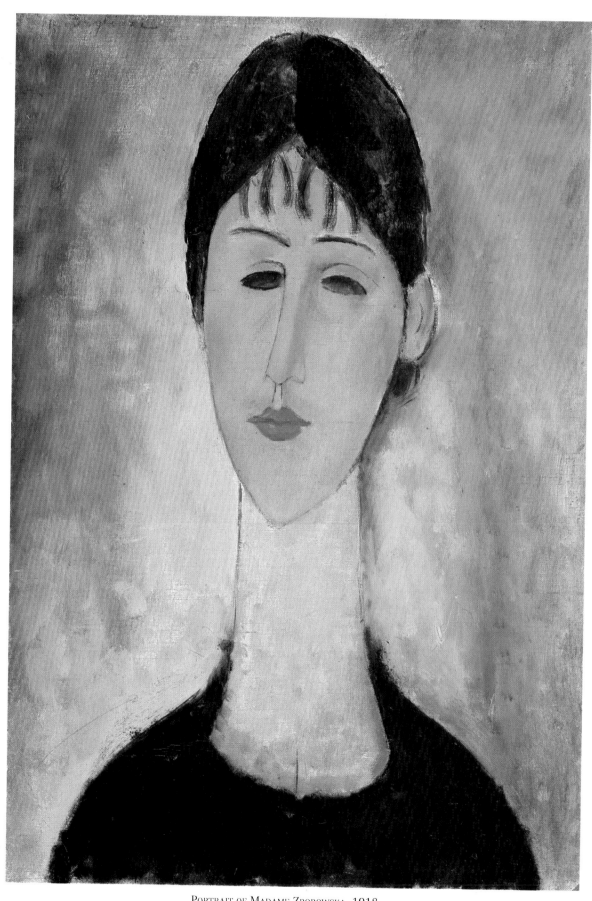

PORTRAIT OF MADAME ZBOROWSKA, 1918.
Oil on canvas, 55 X 38 cm. Ateneum Museum, Helsinki.

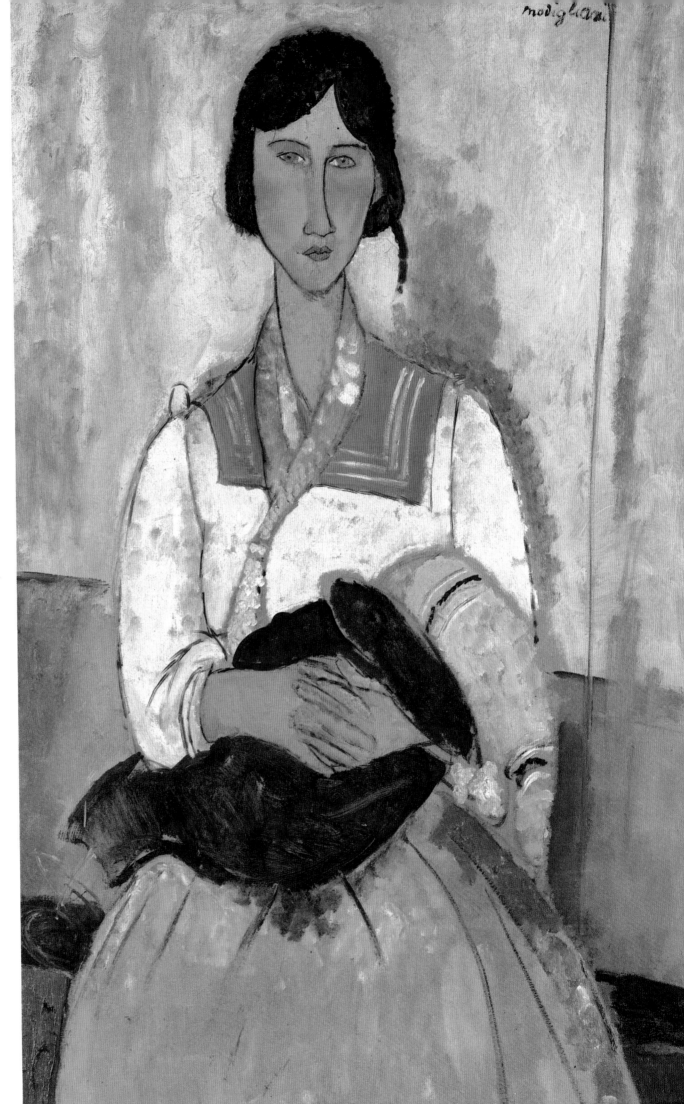

GYPSY WITH A CHILD,
1918.
Oil on canvas,
115.9 x 73 cm.
National Gallery
of Art, Washington.
(Chester Dale
collection)

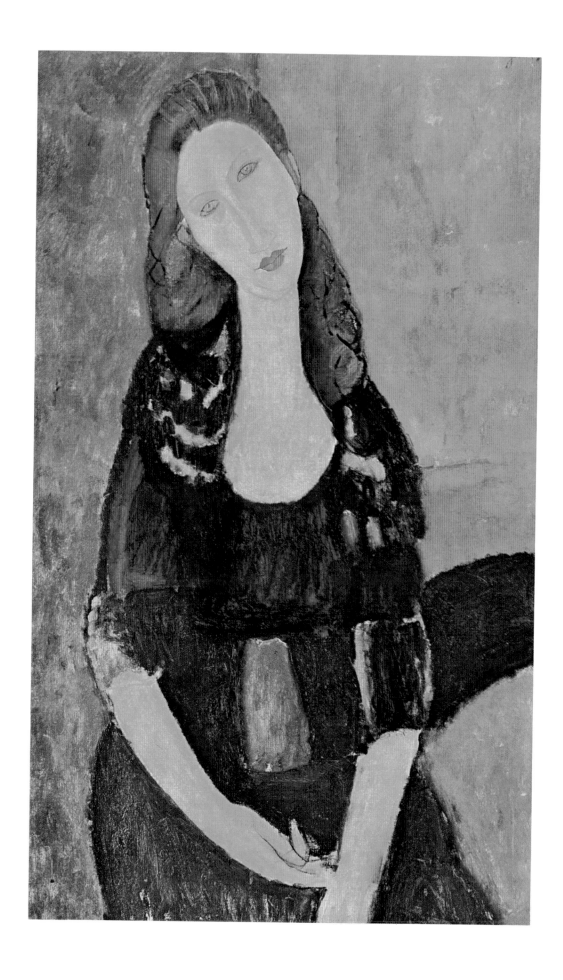

"When painting became common," wrote Théophile Gautier in his *Essays on Museums*, "we went from the reproduction of divine images to that of legendary or historical figures, still with a certain Idealism. Then came the reign of the "Naturalists". Landscape, which until then had been merely a green setting for figures, took on an importance of its own and was painted for its own sake. Lines, straight at first, became rounder and then twisted: backgrounds of gold gave way to those of blue, which in turn were superseded by figures. These changes describe the history of painting in every country and every period. Contrary to apparent logic, the ideal is the starting point and nature the end."

"One can see," Carco continues, "that in using examples of style wherever he found them, Modigliani attained the state reached by his masters, and this was necessary to his progression and elevation to that ideal which we look for in portrait painting nowadays, and which is more important than mere likeness: the element of design, the feeling for volume and a spirit which, regardless of the subject matter, is an inspiration to us all."

Francis Carco concludes that this painter who in his transgression rejected the image of his masters and retreated to a distance, finally achieves his own language of art which lies between Realism and Expressionism:

"There has never been a painter worthy of the name and capable of assimilating into his work the learning amassed through the centuries, who has not rejected his teaching to branch out in new directions."

From his academic training Modigliani retained the noble love of drawing, that alliance between black and white which since da Vinci has always been one of the most faithful mirrors of the artist's soul.

"The painter's drawings are like the intimate diary of a writer", wrote L.Vitali in *Disegni di Modigliani*, published in 1929. "In the one as in the other, the artist reveals his naked self, with none of the pretence or window dressing that the aristocratic black and white would in any case not tolerate…"
"One rarely finds any interest in chiaraoscuro; often it is a fine, even line, flowing like a jet, like a fine thread, of singular purity, outlining forms in a rhythmical dance of elegant and exquisite *arabesques*. The curved lines interlace and intermingle in an almost musical pattern, with pauses and reprises, meeting and becoming suspended; suggesting rather than describing, making a whole of the parts without

detailing them. And, as the tune of a pastoral flute evokes with its modulated cadences an idyllic nostalgic world, so do the dancing lines of a Modigliani drawing go beyond the slim reality of his model, elevating it to a different and higher world, where women steeped in a strange languour have bodies of virginal purity."

Opposite:
PORTRAIT OF LÉOPOLD SURVAGE,
1918.
Oil on canvas, 61 x 46 cm.
Ateneum Museum, Helsinki.

Modigliani composes his figures in space in one of two regal ways: in a straight line or in a curve.

I believe that the soul of his drawing lies between the two, in the use of both. He understands so well how to manage the rhythm of a composition using the counterpoint of straight line and curve.

Chronologically speaking, it can be seen that Modigliani gave more importance ultimately to the straight line.

"Later on," recalls Waldemar George, "Modigliani increased the number of his styles of composition. In particular, he gave up the very pure structure in which the straight line dominated (...) in a number of pictures of young girls he smashed the block of the human body and took it to pieces. Despite the fact that they still work as a whole, the parts of these bodies, with their supple flexible lines, work separately as well."

This geometric approach springs from the art of the African idol, and finds its way into the language of Waldemar George when he is describing certain Modigliani portraits:

"I remember well that, hanging beside a portrait of Paul Guillaume, was one of Rivera in which the tilted head with its simian features emanates from a shadowy blue area of the canvas."

"I am thinking about those *hatched* heads of young women drawn in a network of *bisecting* lines. The painter does not take long to achieve form. However, the portrait of Cocteau, with the wide *horizontal* shoulders and the neck treated as a *cylinder*, the symmetrical arms and *angular* face, should still be classified because of certain of its attributes as belonging to his original style. In *The Doll*, the principles of *rectilinear* composition appear to have been abandoned. In this painting Modigliani does not even use the contrast of form against form, as he did in the portrait of the poet Jean Cocteau, where the *horizontal* lines of the shoulders balance the *diagonal* arms. This picture is made up entirely of *segments from a circle*. The background is enlivened by similar shapes. The figure itself is off-centre and leans to the left. The face with its black, 'almond' eyes and nose, whose jutting bridge looks as though it were carved with a billhook, is set within an *ovum*."

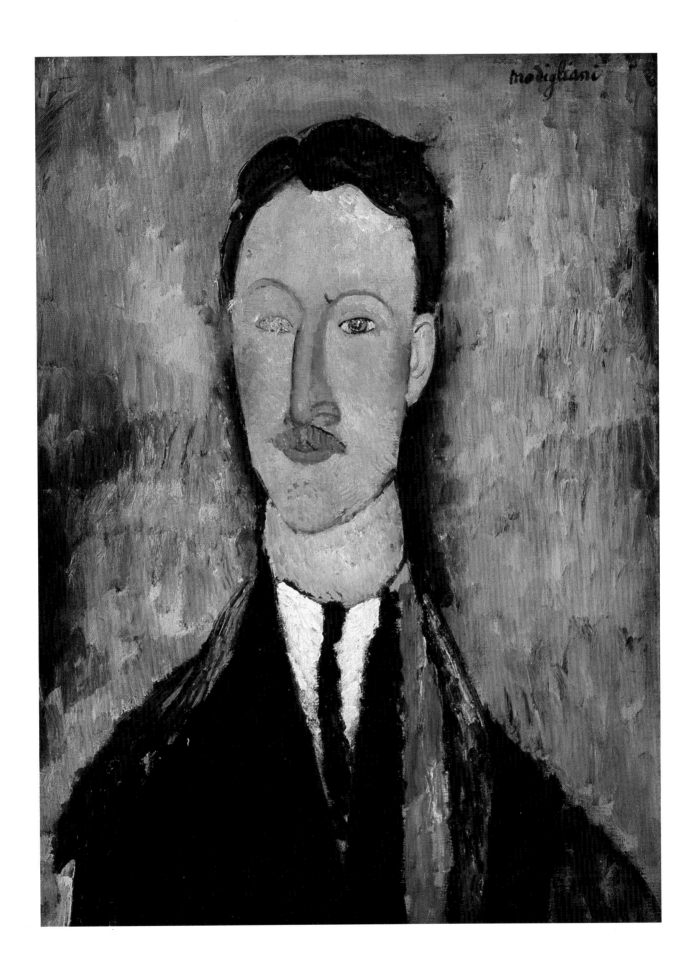

PORTRAIT OF VÉRONIQUE, 1918.
Pencil drawing and watercolour on paper, 42 x 26.5 cm. Private collection.

SEATED NUDE, 1914.
Pencil and watercolour on paper, 53 x 41 cm, Museum of Modern Art, New York.

The *arabesque*, or stylistic ornamentation, is a favourite subject with the critics. The quasi-classical *arabesques* of the caryatids and the heads. The Mannerist *arabesques* of the portraits and the nudes.

"The painter acquired a taste for complex *arabesque* elements in his compositions. Clever management of empty space testifies to his knowledge of design", wrote Waldemar George.

"...The light, which this painter liked to be more or less evenly distributed, breaks the line, giving it more sensitivity and, while not spoiling its decorative *arabesque* function, animates it to even finer subtlety", wrote André Salmon. Florent Fels feels the "Byzantine hieratism" of Modigliani's art is more in the ascendant.

Hieratism or *arabesque*, to Waldemar George it appeared that when painting the female nude he used both and married them perfectly:

"His great reclining nudes, composed of waves of curving lines, are hieratic in their simplicity. The eye is relentlessly led from the tip of the feet to the top of the head, past the rounded lap, the pinched-in waist, the rounded breasts which give birth to the arms, the face with its fine, pointed nose forming a continuation of the harmonious crescent of the arch of the eyebrow."

I leave it to Waldemar George to ask the question: "Was Modigliani a colourist or a draughtsman?" and allow him the privilege of being the first to reply:

"Such an academic distinction would appear to be outdated. It is valid only for purposes of demonstration."
"In the hierarchy of importance given to the value of different visual forms of plastic art, Modigliani, a Tuscan, gave pride of place to line, the conventional means of limiting form. He ignored "atmosphere", which dims form even as it gives it position. He ignored the use of chiaroscuro. I have said that at the beginning of his career he painted with a rough and flat technique. Towards the end of his life he refined his colours. He ceased to clothe his compositions in uniform tones, applied in wide planes. He modulated and shaded off his colours. His variegated flesh tones sometimes became tinged with pink. The artist seemed to delight in refinements to his pictorial cuisine. Master of all techniques, he paralleled Mannerism."

In *French Painting from 1906 to the Present Day*, Maurice Raynal emphasises how the Italian quality of the line takes precedence:

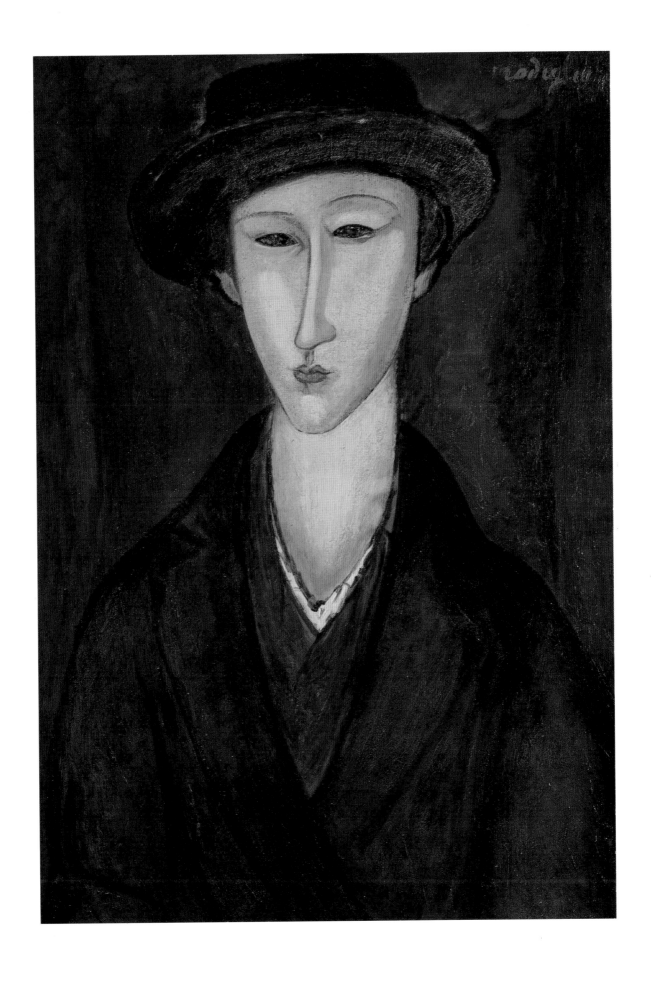

135

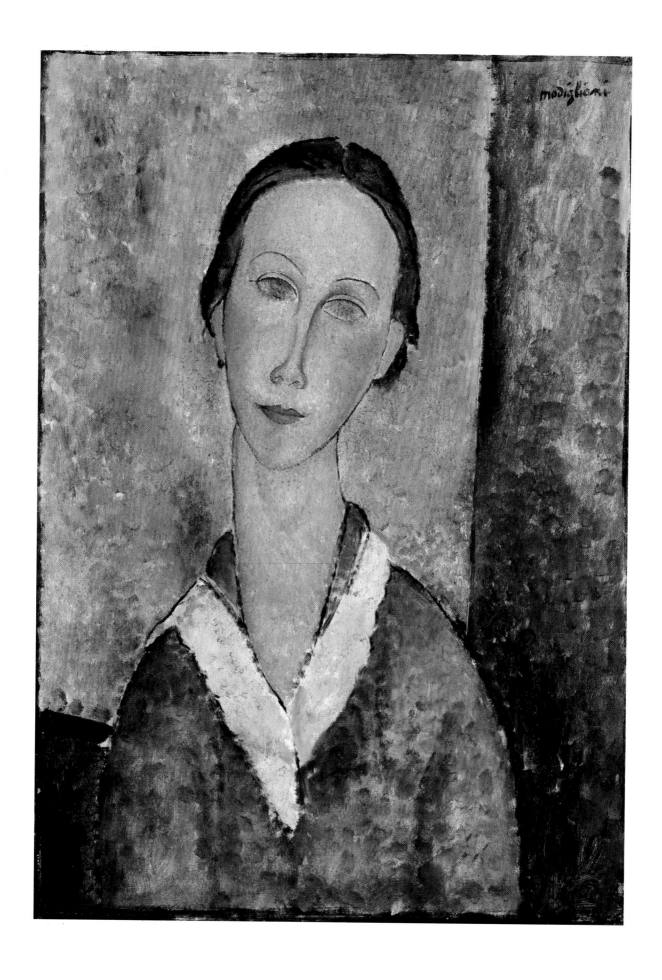

136

"Modigliani remains an Italian primitive, but we can only judge by what we know of an œuvre which was never completed. He considered a painting to be finished once the drawing had composed the image and this is perhaps why the drawing is always so apparent in his work, and why the composition and the forms are outlined in a decorative line that confers a certain illustrative quality."

Waldemar George recalls that the painter, in his early pictures, was engrossed by texture, the effect of the material. Painting itself as an element fascinated him:

"The dark austere impact of his early pictures is highlighted by a rough, grainy texture. Fragments of newspaper occasionally enliven his backgrounds but the painter knew how to use and incorporate them."

And Florent Fels goes further:

"Modigliani's early works are an explosion of his painter's temperament. Bursts of blue and red, fiery layers of impasto paint, testify to an ardour which sometimes made him neglect the drawing in these pictures which (though Modigliani never knew it) are reminiscent of the canvases of Carpeaux. He paints violently. Delirious with the fever of painting, he tries to capture resemblances, but mostly produces dazzling compositions in which the subject, the figure, has vanished in the ardour of creation."

Basler also noted Modigliani's knowledgeable but perhaps instinctive use of colour. The way in which contrast embellishes tone.

"With no great gifts as a colourist, he knew how to use a range of happy contrasts to give sparkle and a pleasing tone to paintings which shone with the brilliance of a flattering aestheticism. His talent, not always kindly, is one of the most seductive among modern artists."

"But soon," continues Fels, "drawing brought him back to the discovery of form, form very like that produced by a sculptor. He drew caryatids, designs for fountains."

By form is meant line, draughtsmanship. "Within one barely discernible line may be contained a whole structure; it might support the slight bulge of a belly, carry a movement through to the very soul, make it live... I would like to express my admiration for Modigliani's drawings. They have all the grace and style we now find in his painting, where the artist is committing to canvas his feelings, his vision of the world and of rhythm and colour."

Opposite:
YOUNG WOMAN IN A SAILOR COLLAR, 1918.
Oil on canvas, 60.3 x 46.4 cm.
The Metropolitan Museum of Art, New York.

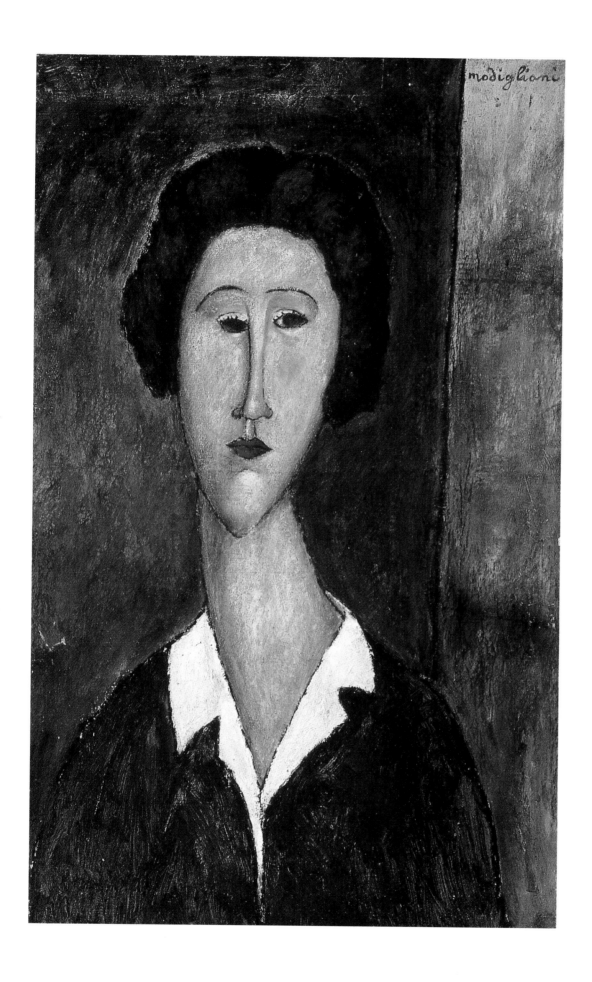

PORTRAIT OF WOMAN, 1917.
Oils on canvas, 63 x 44 cm.
Private collection.

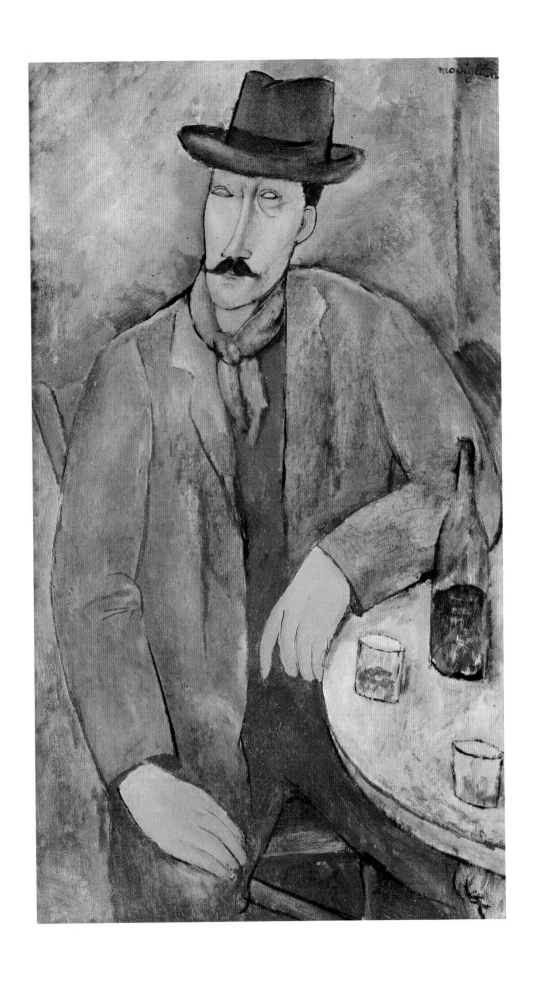

SEATED MAN, 1918.
Oil on canvas, 93 x 55 cm.
Private collection.

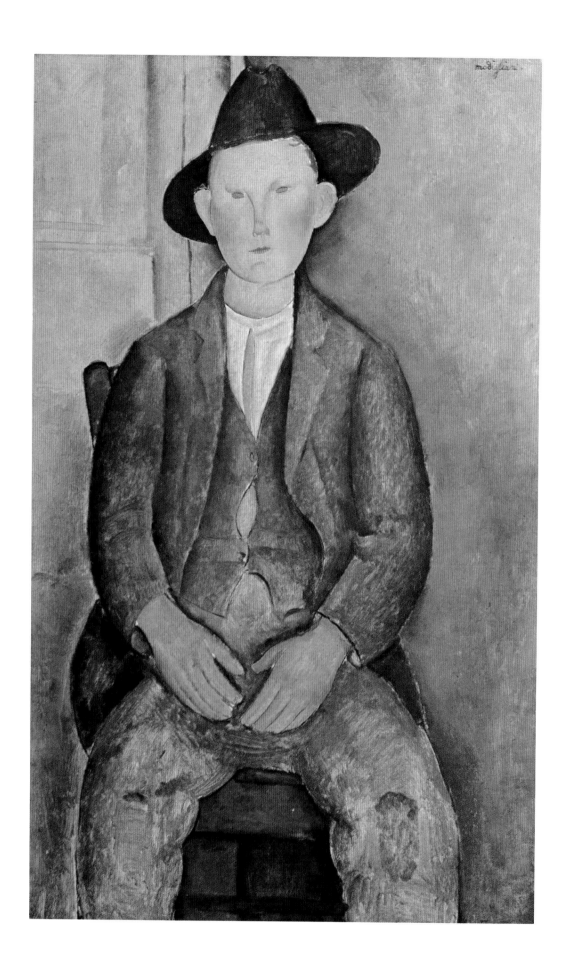

THE LITTLE PEASANT,
circa 1918.
Oil on canvas, 100 x 65 cm.
The Tate Gallery, London.

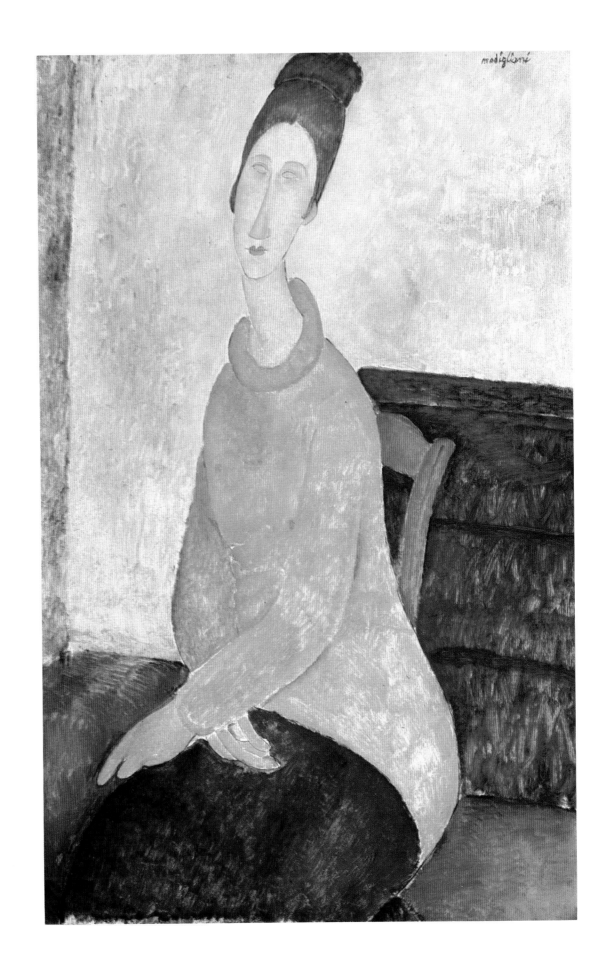

PORTRAIT OF JEANNE
HÉBUTERNE, 1918.
Oil on canvas, 100 x 65 cm.
Solomon R. Guggenheim
Museum, New York.

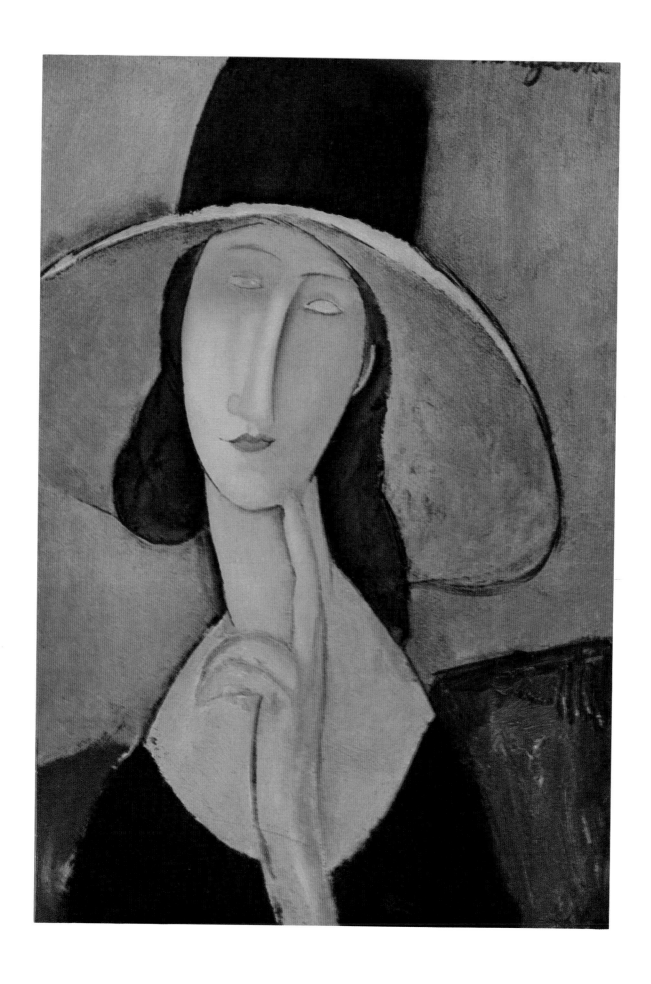

Maurice de Vlaminck recalls Modigliani, the man who could draw a face with a single, aristocratic, supple line in the big sketchbook which he always carried.

"I can see him now (he wasn't stupid), distributing sketches as a reward to the friends who surrounded him."

"With the gesture of a millionaire, he would tender the piece of paper (...) as though he were offering a banknote in payment for the glass of whisky he had just been given."

"Before becoming a painter, or at any rate before his paintings were known, Modigliani was a draughtsman", recalls Waldemar George.

Gustave Coquiot also extolled the charm of Modigliani's line:

"In one confident line, without going back over it, he could represent nudes and faces, where all the emphases were delineated without heaviness – what am I saying! – with the delicacy of a spider's web!

"Only certain of Toulouse-Lautrec's drawings can rival this distinguished and haughtily impertinent mastery. And Modigliani's are more refined, of greater quality and closer to life!"

The genius of his line drawing is really seen to flower when he draws a face simply using a graphite pencil. The line is sometimes effaced, or diminished, once colour is involved:

"Once he began working his distorted figures in pinks and blacks, his drawing relied less and less on line", states Francis Carco. "He hinted at form. He retained, through fineness of language, the elements of a noble and moving style. Everything submitted to this style."

He also recognised that colour could enhance line:

"The light which this painter liked to be more or less evenly distributed, breaks the line, giving it more sensitivity and, while not spoiling its decorative *arabesque* function, animates it to even finer subtlety."

On the subject of light in his art, one cannot help evoking the light of Italy, that subtle light which Modigliani was never to forget.

"I knew Amedeo Modigliani in 1907. He was a very handsome young man, with the virile good looks we admire in the portraits of Bellini", wrote his friend Basler.

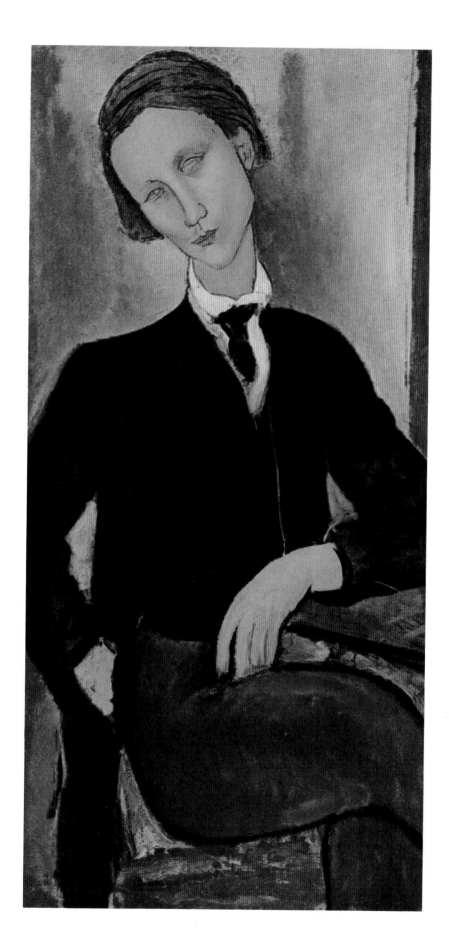

PORTRAIT OF MONSIEUR
BARANOWSKI, 1918.
Oil on canvas, 111 x 56 cm.
Private collection.

It is indeed difficult not to compare this charming young Italian with the grand master of the Venetian Seicento (17th century).

In Montparnasse there still prevailed a nostalgia for the land beyond the Alps. The journey into Italy made by generations of painters, architects and poets remains a part of the spirit, and one is always quoting the great Italian classics in art, whether intentionally or not, from antiquity to the Baroque period, via the Renaissance.

How could such a prestigious past be forgotten by one of its own sons? Even one who had chosen the road of Paris and appeared to have turned his back on the Masters of Livorno, Florence, Naples and Venice? For some critics, the Italian influence is a determining factor in Modigliani's art. André Salmon, in an article published in *L'Amour de l'Art* in January 1922, wrote:

"Modigliani was fond of telling us that it was from the depths of the people, the proletariat (happily, for once used in its proper sense!) that Italy drew its reserves of aesthetic strength, oblivious to everything but quality. He included the daubers employed to renovate chapel decorations, who worked under a hideous system and upheld a tradition of the highest standards – a tradition such as one hoped for, in vain, from academics. In France, stated Modigliani with some truth, only the middle classes were responsible for the changes in artistic life. The more he learned from within himself and through his *métier* of beauty, the more this delicate, refined, sensual intellectual turned to the people of his own country. *Cara Italia!*"

Gustave Coquiot confirms the same idea in different words:

"He had all the characteristics of his Italy, nervous energy, fineness, exaltation... Swift to cut and scatter *arabesques* in the white of his marble sculptures, but always with elegance and beauty..."

"He wanted to be a painter. He rented a studio on the Butte Montmartre, and, being a good student, immediately hung on the walls a number of prints of famous pictures which are still in his country."

"It was a bit of a 'mish-mash' of styles. At 20 the 'subject' exercises a certain ascendancy: the passion of the moment outstrips all thought. One wants everything; hungers for everything; wants to devour everything; one is arrogant; one does not think of selling... one does not specialise."

"And so in the studio of that good student Amedeo, Carpaccio's *Two Venetian Courtesans*, which look so like the hairless specimens sometimes seen at dog shows, hung next to *The Death and Assumption of the Virgin*; and, by Carpaccio again, *Saint Stephen arguing with the Doctors*, and *Saint George and the Dragon*, with a rather "tarty" looking young knight. Modigliani had also pinned up Lotto's *Portrait of a Woman* (from the Carrara museum); *Christ and his Mother* by Orcagna; Veronese's *Jesus at the House of Simon*; Perugina's *Nativity and Don Baltasar*; a *Virgin and Child* from the Pitti Palace, signed Lippi; Botticelli's *Spring* and finally prints of pictures by Titian, Corregio and even Andrea del Sarto."

"Modigliani found all these pictures in a box one day when I was there and began to smile... 'From the days when I was a bourgeois!' he said."

According to André Salmon, the Italian influence was only felt later on:

"Modigliani appears to have come to us (...) attracted by Paris and looking for masters without knowing any. It was not until much later (having learned his lesson in the heavenly school of this century's god-like reformers) that he quietly turned about and, filled with immense hope, fixed his eyes on Italy."

Waldemar George finds an echo of this in the works themselves:

"The Gothic nature of his art, which was also dominated by love of the vertical, had its birth in Italy. His figures are rendered spiritual, even disembodied. The measured elongation of the limbs, the desire to make the body columnar, the feeling for the surface of the painting, are all symptomatic of his Gothic qualities. Modigliani was Gothic from the start, as were the great painters of the Trecento (14th century) such as Barno and Duccio. However, his later works possess more elegance of style and are reminiscent of painters of the Quattrocento (15th century), like Filippo Lippi or even Botticelli. At no time did the analytical spirit, which made Lucas Signorelli and Paolo Uccello pursue their investigations in the new areas of perspective and anatomy, trouble the mind of our contemporary. Dramatic as only Primitive art can be, or representational, Modigliani's work, born of contact with the genius of Italy on the soil of France, imbued with the best of tradition, with the active forces of French genius – that magic crucible by which modern painting is sustained – has preserved his ethnic characteristics."

From Sonare's *The History of Italian Art in the 19th Century* should be added:

146

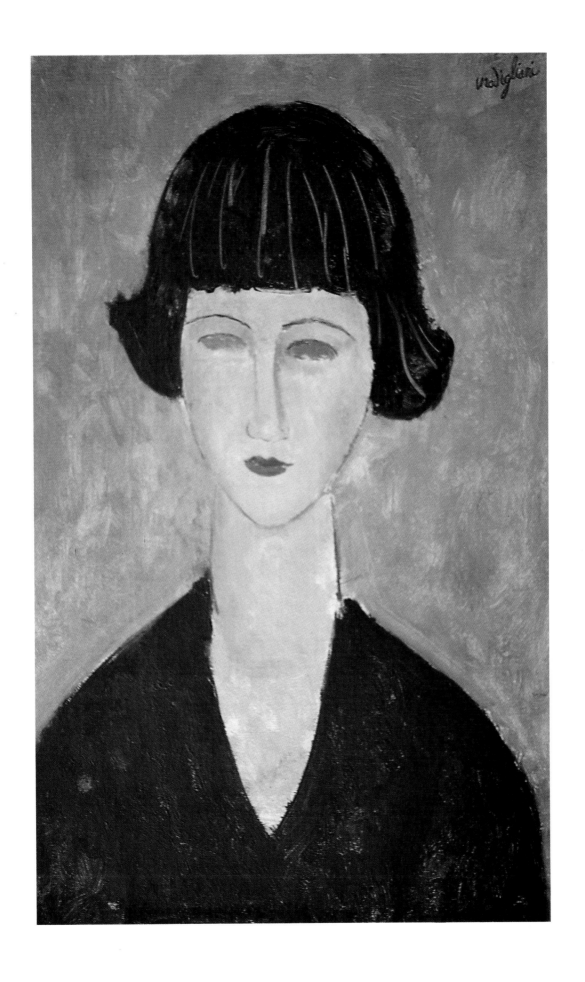

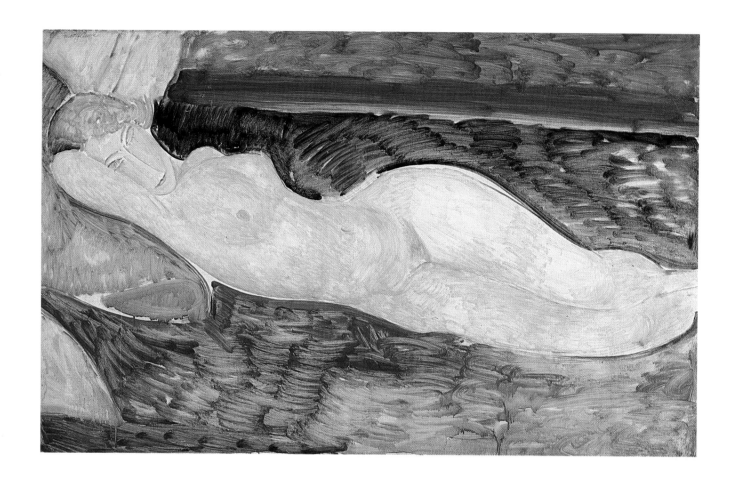

"I only know that the Italy of today has produced one single true painter, which she refuses to acknowledge as her own, since he represents the spirit rather than the letter of her tradition. This painter lived and worked in France. He lies in French soil. His adopted country gave him fame and glory. It has taken upon itself the right, and it will hand his work down to posterity. Italy, an unworthy mother, should be in mourning for the loss of Modigliani."

Can Modigliani be considered French from now on? Does he not owe his success to Paris? Is he brother to Picasso and the others?

Writing in *L'Information*, the critic Roland Chavenon does not seem convinced of this Frenchness when he talks about the famous Paul Guillaume exhibition in 1918; he appears to have rendered judgement in advance of others!

"In an exhibition which is homogeneous despite the diversity of personalities involved, Paul Guillaume has grouped together several painters of today: Derain, sober; de la Fresnaye, likeable in his rigidity; Matisse, well represented; Picasso, better here than elsewhere since he is being himself; Utrillo, the painter of old walls; Modigliani and Chirico, foreigners; Vlaminck the link between Impressionism and Cubism."

A foreigner! But so was Picasso! The term foreign should be interpreted in the sense of strange or different or barbaric. But it must be said that 12 years after his arrival in Paris Modigliani was still considered a foreigner (in the true sense of the word) by some of the critics.

The works in the Paul Guillaume exhibition referred to above were *The Lady with a Veil*, *The Pretty Housewife*, *Madame Pompadour* and *Beatrice*; in the same vein, Utrillo is called the "mysterious ether addict". Vlaminck is the "giant blond from Chatou", whilst the works of Derain are categorised as "austerely archaic" and those of Picasso need to be "decoded". Happily his colleague Bissière, of the *Paris Midi*, unreservedly approved of Paul Guillaume's choice:

"It was a happy choice and one would like to see such important collections gathered together more often under one roof: it might prevent so many people from talking erroneously and at cross-purposes about Modern Art, without ever having seen anything but a few second class attempts... We must praise M. Guillaume who has given us such a rare opportunity today to see good painting."

The New York Herald, La Croix, L'Eveil, La Liberté, La Victoire, La France, Excelsior, La Petite République, L'Action Française, L'Action, Le Carnet de la Semaine and *Le Monde Illustré* all reviewed, with

varying degrees of approval, this little exhibition which was such an enormous success. Modigliani came through it with flying colours.

This was also the opinion of Francis Carco who rated him with the best of his contemporaries:

"But if we leave the theoreticians to their waffling, a painter like Modigliani seems to us to become with each day that passes a truer representative of contemporary art. He repudiates his primitive and literary beginnings and the influence of Gauguin – noted subconsciously but already only a long-gone landmark in his evolution, like the Spanish artists who 12 years before were the forerunners of Modern art."

Francis Carco, in his *The Nude in Modern Painting*, pays the following homage to Modigliani, comparing him to Manet and thus placing him on an entirely French pedestal:

"There is no one greater than this young master, for 35 years brought up on the joys of painting. No one has better learned the lesson of Manet – Manet before he was tempted by Impressionism. None have penetrated deeper than he in following in the footsteps of the creator of *Olympia*, in understanding the part that the supremacy of colour should play. There are probably more prolific, more constant œuvres around than his. But where will you find one that is more interesting or more expressive? Where is the face which is a more successful incarnation of the passion of life, or wherein the argument for voluptuousness results in such a vibrant, rich harmony or with greater justification?"

None the less, as Adolphe Basler remembers, Modigliani was "still small fry... Modigliani as a painter was barely noticed among the *Indépendants*, in whose company he exhibited in 1909 – in my opinion, a few pictures here testified more to his intelligence than to any personal conviction. In the same room as his work, paintings by Delaunay and Le Fauconnier hung next to a great canvas by Henri Rousseau."

There was a temptation then to classify him as being influenced by one of the trends of that particular time. Starting with Picasso:

"Newly arrived from Livorno, the town of his birth, he took up residence in the Butte Montmartre, where he rapidly made himself

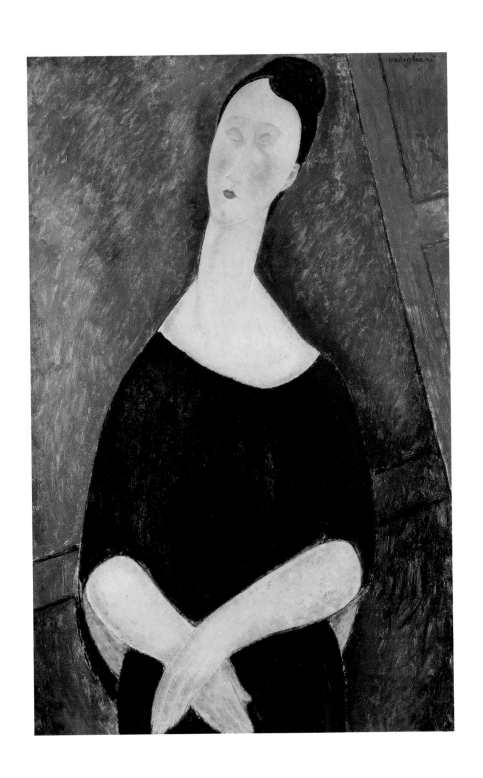

151

popular; he was seen as often at *Frédé* or the *Lapin Agile* as in the Place Ravignan, in the company of Max Jacob, Picasso and other inhabitants or *habitués* of the area", recalls Gustave Coquiot.

"Although it must be agreed that during these times he benefited from Pablo Picasso's early artistic explorations and made use of the painter's constructional elements, the similarities between Modigliani's work and that of the Cubists are certainly not those of one merely copying a model. Is it a case of a similarity in the means he used to express himself, a new and personal way of utilising the discoveries of others, or a free, original, interpretation of the use of existing plastic means of expression?" wonders Waldemar George.

The same writer defines elsewhere the strategic place Modigliani occupied in the sphere of influence of his times:

"Modigliani lived through stirring times. His early pictures bear the marks of deep anxieties which were the concerns of the best of his contemporaries. Modigliani was too great an artist to stand aloof from the arguments raging around him, but the style of his painting was never once affected by any fashion that was foreign to his own self."
"The œuvre of Modigliani represents not merely a stage in the evolution of Modern art. If in some respects it is allied to contemporary art, this does not mean that he falls into the category of a professional artist who remains in the ranks. What Modigliani brought to art is not a matter of technique. André Levinson, talking about the use made by Chagall of Cubism's solution to certain problems, does not fail to point out that the Russian painter lyrically and expressively distorted those elements which, for French painters, had an exclusively plastic significance. If Cubism did exercise any effect on Modigliani's work, this effect has been watered down."

Soon all the critics are in agreement that Modigliani's art is unique, without precedent or later parallel, whether because of or despite those influences deliberately or subconsciously received. The different periods he went through follow each other in the same harmonious way. Every facet of his *œuvre* is imbued with the same feeling of harmoniousness. Whether he is "working in the African style, or joining the Cubist school", or following in the footsteps of the Italian masters, "his drawing is sensitive, his form eloquent", as Waldemar George expresses it.

"When one finds oneself in the presence of a painter such as Modigliani", Carco tells us, "one has the impression, or rather the

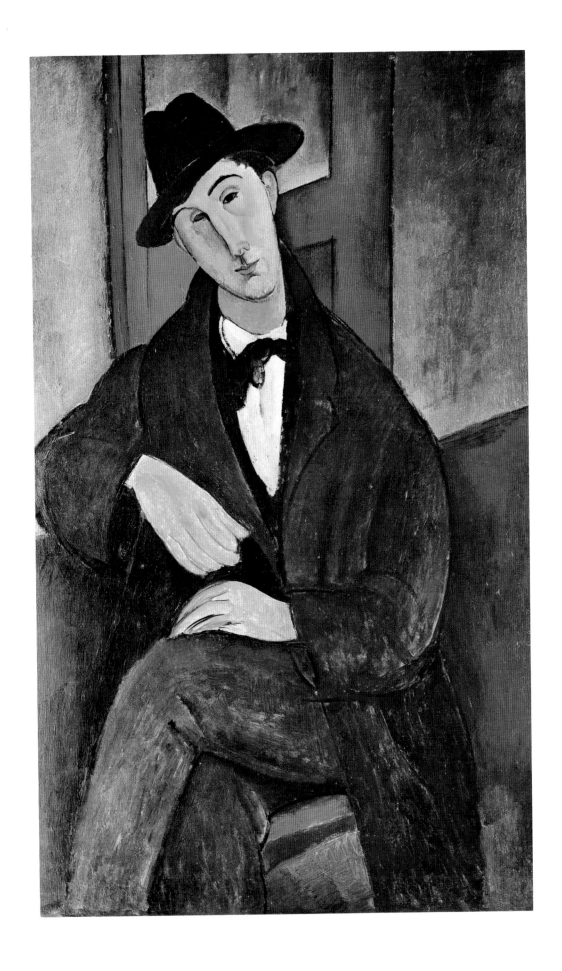

153

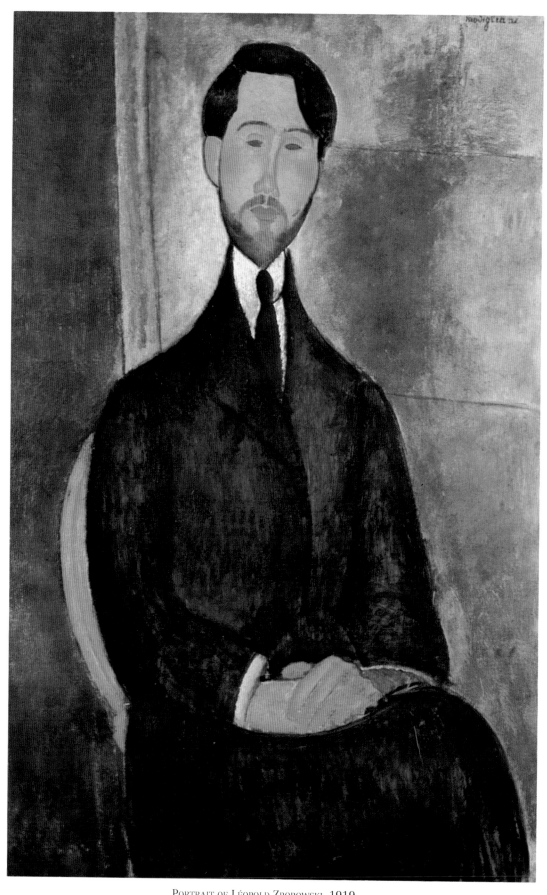

PORTRAIT OF LÉOPOLD ZBOROWSKI, 1919.
Oil on canvas, 100 x 65 cm. Museu de Arte, São Paulo.

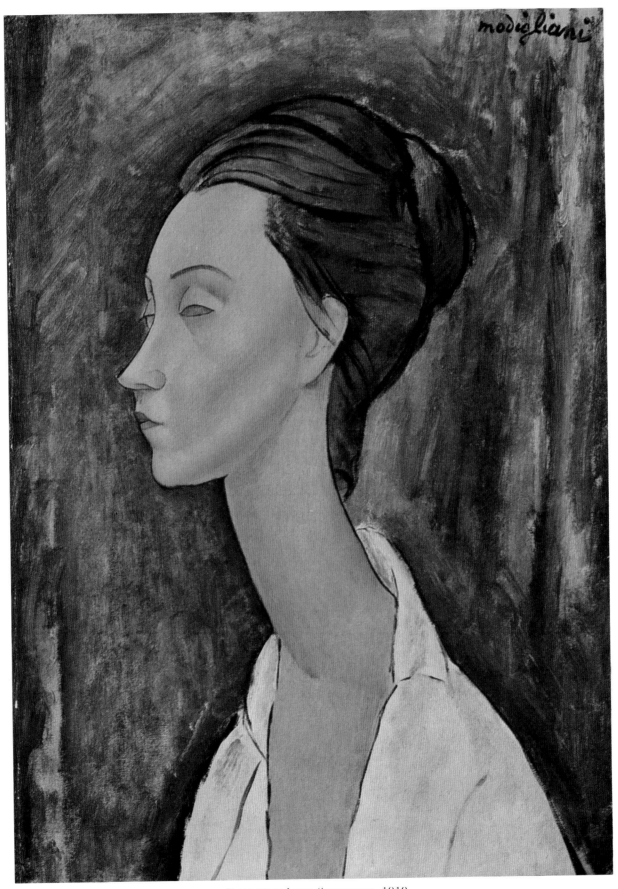

PORTRAIT OF LUNIA CZECHOWSKA, 1919.
Oil on canvas, 46 x 33 cm. Private collection.

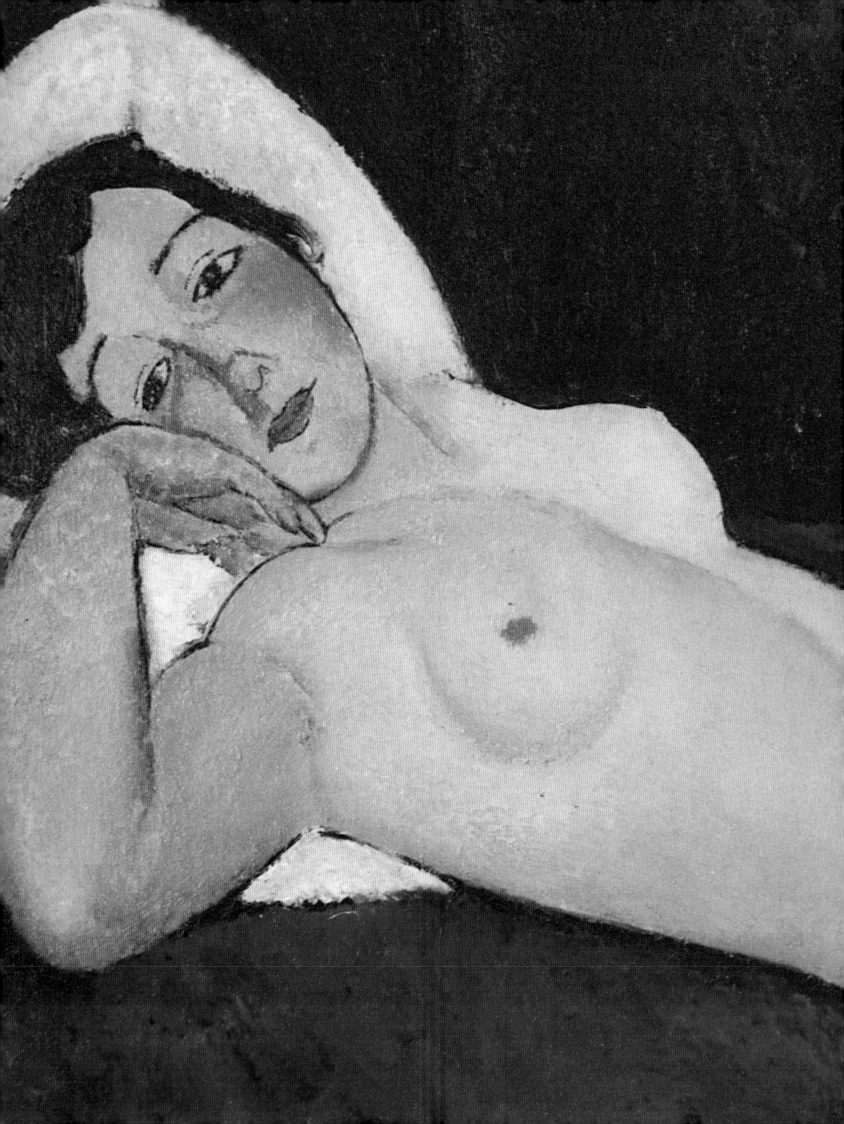

certainty, that artistic influences from outside have only had a very superficial effect on his work and were incapable of making any difference to his own essential gift."

And Carco goes on: "*Cara Italia*! was the sigh of the dying painter on his way to hospital. He owed a great deal to France, who is happy to be his creditor. Among so many strangers he was one of the most generous in what he gave to France. He found the secret of creating a subtle and deep link between two great traditions..."

"Modigliani carried within him epic powers, those fiery and softer passions which are the glory of being a man. He encapsulated these in a figure, a mirror of the universe. With this learned artist, carefully planned compositions always left room for immediacy of feeling."

"Modigliani was never a painter who worried about exhibitions or who attacked or destroyed his colleagues. He lived within himself and for himself, with all his virtues and vices. A painting chosen from among his works is a lifelong pleasure to those who passionately love painting."

This would appear to be the conclusion reached by Gustave Coquiot who does not enter into the debate on influences or allegiances. For him, as indeed for the majority of the critics, the great strength of Modigliani is that he remained totally himself despite all the hazards of a difficult career and a way of life in which it was extremely hard to keep going.

An ultra-sensitive being, he kept his sensitivity for the things that mattered: his work, his loves and his friends.

Imperturbably, in the teeth of a comfortless life, he followed his dream and carried out his work. As early as the age of 18 he had written to Oscar Ghiglia: "It is your duty to achieve your dream".

Whatever the praises or reservations of the critics in his lifetime (for the most part verbal since the written ones can be counted on the fingers of one hand), Modigliani remained true to himself and was never concerned with what posterity would say of him after he was gone. Waldemar George wrote, soon after his death:

"What a supreme adventure was the far too short career of Modigliani! What other modern painter can be said to have reached such maturity so young? What other has succeeded so well in preventing himself from being affected by ephemeral influences? In less than ten years Modigliani has fulfilled himself."

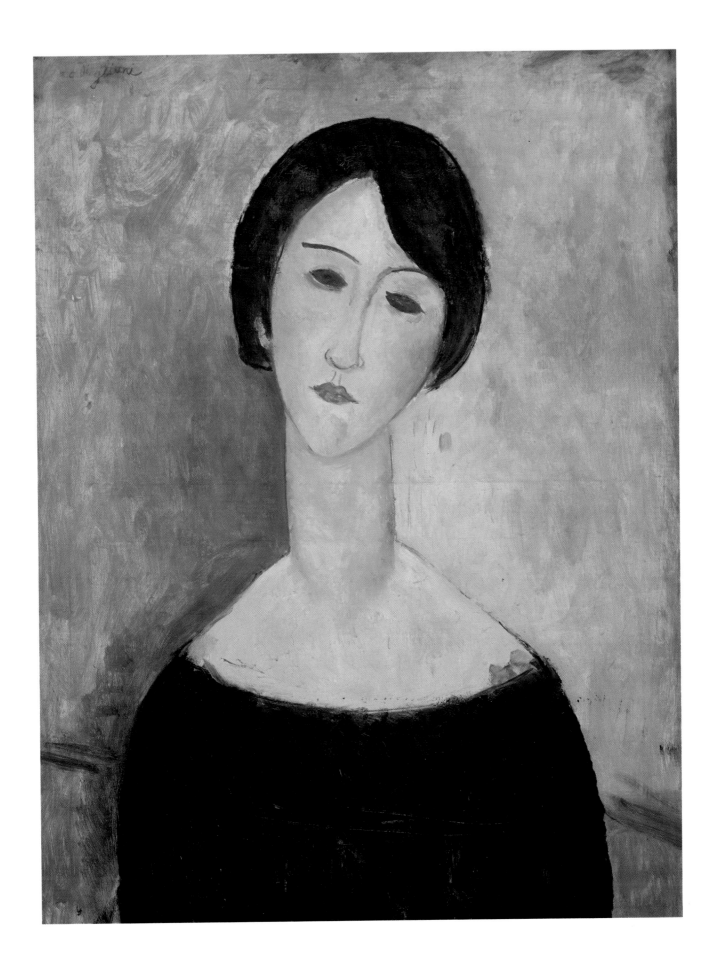

The extracts quoted in this chapter are from the following:

Reviews of the Paul Guillaume Exhibition:
Les Arts à Paris, news and reviews of literature, the arts and other curios, No. 4, published 15 May 1919, Paul Guillaume, Paris, 108 Faubourg St-Honoré.
M.J.G. Lemoine in *L'Intransigeant*; R. Chavenon in *L'Information*, M. Bissière in *Paris Midi*, Anon. in *Les Ecoutes*.

Francis Carco: "Modigliani", in *L'Eventail*, Geneva, 15 July 1919, pp. 201-109.

André Salmon: "Modigliani', in *L'Amour de l'Art*, Paris, January 1922.

Francis Carco: *Le Nu dans la Peinture Moderne* (1863-1920), Editions Grès, Paris, 1924, pp. 112-118.

Gustave Coquiot: *Peintres Maudits*, A. Delpeuch, Paris, 1924, pp. 101-112.

Maurice Raynal: "Modigliani", in *Anthologie de la Peinture en France de 1906 à nos Jours*, Paris, 1927.

Florent Fels: "Modigliani", in *Nouvelles Littéraires et Artistiques*, 24th October 1925.

Waldemar George: "Modigliani" in *L'Amour de l'Art*, Paris, October 1925.

Maurice de Vlaminck: "A memoir of Modigliani", in *L'Art Vivant*, Paris, No. 21, 1st year of publication, 1 November 1925.

Giovanni Scheiwiller: "Amedeo Modigliani", in *Arte Moderna Italiana*, Milan, 1927.

André Warnod: *Les Peintres de Montmartre*, La Renaissance du Livre, Paris, 1928, p. 167.

Lamberto Vitali: "The Drawings of Modigliani', in *Arte Moderna Italiana*, No. 15, Milan, 1929.

Adolphe Basler: *Modigliani*, Editions Grès, Paris 1931, pp. 5-15.

Henri Lormian: "Modigliani and his Legend", in *Beaux-Arts, chronique des arts et de la Curiosité, le Journal des Arts*. Editor Georges Wildenstein, No. 54, Paris, 12 January 1934, p. 5.

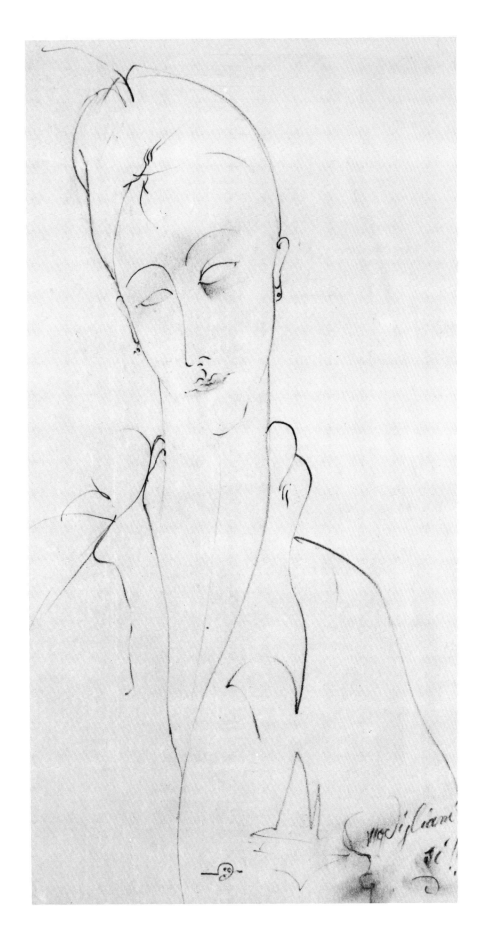

Modigliani
the Draughtsman

Modigliani was a great draughtsman. Although entirely distinctive, even unique, his drawing was refined by contact with the avant-garde trends of the beginning of the century.

He used various media: pencil, pastel, charcoal and Indian ink with which he also sketched out subjects on the surface of his canvases

From Montmartre to Montparnasse, from the Lapin Agile to La Rotonde, Modigliani carried with him his blue sketchbook.

From 1910 to 1914 he made drawings in which the geometric contours took account of the configuration of the space around the model.

Between 1915 and 1919 Modigliani simplified his line to a bare essential, in order to attain that perfection of linear fluidity which is the very essence of his style.

Left and on the following two pages:
Seven sheets of signed drawings from an eight-page sketchbook entitled:
PORTRAIT OF LUNIA, 1918.
Pencil drawings on paper, 42,7 x 26.6 cm.
Private collection.

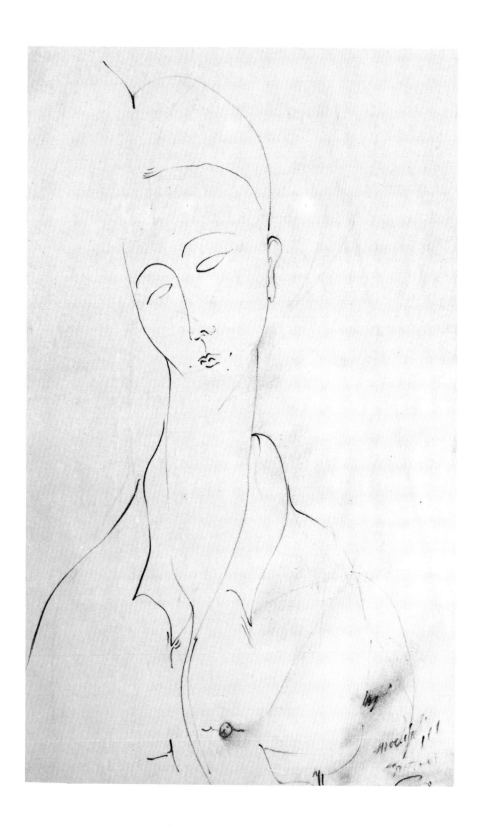

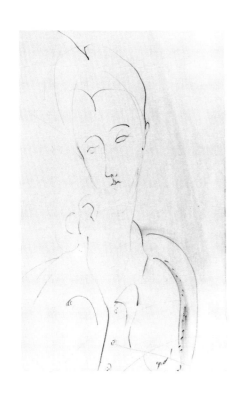

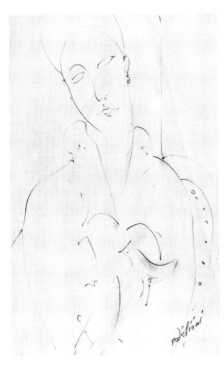

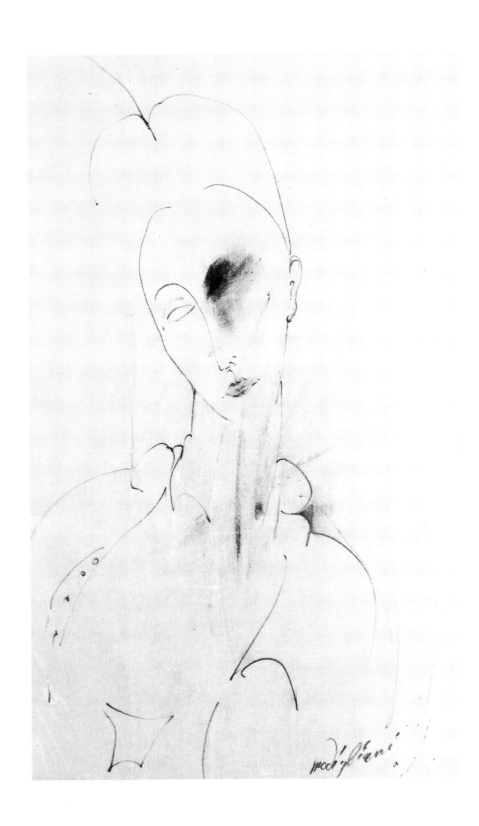

PORTRAIT OF A WOMAN, 1910.
Pencil on paper, 31 x 22 cm. Private collection.

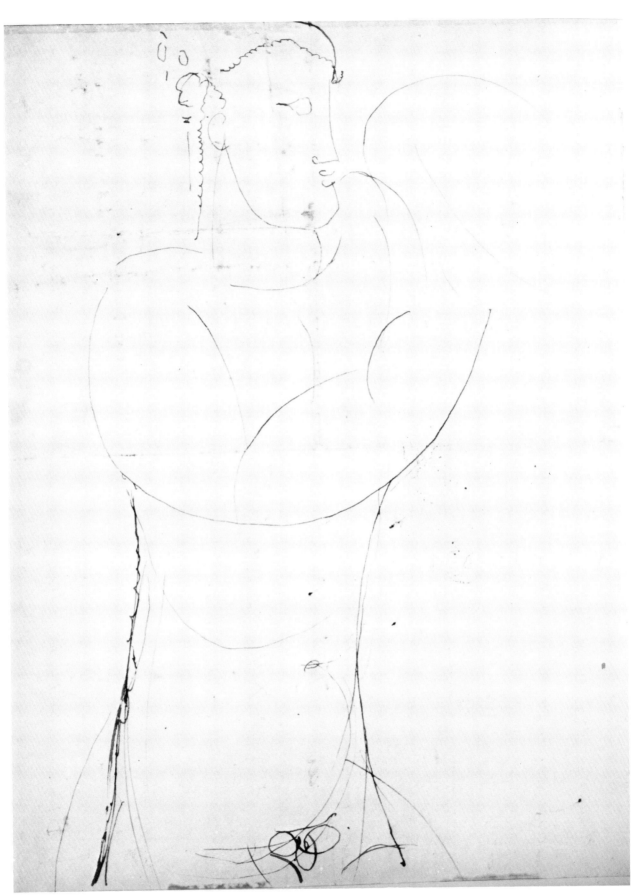

TORSO (ATHLETE), 1910.
Indian ink on paper, 26.5 x 21 cm. Private collection.

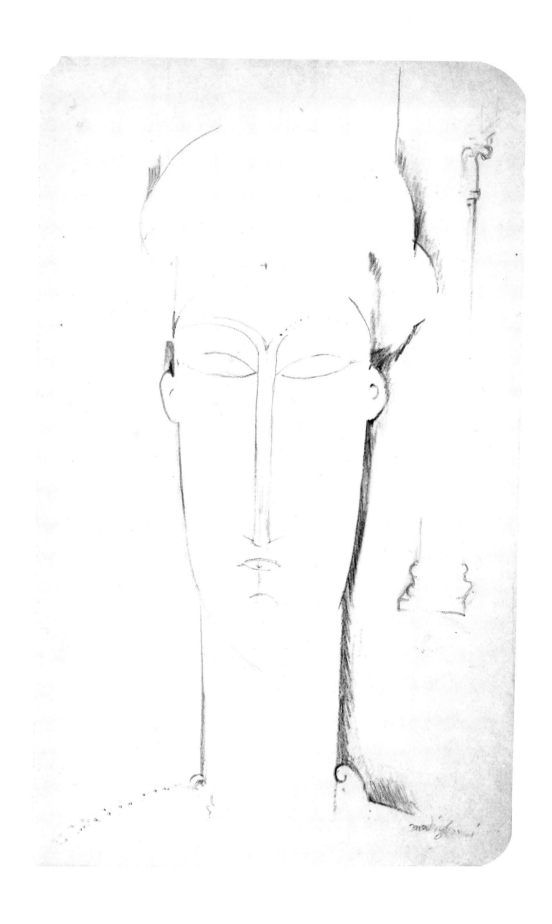

CARYATID, 1913.
Pencil and blue crayon drawing on paper, 42.5 x 26 cm. Private collection.

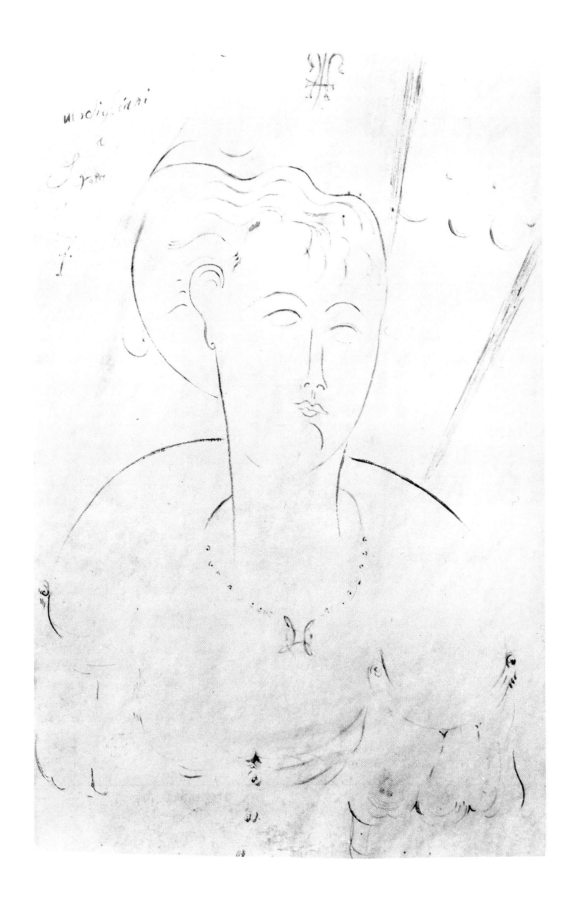

LYSA, 1915.
Graphite pencil drawing on paper, 42 x 26 cm. Private collection.

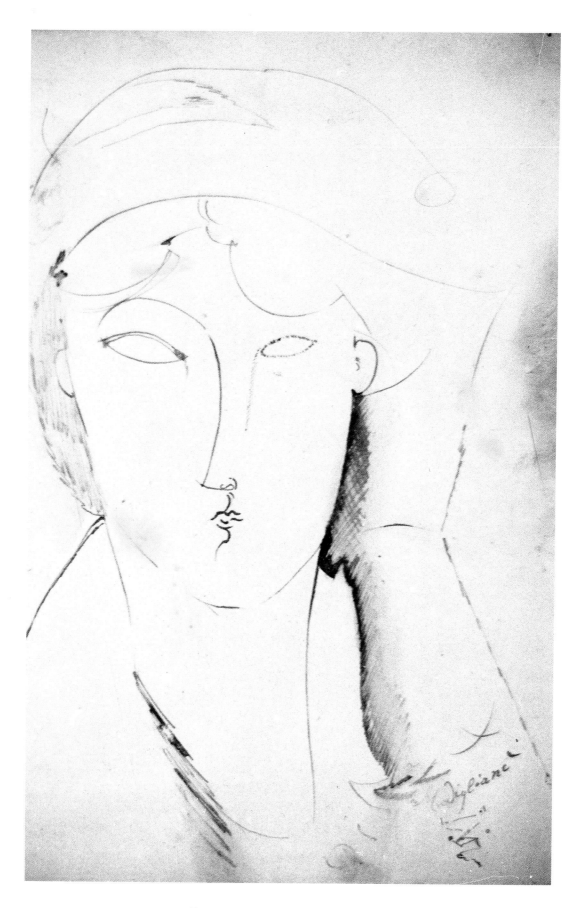

PORTRAIT OF BEATRICE HASTINGS, 1915.
Ink on paper, 30.5 x 22.3 cm. Private collection.

Portrait entitled Bea, 1915.
Ink on paper, 32 x 20.5 cm. Private collection.

HEAD OF WOMAN, 1915.
Pencil drawing on paper, 30 x 22.5 cm. Private collection.

RECLINING NUDE, 1916.
Pencil drawing on paper, 22.5 x 30 cm. Private collection.

Man with a Moustache, 1917.
Pencil drawing on paper, 42.5 x 26 cm. Private collection.

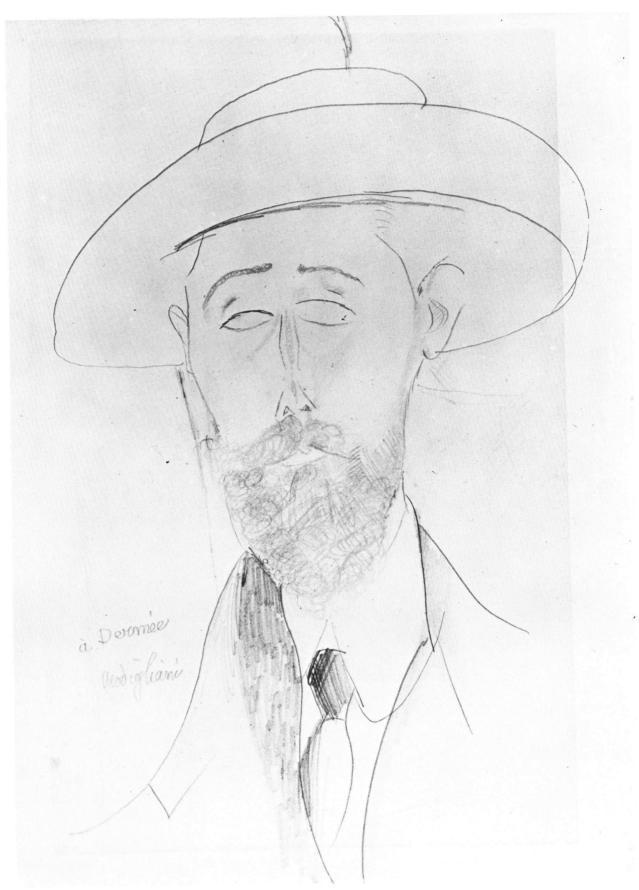

à Dermée

Modigliani

PORTRAIT OF PAUL DERMÉE, 1916.
Pencil drawing on paper, 33 x 25 cm. Private collection.

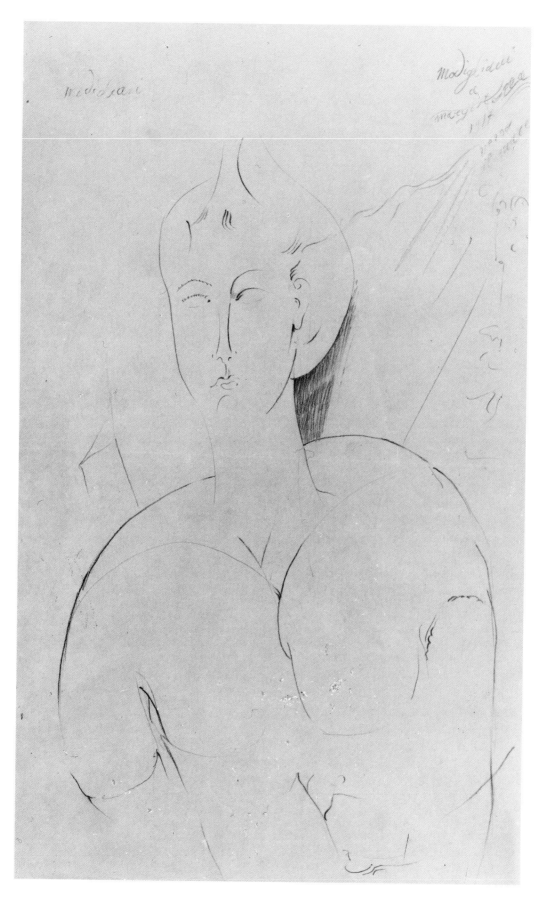

PORTRAIT OF MARY-STELLA, 1917.
Pencil drawing on paper, 41 x 26 cm. Private collection.

174

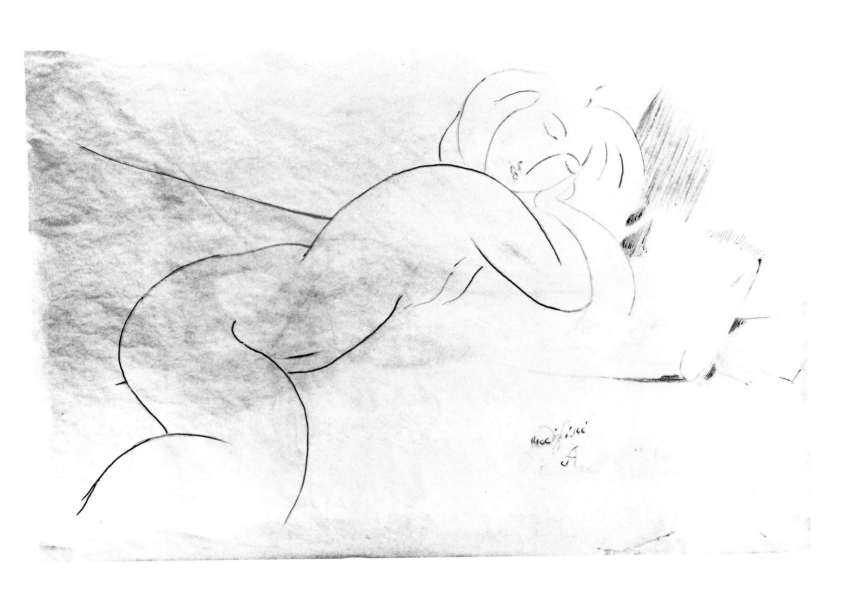

SLEEPING NUDE, 1917.
Graphite pencil drawing, 26 x 41 cm. Private collection.

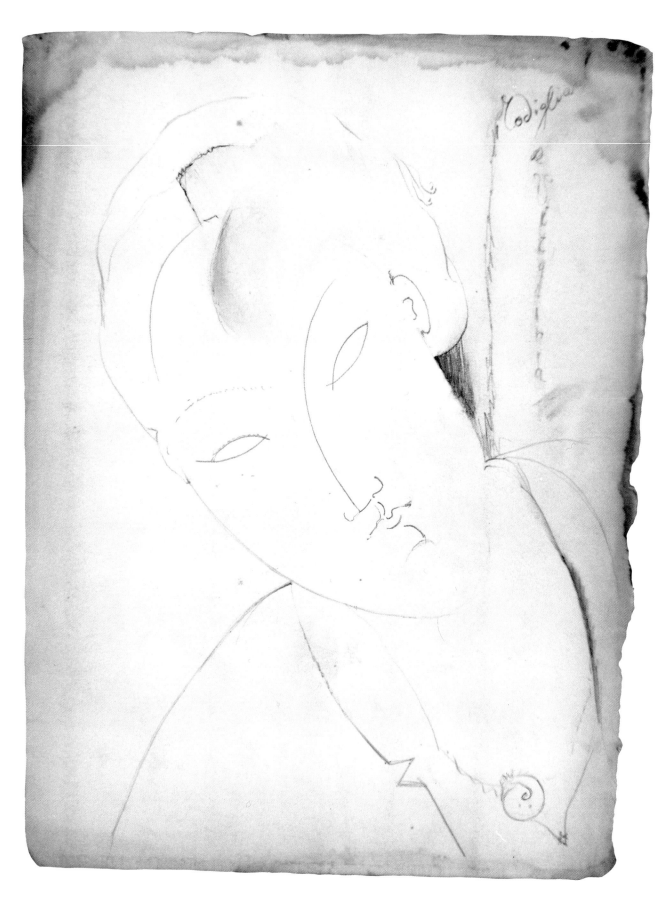

Portrait of Virginie, 1917.
Pencil drawing on paper, 30.5 x 22.3 cm. Private collection.

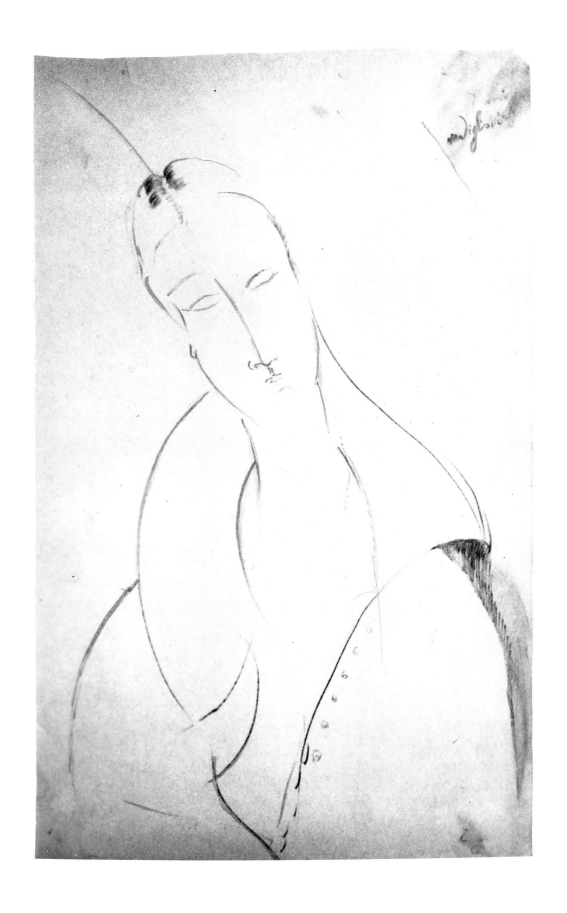

MADAME ZBOROWSKA, 1917.
Pencil drawing on paper, 42.5 x 26 cm. Private collection.

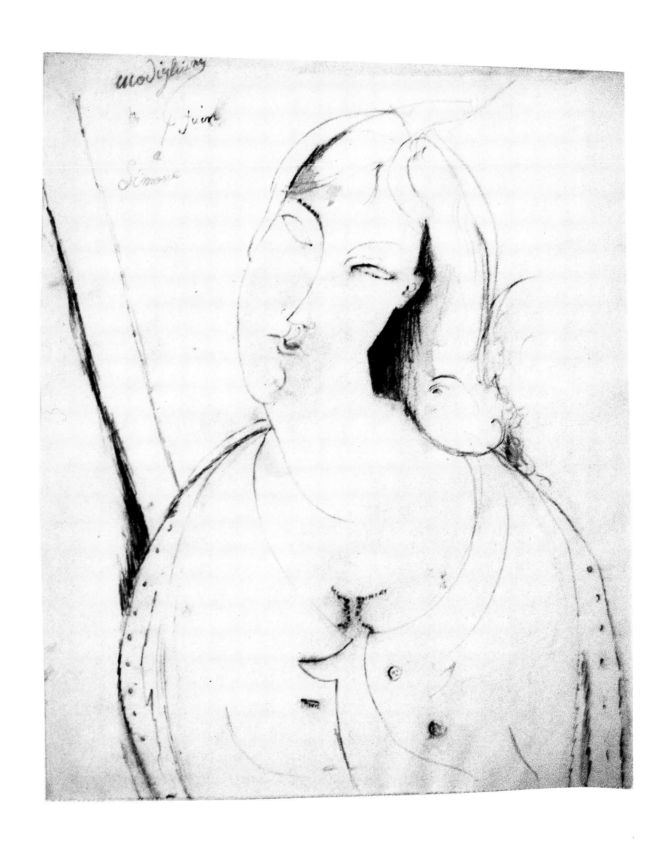

SIMONE, 1917.
Pencil and ink on paper, 26 x 22.5 cm. Private collection.

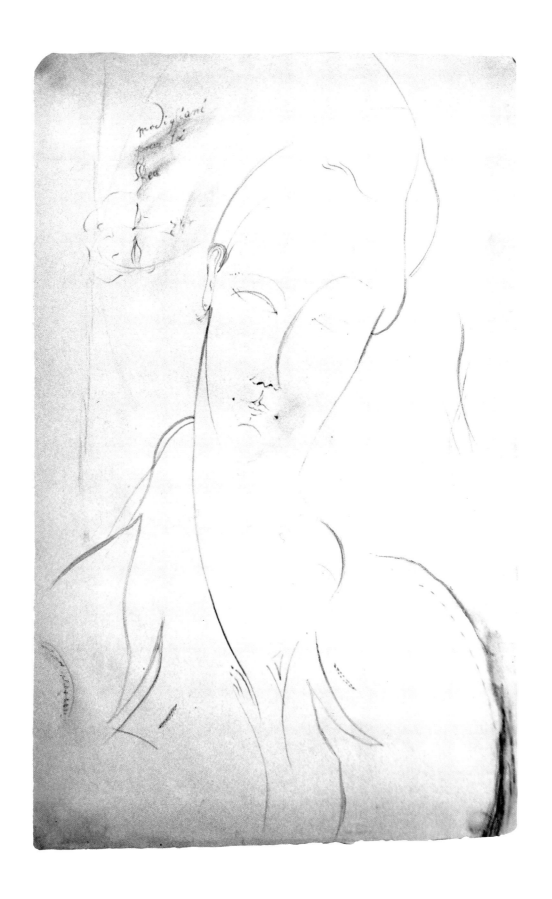

PORTRAIT OF BEA, 1917.
Pencil drawing on paper, 42.5 x 26 cm. Private collection.

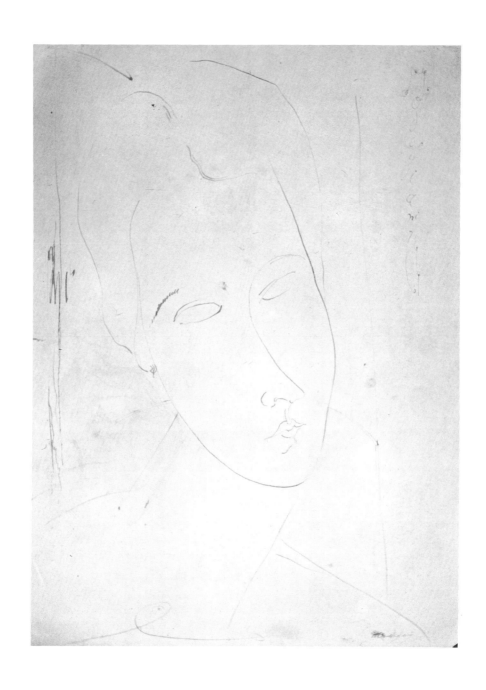

PORTRAIT OF WOMAN, 1917.
Pen and ink drawing on paper, 27 x 35 cm. Private collection.

THE YOUNG RABBI, 1917.
Graphite pencil drawing on paper, 42.5 x 26.5 cm. Private collection.

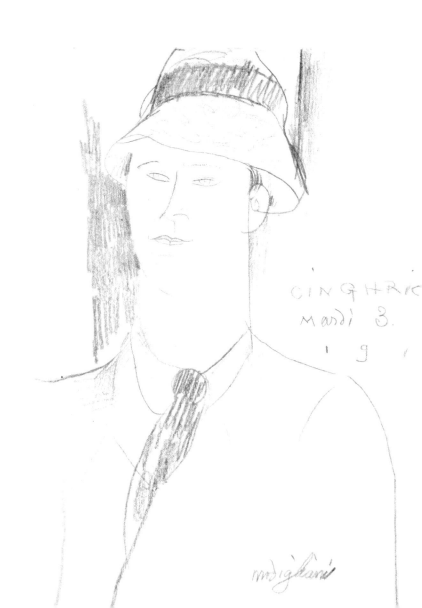

From THE TOP OF THE BLACK
MOUNTAIN:
poem composed by the artist
and written by him on the back
of a portrait of his friend
Cingria.

PORTRAIT OF CHARLES ALBERT
CINGRIA, 1917.
Pencil and crayon drawing
on paper,
27.5 x 21.5 cm.
Private collection.

182

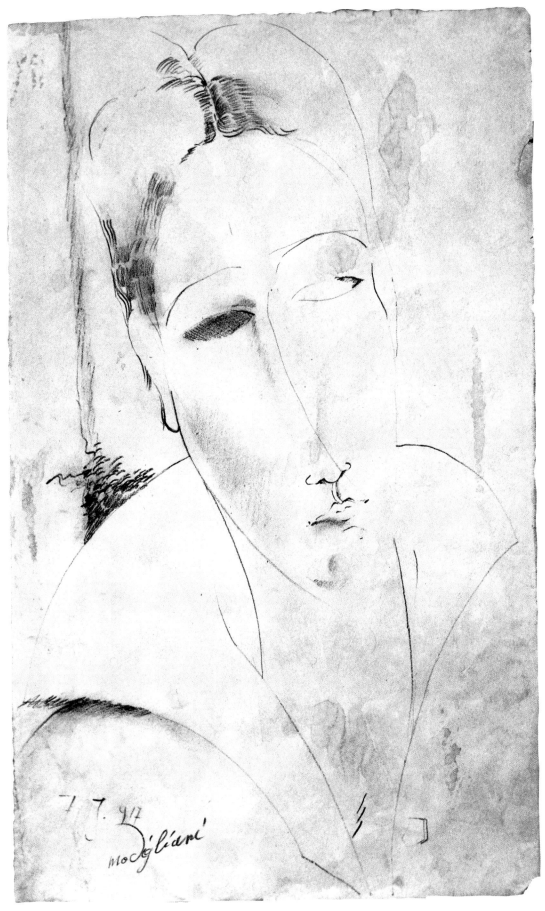

ANNA ZBOROWSKA, 1917.
Pencil drawing on paper, 42 x 25 cm. Private collection.

Young Woman, 1917.
Pencil drawing on paper, 42.5 x 26 cm. Private collection.

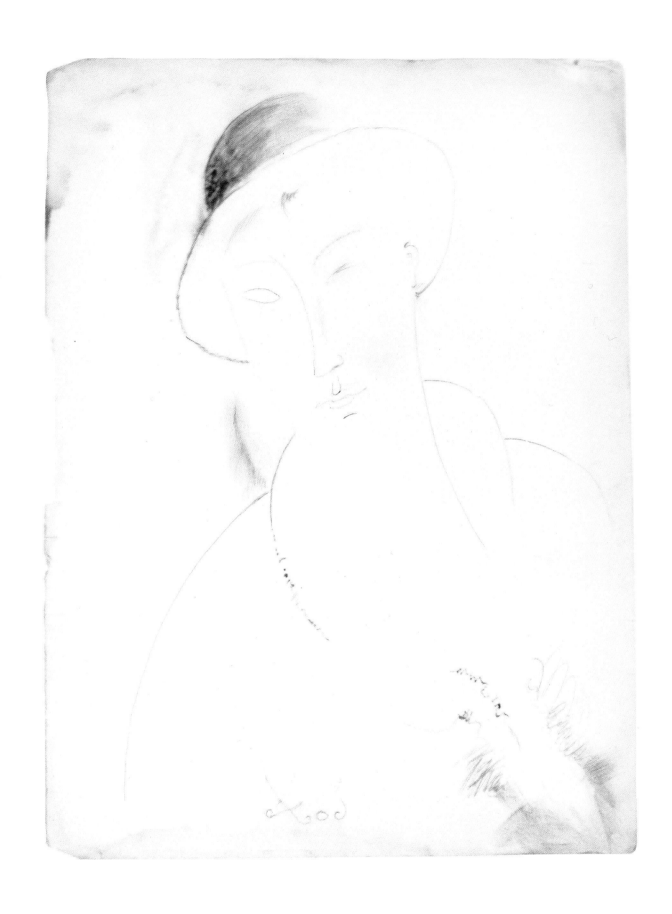

WOMAN WITH HAT, 1919.
Pencil drawing on paper, 30.4 x 22.5 cm. Private collection.

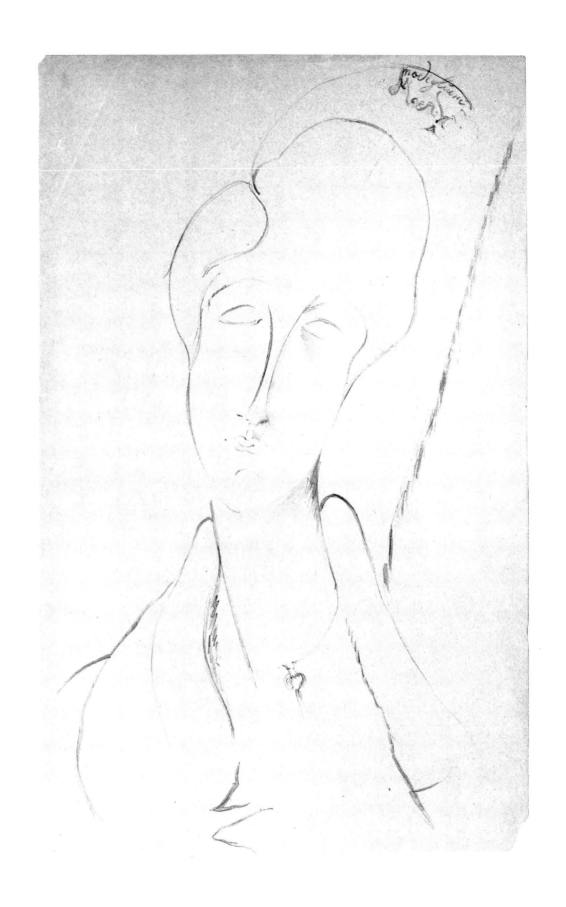

STUDY OF A WOMAN, 1918.
Pencil drawing on paper, 42,5 x 26 cm. Private collection.

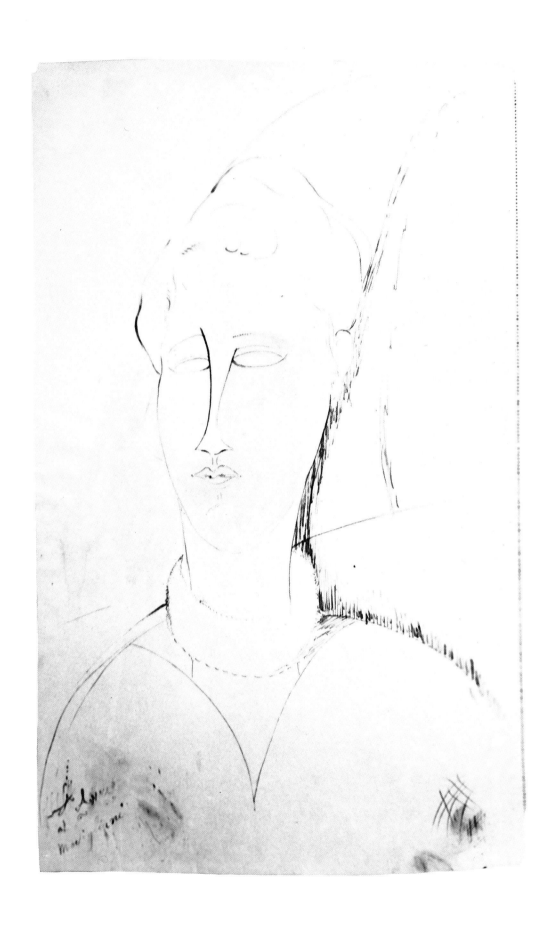

MADAME ZBOROWSKA, 1918.
Pen and pencil drawing on paper, 42.5 x 26 cm. Private collection.

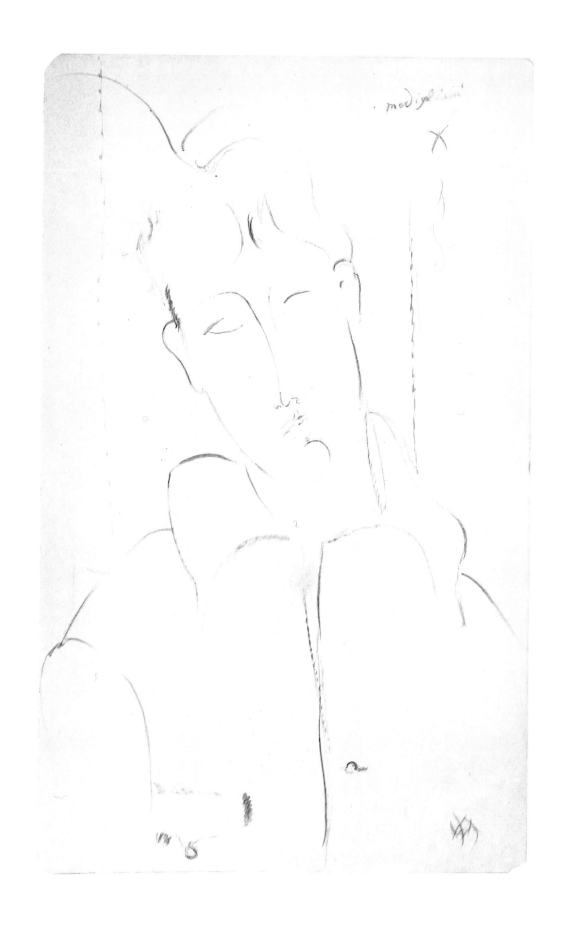

YOUNG MAN, 1918.
Ink and pencil drawing on paper, 42.5 x 26 cm. Private collection.

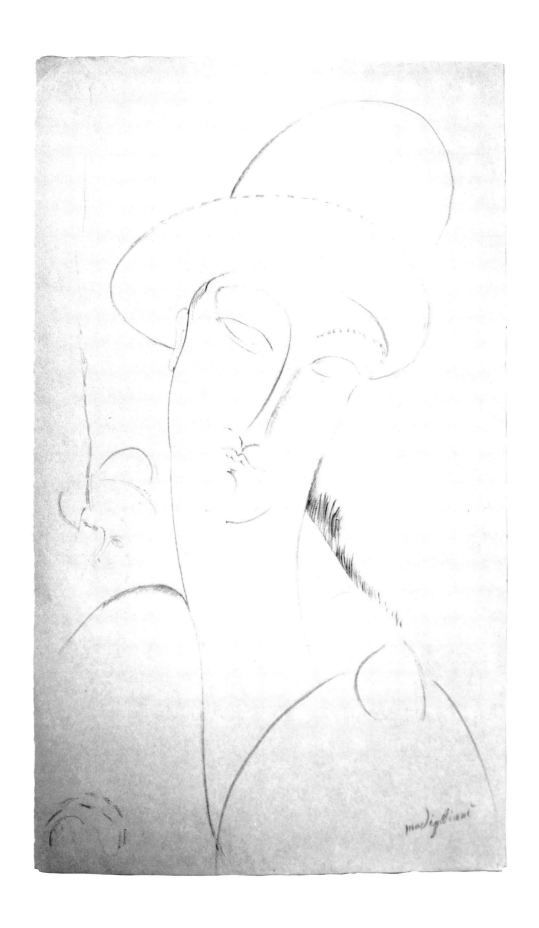

WOMAN IN A BOWLER HAT, 1918.
Pencil drawing on paper, 42.5 x 26 cm. Private collection.

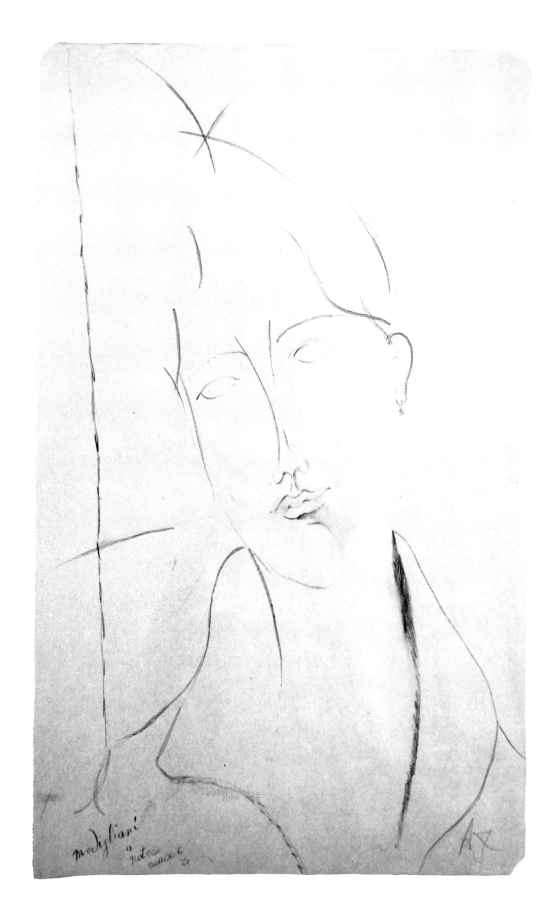

STUDY OF A WOMAN, 1918.
Pencil drawing on paper, 42.5 x 26 cm. Private collection.

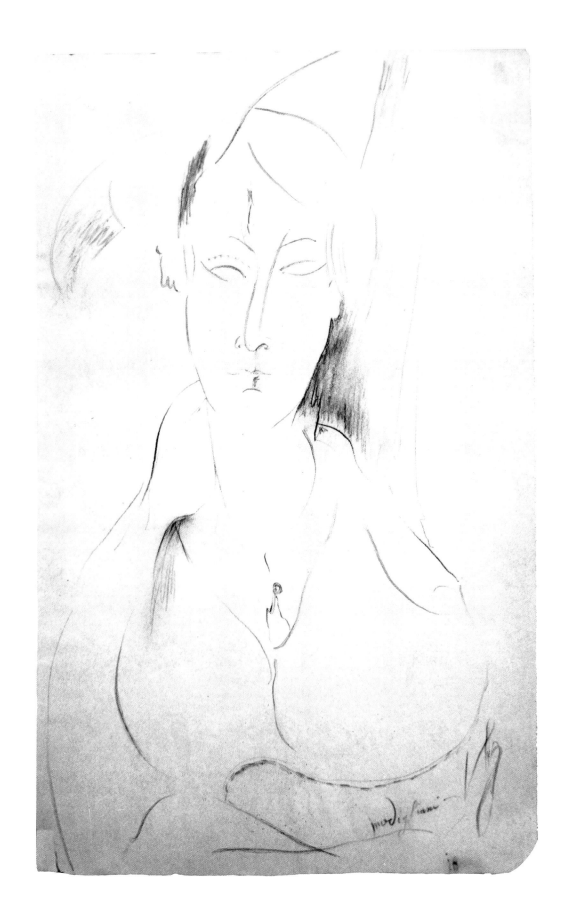

Woman with a Pendant, 1918.
Pencil drawing on paper, 42.5 x 26 cm. Private collection.

WOMAN IN A HAT, 1919.
Pencil drawing on paper, 30.4 x 22.5 cm. Private collection.

Exhibitions

1907

Paris, Modigliani becomes a member of the Société des Artistes Indépendants and exhibits for the first time (seven works).

1908

Paris, Salon des Artistes Indépendants, 7, Place J.-B. Clément, he exhibits the following (original catalogue numbers):

4325 - *The Jewess*
4326 - *Female Nude*
4327 - *Study*
4328 - *Female Nude*
4329 - *The Idol*
4330 - *A Drawing*
(Property of M. Gaston Lévi)

1910

Paris, Salon des Artistes Indépendants, 14 Cité Falguière, 6 works exhibited under numbers:

3686 - *The Cellist*
3687 - *Lunar*
3688 - *Study*
3691 - *Study*
3690 - *Beggarman*
(The property of M. Paul Alexandre).
3691 - *Beggarwoman*

1911

Paris, Modigliani exhibits seven sculptures in Souza Cardoso's studio in the rue Colonel Combes.

1912

Paris, Salon d'Automne.

1914

London, Whitechapel Art Gallery, "Twentieth Century Art".

1916

Paris, exhibition at Emile Lejeune's studio.

1917

Paris, exhibition at the Berthe Weill Gallery (five censored nudes).

1918

Paris, Paul Guillaume Exhibition.

1921

Paris, Galerie L'Evêque: "Modigliani Retrospective".

1922

New York, New Gallery, "Paintings by Dérain, Modigliani, Matisse and others'.
Paris, Galerie Bernheim Jeune, "Modigliani".

1925

Paris, Galerie Bing, "Modigliani".

1926

New York, Grand Central Art Galleries, "Modern Italian Art".
Paris, Salon des Indépendants, "Modigliani Retrospective":

3096 - *The Jewess*, 1908. (Property of Dr Alexandre).
3097 - *Portrait on the Cross*, 1909. (id.)
3098 - *The Cellist*, 1909. (id.)
3099 - *Female Nude (Jeanne, seated)*, 1910. (id.)
3100 - *Beggarwoman*, 1910. (id.)
3101 - *Portrait in front of a Window*, 1913. (id.)
3102 - *Portrait of M. Paul Guillaume*, 1915. (Property of M. Paul Guillaume).
3103 - *Portrait of M. Jean Cocteau*, 1916. (Property of M.P. Guillaume).
3104 - *Sleeping girl* (arms behind her head). (Property of M. Fénéon).

3105 - *Figure*. (Property of M. Zamaron).
3106 - *Figure*. (Property of M. Zamaron).
3107 - *Figure*. (Property of M. Netter).
3108 - *Portrait of a Young Woman*
(Property of M. Marcel Bernheim).

1927
London, Arthur Tooth & Sons, "Artists of the Italian
Novecento".
Paris, Galerie Bing, "Modigliani".
Zurich, Kunsthaus, "Italian Artists".

1928
Lyons, Galerie des Archers, "Bonnard, Vuillard,
Roussel and Modigliani".
Moscow, "French Contemporary Art".

1929
Chicago, The Arts Club.
Geneva, Galerie Moos, "Modigliani".
London, Lefevre Galleries, "Paintings by Modigliani".
New York, De Hauk & Co.
"Paintings by Amedeo Modigliani".
Paris, Galerie Bernheim Jeune, "Great Contemporary
Painting from the Paul Guillaume collection."
Tokyo - Nagasaki, "French Art of the Twentieth
Century".

1930
Brussels, Galerie du Centaure,
"Thirty Years of French Painting".
Glasgow, "19th and 20th Century French Painting".
Paris, Galerie Georges Petit,
"100 Years of French Painting".
Venice, 17th Biennale,
"One man show of the Work of Amedeo Modigliani".
Zurich, Kunsthaus, "Modigliani".

1931
New York, Demotte Galleries, "Retrospective
Exhibition of Paintings by Amedeo Modigliani".
New York, Museum of Modern Art,
"Memorial Exhibition: The Collection of the late Lillie
P. Bliss".

Paris, Galerie Marcel Bernheim,
"Modigliani Retrospective".
Prague, "Exhibition of French Art".

1932
London, Lefevre Galleries, "Masterpieces by 20th
century French Painters of the Paris School".

1933
Brussels, Palais des Beaux-Arts, "Modigliani".

1934
Basle, Kunsthalle, "Modigliani".
New York, Museum of Modern Art,
"Machine Art"
New York, Museum of Modern Art,
"Modern Works of Art, Fifth Anniversary Exhibition".
Philadelphia Museum of Art, "Speiser Loan
Collection".

1935
Amsterdam, Stedelijk Museum,
"Exhibition of Modern French Art".
New York, Museum of Modern Art,
"Summer Exhibition".
Paris, Galerie Ernest de Frenne,
"Modigliani - Bonnard".
Paris, Musée du Petit Palais,
"Masterpieces from the Musée de Grenoble".
Northampton, USA, "The Bliss Collection".
Zurich, Kunsthaus, "Art from Abroad in Zurich".

1936
Belgrade, Prince Paul Museum,
"Modern French Painting".
Cambridge, Mass., Harvard University, Dunster
House, "Exhibition of Modern Paintings".
Detroit, Society of Arts and Crafts,
"Thirteen Paintings".
New York, Museum of Modern Art,
"New Acquisitions: Gift of Mrs John D. Rockefeller".
New York, Valentine Gallery,
"20th Century French Paintings".
Washington D.C., Studio House, "Fourteen Paintings".

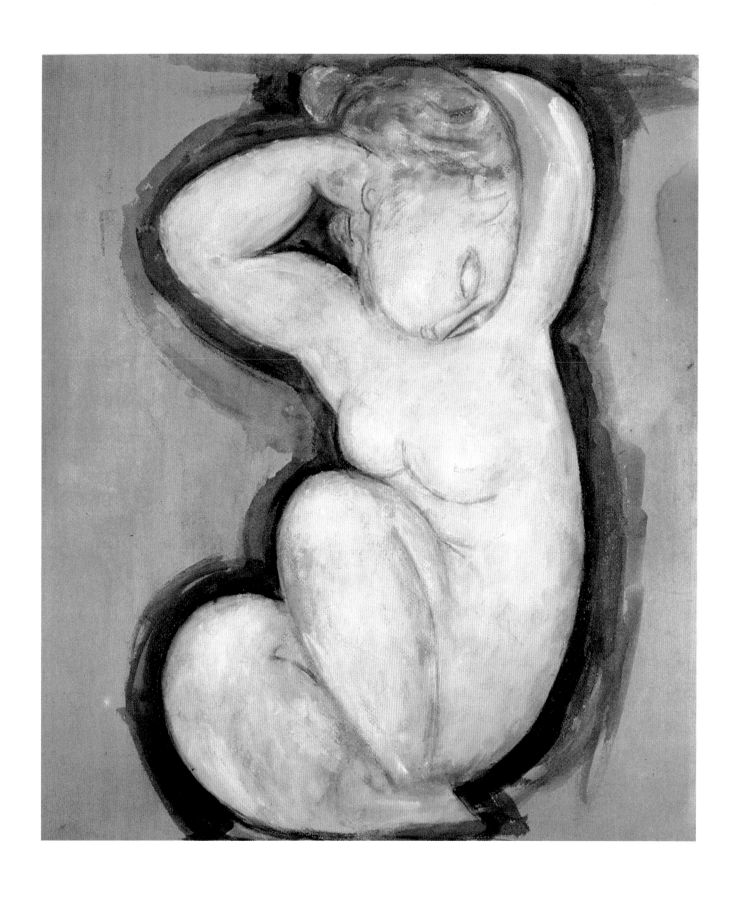

CARYATID, 1913.
Oil on board, 60 x 54 cm. Musée National d'Art Moderne, Centre Georges Pompidou, Paris.

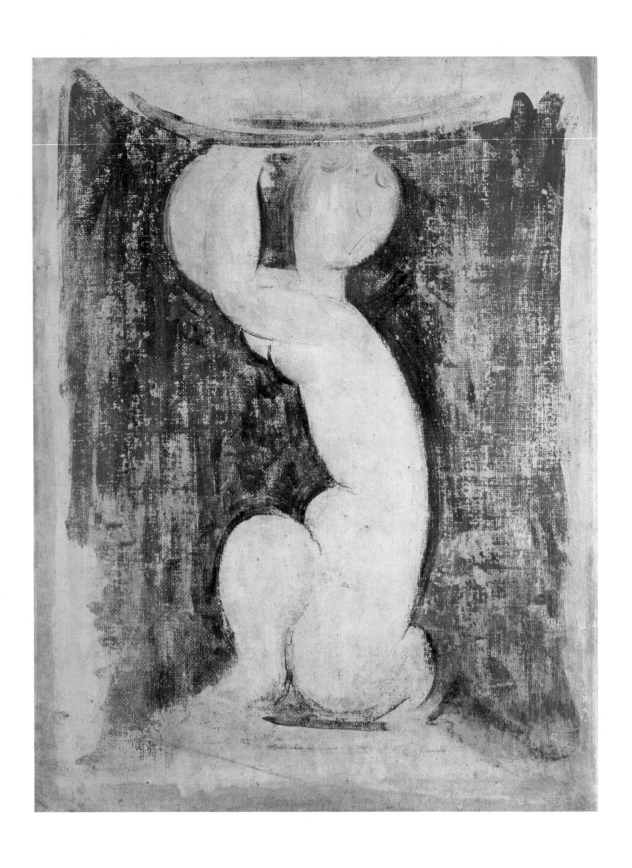

CARYATID, 1913.
Oils on board, 48 x 37 cm. Private collection.

1937
Paris, Musée du Petit Palais
"The Masters of The Independant School, 1895-1937"
Philadelphia, Museum of Art, "French Art".
Travelling exhibition organised by the M.O.M.A., N.Y.,
"Drawings by American and European Artists",
Sept. 1937-Sept. 1938.

1938
Boston, Museum of Fine Arts,
"20th Century Paintings from the Museum of Modern
Art, New York".
London, Reid and Lefevre Galleries,
"The Tragic Painters".
London, Arthur Tooth & Sons, "Amedeo Modigliani".
Montreal; Ottawa; Toronto,
"Paintings by French Masters, Delacroix to Dufy".

1940
New York, Museum of Modern Art,
"12 Favorites: Paintings selected by students from the
museum collection".
Zurich, Galerie Aktuaryus,
"Drawings and prints of Matisse and Modigliani".

1941
Detroit, Institute of Arts, Alger House,
"19th and 20th Century French Drawings".
Saint Louis, City Art Museum, "20th Century Art".

1942
New York, Museum of Modern Art,
"20th Century Portraits".
New York, Museum of Modern Art,
"Recent Acquisitions: Painting and Sculpture".
Portland, Art Museum,
"50th Anniversary of the Portland Art Association".

1943
USA: Iowa City; Nashville, Poughkeepsie; Amherst;
Palm Beach Wellesley; Tallahassee; Ithaca; St Paul,
"European and American Paintings",

Sept.1943 to Sept. 1944.
Paris, Galerie Berri,
"Petite Peinture, de 2 à 6".
Philadelphia,
"Paintings from the Chester Dale Collection".
Washington D.C., Phillips Memorial Gallery,
"East - West".

1944
Albany, N.Y, Institute of History and Art,
"Beauty and Art".
New York, Kleeman Galleries,
"Paintings and Drawings by Modigliani and Pascin".
New York, The American British Art Center,
"Amedeo Modigliani".
New York, Museum of Modern Art,
"20th Century drawings".

1945
Paris, Galerie Claude, "Modigliani and his Models".
Paris, Galerie de France, "Modigliani".

1946
Baltimore Museum of Art,
"Paintings from the Collection of the Museum of
Modern Art".
Milan, Associazione fra gli Amatori e i Cultori delle
Arte Figurative Contemporanee, "Modigliani".
Paris, Galerie Charpentier,
"100 Masterpieces of the Paris School".
Zurich, Kunsthaus,
"The Grenoble Museum and Library".

1949
Dallas, Museum of Fine Arts,
"The Winterbotham Collection of 20th Century
European Paintings".
New York, Museum of Modern Art,
"20th Century Italian Art".
Paris, Galerie Charpentier, "Childhood".
South America, travelling exhibition,
"Contemporary French Painting".

Adolphe Basler, 1914.
Crayon drawing, 29 x 21 cm. The Brooklyn Museum New York.

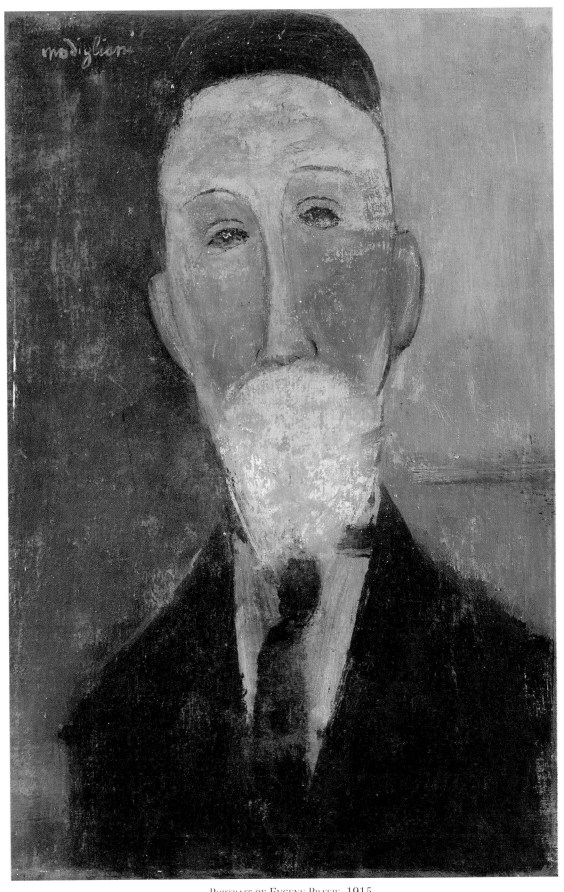

PORTRAIT OF EUGENE PRATJE, 1915.
Oil on canvas, 59.5 x 38.5 cm. Private collection.

1950
Amsterdam, Stedelijk Museum,
"Figures from Italian Art".
Brussels, Palais des Beaux-Arts,
"Contemporary Italian Art".
Lille, Musée des Beaux-Arts,
"Half a century of French Painting".
London, Edinburgh and Manchester,
"Contemporary Italian Art".
New York, Metropolitan Museum of Art,
"Summer Loan Show".
Paris, Musée National d'Art Moderne,
"Modern Italian Art".
Springfield, Mass., Museum of Fine Arts,
"In Freedom's Search".
Zurich, Kunsthaus,
"European Art from the 13th to the 20th century".

1951
Cleveland, Museum of Art, Jan.-March; New York,
Museum of Modern Art, April-June,
"Amedeo Modigliani".
London, Royal Academy of Arts,
"The Paris School, 1900-1950".
New York, Museum of Modern Art,
"New York Private Collections".
Rome, 6th Quadriennale Nazionale d'Arte,
"Amedo Modigliani".
Travelling exhibition, "45 Drawings from the
Collection of the Museum of Modern Art, New York",
April 1951-June 1955.

1952
Coral Gables, The Lowe Gallery, University of Miami,
"Exhibition of 19th and 20th Century French
Painting".
Paris, Musée des Arts Décoratifs, "50 years of French
Painting, from Private Collections".
Amsterdam and Brussels,
"100 Masterpieces from the Paris Musée National
d'Art Moderne".

1953
Berne, "European Art in Private Collections in Berne".

Palm beach, Norton Gallery and School of Art,
4th-28th Feb.; Coral Gables, Miami, Lowe Gallery,
11th-28th March, "French Painting - David to
Cézanne".

1954
Fort Worth, Texas, Art Center,
"Inaugural Exhibition".
Houston, Contemporary Arts Museum,
"Works of Modigliani".
New York, Fine Arts Associates, "Modigliani".
New York, Museum of Modern Art,
"Figures and Faces: Drawings from the Collection
of the Museum of Modern Art".
New York, Museum of Modern Art,
"25th Anniversary Exhibition: Paintings".
Palm Beach, Florida, Society of the Four Arts, Jan.;
Coral Gables, Miami, Florida, Lowe Gallery, Feb.,
"Amedeo Modigliani".
Paris, Galerie Bernheim Jeune,
"The Nude through the Ages".
Paris, Musée National d'Art Moderne,
"Drawing, from Toulouse-Lautrec to the Cubists".
Paris, Musée du Petit Palais,
"The Girardin Collection".
Travelling Exhibition organised by the Museum of
Modern Art, New York, "Figures and Faces: Drawings
from the Collection of the Museum of Modern Art,
New York".

1955
Antwerp, 3rd Biennale, "Sculpture in the Open Air".
Barcelona, Palacio de la Virreina,
Biennale of Hispano-American Art,
"Contemporary Italian Painting".
Berne, Kunsthalle, "Modigliani, Campigli, Sironi".
Buffalo, Albright Knox Art Gallery, N.Y.,
"Fifty paintings, 1905-1913".
USA: Chattanooga; Long Beach; Phoenix; Terre Haute;
"Modern Portraits", July 1955-Jan. 1956.
Chicago, The Art Institute,
"Drawings by Amedeo Modigliani from the Collection
of Mr and Mrs J.W. Alsdorf".
Kansas City, William Rockhill Nelson Gallery of Art

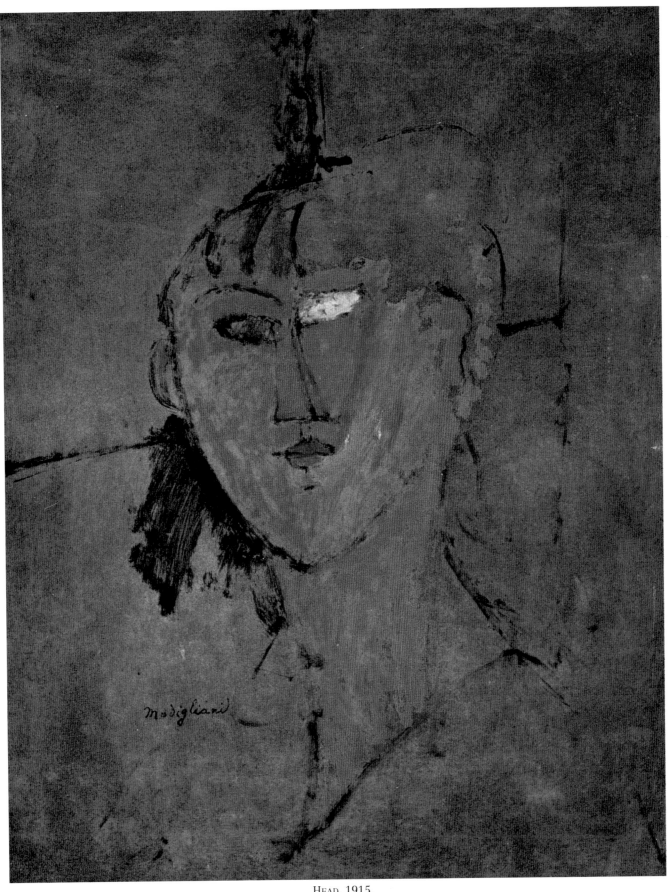

HEAD, 1915.
Oil on paper, 54 x 42 cm. Musée National d'Art Moderne, Paris.

and Mary Atkins Museum of Fine Arts,
"Contemporary Art by Jewish Artists".
Livorno, "Tribute to Modigliani".
Newport, Rhode Island, The Preservation Society.
Vevey, Musée des Beaux-Arts,
"Utrillo, Modigliani and Suzanne Valadon".

1956

Brussels, Palais des Beaux-Arts, "From Toulouse-Lautrec to Chagall: Drawings, Watercolours and Gouaches".
London, Tate Gallery,
"Modern Italian Art from The Estorick Collection".
New York, New Gallery,
"Drawings by Modigliani and Pascin".
New York, Perls Galleries,
"Modigliani: The Sidney G. Biddle Collection".
Tournai, "Masters of Contemporary Art".
Valenciennes, Dijon, Besançon, Strasbourg and Rheims,
"Fifty Masterpieces from the Musée d'Art Moderne", April 1956-Jan. 1957.
New Haven, Yale University Art Gallery,
"Pictures collected by Yale Alumni".
Yverdon,
"Fifty Sculptures by Painters - from Daumier to Picasso".

1957

Basle, Kunsthalle, "Basle Private Collections".
Berlin, Hochschule für Bildende Kunste,
"20th Century Italian Art".
Brussels, Bibliothèque Royale de Belgique,
"Frans Hellens".
Cardiff, National Museum of Wales; Plymouth, City Museum and Art Gallery; Birmingham, City Museum and Art Gallery,
"Modern Italian Art from the Estorick Collection".
Marseille, Musée Cantini,
"50 Contemporary Masterpieces".
Messina, "Italian Sculpture of the Novecento".
Munich, Haus der Kunst,
"Modern Italian Art".
New York, Perls Galleries,

"Fifteen Major Selections".
New York, Knœdler & Co.; Cambridge, Mass., Fogg Art Museum,
"Modern Painting, Drawing and Sculpture".
New York, Knoedler & Co., 3 Dec. 1957-18 Jan. 1958; Ottawa, National Gallery of Canada, 5 Feb.-2 March; Boston, Museum of Fine Arts, 15 March-20 April, "Paintings and Sculptures from the Niarchos Collection".
San Antonio, Marion Koogler McNay Art Institute,
"Amedeo Modigliani".

1958

Amherst, Amherst College, Mead Art Building, "20th Century European Painting".
Brussels, The World Fair,
"50 Years of Modern Art".
Columbus, Gallery of Fine Arts,
"The Adelaide Milton de Groot Collection".
Dallas, Museum for Contemporary Arts,
"Signposts of 20th Century Art", Oct.-Dec.
Houston, Museum of Fine Arts, "The Human Image".
Canada: Hamilton, Jan.; London, Feb.; Ottawa, March; Quebec, April; Winnipeg, May-June; Regina July-August, Travelling exhibition, organised by the Museum of Modern Art, New York.
London, Tate Gallery,
"The Niarchos Collection of Paintings".
Marseille, Musée Cantini, "Modigliani".
Metz; Nancy, "Painting from 1905 to 1914".
Milan, Palazzo Reale, "Amedeo Modigliani".
New York, Chalette Gallery, "Sculptures by Painters".
New York, Perls Galleries, "Masterpieces from the Collection of Adelaide Milton de Groot".
Oakland, Art Museum,
"Vincent Price Collects Drawings".
Paris, Galerie Charpentier,
"Fifty Pictures by Modigliani".
Pasadena, Art Museum,
"20th Century Italian Art".
Rheims; Bar-le-Duc; Brive-la-Gaillarde,
"Contemporary Drawings".
Staten Island, N. Y.,Staten Island Museum,
"A Chosen Few".

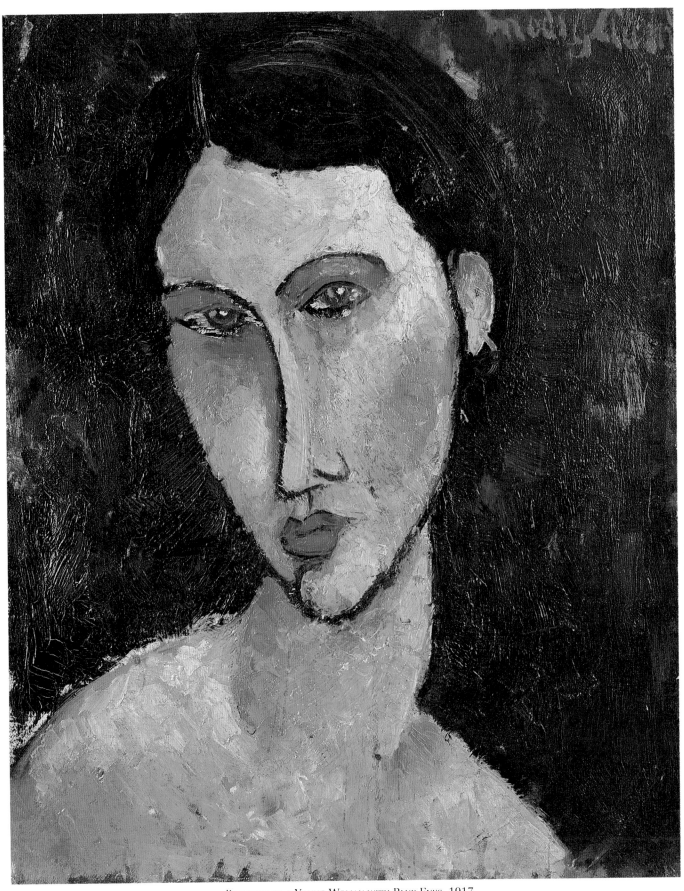

PORTRAIT OF A YOUNG WOMAN WITH BLUE EYES, 1917.
Oil on canvas, 41 x 33 cm. Private collection.

1959

Blois, Château Museum, "Italian Painters and Sculptors".

Charleroi, Palais des Beaux-Arts; Ixelles, Musée des Beaux Arts; Tournai, Musée des Beaux Arts; Luxembourg, Musée des Beaux Arts, "From Maillol to the Present Day", Sept. 1959-Feb. 1960.

Chicago, The Arts Club, Jan-Feb.; Milwaukee, Art Center, March-April, "Amedeo Modigliani".

Cincinatti, The Contemporary Arts Center, Cincinatti Art Museum, "Amedeo Modigliani".

Hamburg, Kunsthalle, "20th Century French Drawings".

Madrid, National Library, "Sephardim".

Paris, Musée National d'Art Moderne, "The Paris School, in Belgian Collections".

Rome, Galleria Nazionale d'Arte Moderna, "Amedeo Modigliani".

Zurich, Kunsthaus, "The S. Niarchos Collection".

1960

Atlanta Art Association, "The Art of Amedeo Modigliani".

Houston Museum of Fine Arts, "From Gauguin to Gorky".

Milan, Palazzo Reale, April-June; Rome, Galleria Nazionale d'Arte Moderna, July-Sept., "20th Century Italian Art in American Collections".

Minneapolis, Minn.; Manchester, N.H.; Exeter, N.H.; Louisville, Ky.; Lincoln, Mass.; Ithaca, N.Y.; Cincinnati, Oh.; Omaha, Neb.; Columbus, Oh.; Providence, R.I.; Madison, Wis.; York, P.A.; San Antonio, Cal.; Tacoma, Wash.; Garden City, N.Y.; Brunswick, Me.; Greensboro, Nc.; Macon, Ga.; Tampa, Florida, "Portraits from the Collection of The Museum of Modern Art, New York", Nov. 1960-Feb. 1964.

New York, Museum of Modern Art, "Portraits from the Museum Collection".

New York, Museum of Modern Art, "Recent Acquisitions: Drawings and Watercolours".

Nice, Musée Massena, "Paintings in Nice and on the Cote d'Azur, 1860-1960".

Paris Musée National d'Art Moderne, "Sources of the 20th Century".

Paris, Musée Rodin, "Contemporary Italian Sculpture".

Quimper; Rennes; Bourges; Dijon, "French drawing from Signac to Abstract Art."

1961

Amsterdam, Stedelijk Museum; Recklinghausen, Kunsthalle, "Polarity: The Apollonian and Dyonisian Sides to Fine Art".

Boston, Museum of Fine Arts, Jan.-Feb.; Los Angeles, County Museum, March-April, "Modigliani, Paintings and Drawings".

Cambridge, Harvard University, Fogg Art Museum, "Works of Art from the Collections of the Harvard Class of 1936".

New Haven, Yale University Art Gallery, "Paintings and Sculptures from the Albright Knox Art Gallery".

Tokyo, Nov. 1961-Jan. 1962; Kyoto, 25 Jan.- 15 March, "French Art, 1840-1940".

Wolfsburg, Stadthalle, "French Art from Delacroix to Picasso".

1962

London, Hanover Gallery, "Matisse and Modigliani".

New York, Metropolitan Museum of Art, "Summer Exhibition".

New York, Museum of Modern Art, "Fifty Drawings: Recent Acquisitions".

New York, Wildenstein Gallery, "Modern French Painting".

Paris, Galerie Charpentier, "19th and 20th Century Masterpieces from French Collections".

Paris, Galerie Max Kaganovitch, "A Selection of 20th Century works".

1963

Düsseldorf, Kunsthalle, "20th Century Art, First Comprehensive Exhibition of Work from the Nordrhein-Westfalen Collection".

Edinburgh, Scottish Royal Academy: London, Tate

LOLOTTE, 1917.
Oil on canvas, 55 x 35.5 cm.
Musée National d'Art
Moderne,
Centre Georges Pompidou,
Paris.

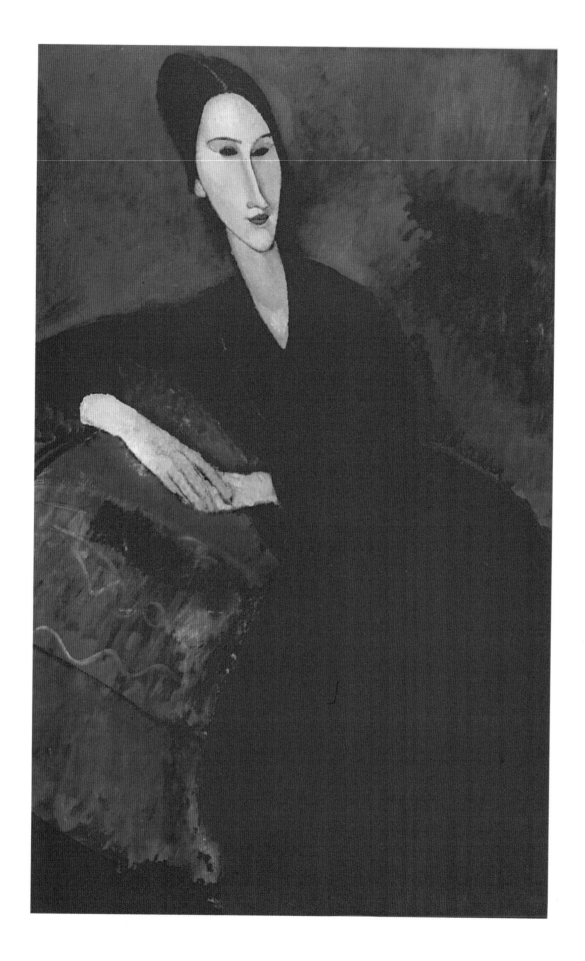

PORTRAIT OF MADAME ZBOROWSKA,
1917.
Oil on canvas, 130.2 x 81.3 cm.
Museum of Modern Art, New York.

206

Gallery, "Modigliani".
Frankfurt, Steinernes Haus Romerberg,
"A. Modigliani".
New York, Perls Galleries, "Amedeo Modigliani".

1964
Berlin, Akademie der Künste,
"Beginnings of Modern Art".
Bordeaux, Musée des Beaux-Arts,
"Woman and the Artist, from Bellini to Picasso".
Denmark, Humlebaek, Louisiana Museum
"Drawings from the Musée National d'Art Moderne,
Paris".
Lausanne, Palais de Beaulieu, "Masterpieces in Swiss
Collections from Manet to Picasso".
Northampton, Smith College Museum of Art, "The
Freddy and Regina T. Homburger Collection".
Paris, Musée National d'Art Moderne, "The André
Lefèvre Collection".
Toledo, Museum of Art, "The Collection of Mrs C.
Lockhart McKelvie".

1965
Birmingham, Museum and Art Gallery; London,
Marlborough Fine Arts Ltd,
"19th and 20th Century French Paintings from
English
Private Collections".
Brussels, Musée des Beaux-Arts, 5-24 Jan.; Mons,
Musée des Beaux-Arts, 11-26 Feb.,
"Half a Century of Franco-Belgian Literary and
Artistic Links".
Duisburg, Wilhelm Lehmbruck Museum, "Parisian
Encounters, 1904-1914".

1966
Montrouge, Draeger Printing Co.,
"80 Years of Draeger".
New York, Perls Galleries, "The Nudes of Modigliani".
Paris, Musée des Arts Décoratifs, "The Twenties",
Paris, Orangerie des Tuileries,
"The Jean Walter - Paul Guillaume Collection".
Montreal,
"International Exhibition of Fine Arts".

Paris, Orangerie des Tuileries, "Masterpieces in Swiss
Collections from Manet to Picasso".

1968
Buenos Aires, Museo Nacional de Bellas Artes;
Santiago, Museo de Arte Contemporaneo de la
Universidad de Chile; Caracas, Museo de Bellas Artes,
"Cézanne to Miro", April-Sept.
Saint Louis, City Art Museum,
"Works of Art of the 19th and 20th Century, collected
by Louis and Joseph Pulitzer Jnr.".
Southfield, Michigan, Shaarey Zedek Congregation,
"Works by Jewish Artists".
Tokyo, Seibu Gallery, May-June; Kyoto, National
Museum of Modern Art, June-August,
"Modigliani".
Utrecht, "Works of Modigliani in
Netherlands Collections".
Washington D.C., National Gallery of Art,
"Paintings from the Albright Knox Art Gallery".
Washington D.C., National Gallery of Art; New York,
Metropolitan Museum of Art; Boston, Museum of Fine
Arts, "Painting in France, 1900-1967".
Wuppertal, Kunst und Museumsverein,
"Exotic and Modern Art".

1969
Bourges, Maison de La Culture,
"A Painter's Pleasures".
Buenos Aires, "The Albright Knox Art Gallery".
Cairo; Teheran; Athens; Ankara; Istanbul,
"French Painting from Signac to Surrealism".

1970
Indianapolis, Museum of Art,
"Treasures from the Metropolitan Museum of Art".
Livorno, Villa Fabbricotti, "Amedeo Modigliani,
Exhibition for the 50th Anniversary of his death:
300 visual documents of the life, works and
friends of the painter".
New York, Metropolitan Museum of Art,
"Masterpieces of Fifty Centuries".
Paris, Grand Palais, "Salon des Indépendants".
Tours, Comédie de La Loire.

1971
Auckland, City Art Gallery, 7 Sept-17 Oct. 1971;
Melbourne, National Gallery of Victoria,
11 Nov. 1971-2 Jan. 1972; Sydney,
Farmer's Boxland Gallery, Jan.-Feb. 1972,
"From Cézanne through Picasso: 100 Drawings from
the Collection of the Museum of Modern Art,
New York".
Brussels, Crédit Communal de Belgique,
"African Art - Modern Art".
Cambridge, Harvard University, Fogg Art Museum,
"Selections from the Collection of Freddy and
Regina T. Homburger".
Maline, Cultureel Centrum,
"The Human Figure in Art 1910-1960".
New York, Acquavella Galleries,
"Amedeo Modigliani".
Tel Aviv, Tel Aviv Museum,
"Great French Painters of the 20th Century".
Tokyo, National Museum of Western Art,
1 May-10 June; Kurume, Ishibashi Museum,
1 July-1 August,
"From Cézanne through Picasso: 100 drawings
from the collection of the Museum of Modern Art,
New York".

1972
Innsbruck, Tiroler Landesmuseum Ferdinandeum,
"After 1900".
Honolulu, Academy of Arts, Feb.-March; San
Francisco,
California Palace of the Legion of Honor, April-June,
"From Cézanne through Picasso: 100 drawings from
the Museum of Modern Art, New York".
Munich, Haus der Kunst,
"World Culture and Modern Art".
Palm Beach, Flo.; Athens, Ge.; San Antonio, Tex.;
Champaign, Ill.; Little Rock, Ark.,
"20th Century Portraits", Jan.-Dec.

1973
Milan, Rotonda, "Drawings by European Artists in the
Museum of Modern Art, New York".
Otterlo, Kroller-Muller Rijksmuseum,

"One hundred Drawings from the Museum of
Modern Art, New York".
Paris, Galerie Schmit,
"Pictures by French Masters, 1900-1955".
Sheffield, Graves Art Gallery,
"One Hundred European Drawings from the Museum
of Modern Art, New York".
Tokyo, The National Museum of Modern Art, Sept.-Nov.;
Kyoto, National Museum of Modern Art, Nov.-Dec.,
"Paris and Japan in the History of Modern Art".
Zurich, Kunsthalle, "100 Years of Dealing in Art".

1974
Lille, Musée des Beaux Arts, "100 Years of French
Painting in Northern Collections".
Lisbon, Calouste Gulbenkian Foundation,
"100 European Drawings from the Museum of
Modern Art, New York".
London, Tate Gallery, "Picasso to Lichtenstein,
Masterpieces of 20th Century Art, from the
Nordrhein-Westfalen Collection, Dusseldorf".
New York, Museum of Modern Art,
"Seurat to Matisse: Drawing in France".
Paris Musée National d'Art Moderne,
"Drawings from the Musée National d'Art Moderne".
Travelling French Exhibition, Turkey -
Czechoslovakia.

1975
Berne, Kunstmuseum, "10 Years' Acquisitions".
Ingelheim, "Mexican Days".
La Rochelle, Musée des Beaux Arts,
"20th Century Drawings in the Musée de Grenoble".
Leningrad, The Hermitage; Moscow, The Pushkin
Museum, "100 Paintings from the Metropolitan
Museum".
London, Hayward Gallery, "Pioneers of Modern
Sculpture", July-Sept.
New York, Perls Galleries,
"30 Major Acquisitions".
Paris, Musée Jacquemart André,
"The Bateau-Lavoir - Cradle of Modern Art".
Sochaux, Maison des Arts et Loisirs,
"Thirty-three Drawings from the Musée National d'Art

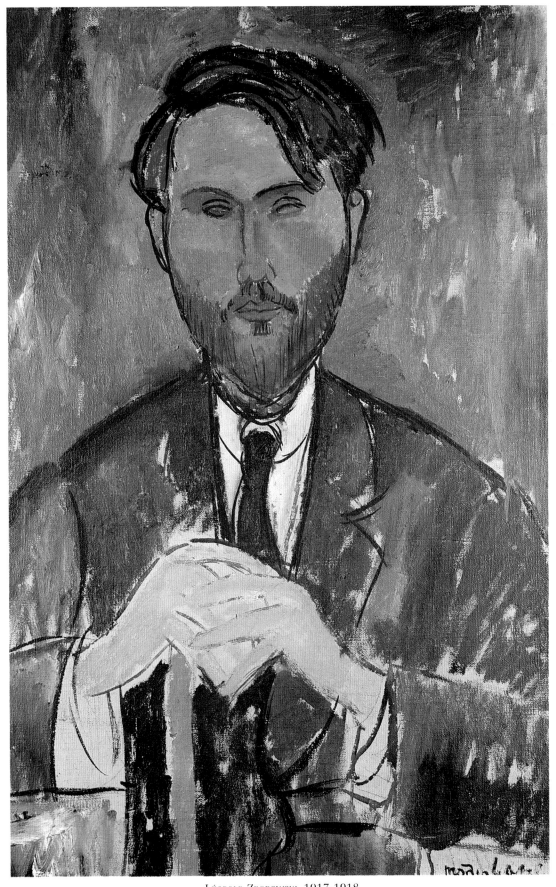

Léopold Zborowski, 1917-1918.
Oil on canvas, 73 x 50 cm. The Samir Traboulsi collection, Paris.

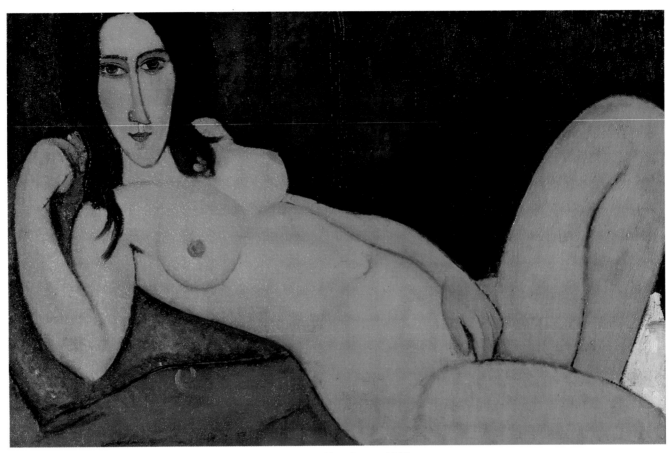

NUDE WITH HER HAIR DOWN, 1917.
Oil on canvas, 100 x 65 cm. Osaka City Museum.

Moderne", May-June.
Sydney, Art Gallery of New South Wales; Melbourne,
National Gallery of Victoria; New York, Museum of
Modern Art, "Modern Masterpieces", April - Nov.
Zurich, Kunsthaus, "Naive Painters".

1976
Detroit, Institute of Arts, "Arts and Crafts in Detroit:
The Movement, The Society, The School".
Malines, Cultureel Centrum,
"Art in Europe, 1920-1960, a Comparison".
Paris, Musée National d'Art Moderne,
"Portraits and Masks".
Troyes, Hôtel de Ville,
"Discovering the Pierre Lévy Collection".

1977
Berne, Kunsthalle, "The Hadom Collection".
Geneva, Musée Rath, "From Futurism to Spacialism -

Italian Painting of the First Half of the 20th Century".
New York, Museum of Modern Art,
"The School of Paris: Drawing in France".
Paris, Galerie N.R.A., Modigliani Drawings".
Paris, Musée National d'Art Moderne, Centre Georges
Pompidou, Drawings Room,
"The Musée National d'Art Moderne, 1971-1976".
Tokyo (Mitsukoshi); Osaka (Mitsukoshi),
"The Bateau-Lavoir".
Troyes, Hôtel de Ville, "Pierre Levy Bequest".
Zurich, Kunsthaus, "Perfection and Imperfection".

1978
Besançon, Musée des Beaux-Arts,
"Mondrian and his Friends".
Ghent, Musée des Beaux-Arts, "The Bateau-Lavoir".
New York, Museum of Modern Art,
"A Treasury of Modern Drawings,
the Joan and Lester Avnet Collection".

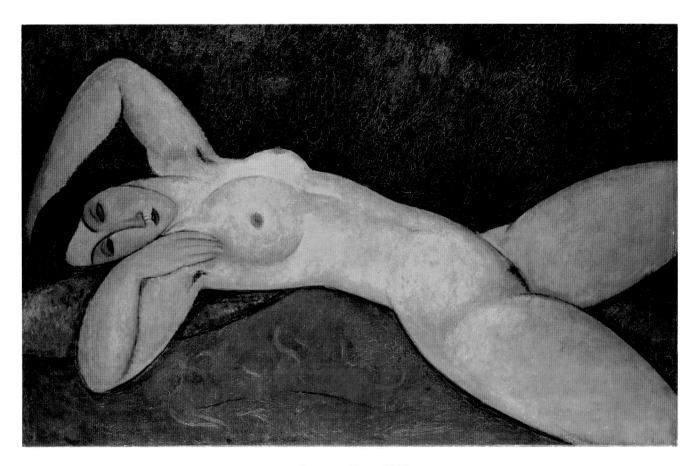

RECLINING NUDE, 1917.
Oil on canvas, 72 x 117 cm. Private collection.

New York, Solomon R. Guggenheim Museum,
"The Evelyn Sharp Collection".
Oxford, Museum of Modern Art, 2 July-13 August;
Norwich, Castle Museum, 19 August-1 Oct.;
Manchester, Whitworth Art Gallery, 7 Oct. - 11 Nov.;
Coventry, Herbert Art Gallery and Museum,
18 Nov.-31 Dec.,
"Paintings from Paris".
Paris, Musée du Grand Palais,
"Modern Art in Provincial Museums".
Paris, Musée Jacquemart-André,
"La Ruche and Montparnasse".
Paris, Musée du Louvre, "Picasso Bequest -
Picasso's Personal Collection".
Paris, Musée National d'Art Moderne,
Centre Georges Pompidou, "Lipchitz".
Paris, Orangerie des Tuileries,
"The Pierre Levy Bequest".
Tokyo (Mitsukoshi); Osaka (Mitsukoshi); Sapporo

(Mitsukoshi); Nagoya (Mitsukoshi),
"La Ruche - The Paris School", 15 August-4 Dec.
Turin, Galeria Pirra,
"Modigliani The Unknown".

1979
Alexandria, Pinacoteca Civica,
"Amedeo Modigliani, Drawings".
Leningrad, The Hermitage;
Moscow, The Pushkin Museum,
"French Painting, 1909-1939", 1 Sept.-18 Dec.
Oklahoma City, Museum of Art,
"Masters of the Portrait".
Paris, 15th Arrondissement Town Hall,
"The Paris School in the 15th Arrondissement".

1979
Paris, Musée d'Art Moderne de la Ville de Paris;
Ixelles, Museum, "Tribute to Pierre Loeb".

PORTRAIT OF "J", 1916.
Mixed technique on board, 28 x 21 cm. Private collection.

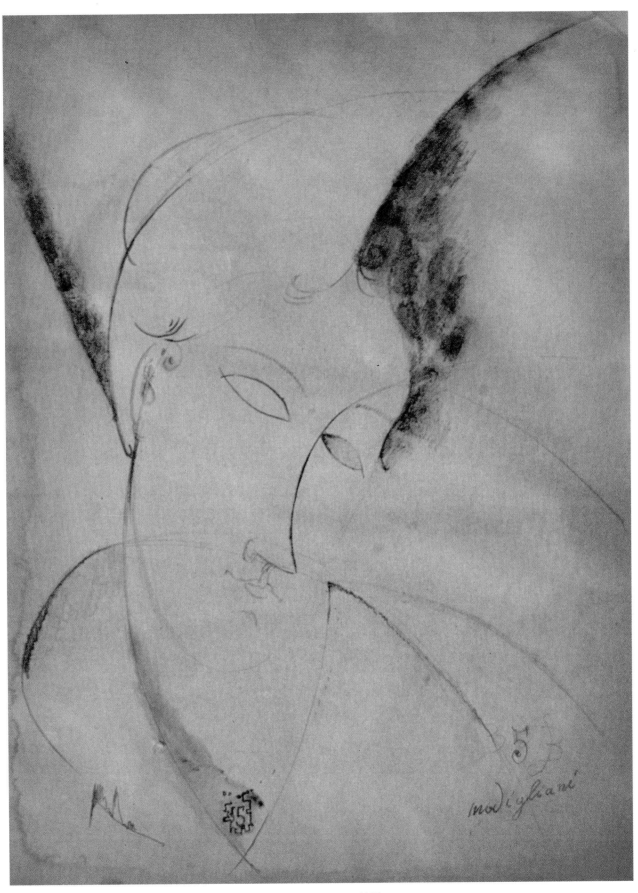

BÉATRICE HASTINGS, 1916.
Gouache on board, 24,5 x 31 cm. Private collection.

Paris, Musée National d'Art Moderne,
Centre Georges Pompidou, "Paris-Moscow,
1900-1930".
Tokyo, Idemitsu Museum,
"A. Malraux and Japan the Eternal".
Tokyo (Daimaru); Osaka (Daimaru),
"Modigliani: Love and Nostalgia for Montparnasse".
Travelling Exhibition in Japan, "Masterpieces of the
Paris Museums", May- Sept. 1980
Athens, Pinakothek, Alexander Soutzos Museum,
"Impressionists and Post-Impressionists in French
Museums, from Manet to Matisse".
Liège, Musée Saint-George, "Modigliani".
Montauban, Musée Ingres, "Ingres and Posterity".
Paris, Galerie Daniel Malingue,
"Impressionist and Modern Masters".
Paris, Hôtel de Ville,
"Treasures from the Museums of Paris".
Paris, Musée du Luxembourg,
"The Geneviève and Jean Masurel Gift
to the Town of Lille".
Paris, Musée National d'Art Moderne, Centre Georges
Pompidou, "Realism, 1919-1939".
Tokyo Art Salon,
"Modigliani, Utrillo, Kisling", exhib. organised by the
Nichido Museum Foundation and the Tokyo Shimbun.
Paris, Grand Palais, "From the Bible to the Present
Day".

1986
Livorno, the Modigliani family house,
"Modigliani", (drawings).

1987
Tokyo, Sogo Gallery, "Masterpieces of Italian
Painting".
1988
Livorno, the Modigliani family house,

"Modigliani", (drawings).
Verona, Palazzo Forti, "Modigliani in Montparnasse".
Kasama (Japan), Kasama Nichido Museum of Art,
"Modigliani and his Friends".
Kawasaki (Japan), Municipal Museum of Modern Art,
"The Great Montparnasse Adventure".
Travelling exhibition in Japan.

1989
Paris, Salon du Vieux Colombier, Carrefour-Vavin,
"Portraits and Landscapes owned by Zborowski".
Paris, Didier Imbert Fine Art,
"Paris, Capital of the Arts".
Venice, Palazzo Grassi, "Italian Art, 1900-1945".
Tokyo, Takashimaya Gallery,
"Paris, Home of the Foreign Painter",
(paintings, drawings and documents from the
A.M.O.A.),
Travelling exhibition in Japan until 24 June 1990:
Sendai; Nagoya; Yokohama; Kyoto; Osaka; Oita.
Paris, Musée Jacquemart-André,
"Europe of the Great Masters",
(sculptures, paintings and drawings).
Paris, Musée de Montmartre, "Modigliani",
(drawings and documents from the A.M.O.A.).

1990
Orléans, Musée des Beaux-Arts d'Orléans,
"Modigliani",
(drawings and documents from the A.M.O.A.).
Ferrara, Palazzo dei Diamante,
(drawings and documents from the A.M.O.A.).
Martigny, Pierre Gianadda Foundation, "Modigliani'.
Florence, French Institute, 18 Oct.-Nov.,
(drawings and documents from the A.M.O.A.).

A.M.O.A.: Amedeo Modigliani Official Archives.

SEATED YOUNG WOMAN, 1918.
Oil on canvas, 92 x 60 cm.
Musée Picasso, Paris.

Comparative chronology

	LIFE OF MODIGLIANI	CULTURAL EVENTS
1884	Livorno, 12th July, birth of Amedeo, fourth and youngest child of Flaminio Modigliani and Eugénie Garsin, descendants of Sephardic Jews long established in Italy.	Friedrich Nietsche publishes *Thus Spake Zarathustra.* First *Salon des Indépendants* takes place in Paris.
1887		Art Nouveau first coined as a term in Belgium.
1889		Paris. The Universal Exhibition: Eiffel's triumphant success. Emile Gallé and Art Nouveau recognised as a style.
1891		First exhibition by the Nabis.
1892		The Master of Aix, Paul Cézanne, paints *Mont Sainte-Victoire* and *The Bathers* and sparks off the beginnings of Modern Art.
1894		Gustave Caillebotte's legacy: 65 Impressionist canvases, some turned down by the Musée du Luxembourg.
1895	Livorno. Winter. First attack of pleurisy soon after enrolment at the Lycée.	
1898	Livorno. Summer. Evinces early desire to paint. Enrols on the 1 August at the Guglielmo Micheli School of Drawing and Painting. Second attack of ill health at the end of this month, typhoid fever with pulmonary complications. Leaves the Lycée.	Paris, 6th April. Birth of Jeanne Hébuterne.
1900		Paris. Picasso, Georges Braque and Raoul Dufy arrive in the city.

LIFE OF MODIGLIANI	CULTURAL EVENTS	
	Paris. Monet Exhibits his first *Nymphs*. Italy. D'Annunzio elected	1900
Further pulmonary attack. Modigliani leaves Livorno for good. Convalescent trip with his mother to Naples, Amalfi, Capri, Rome and Florence. Discovers Italian art treasures and is stimulated by the big cities.	France. Foundation of the Nancy School by Victor Prouvé, Emile Gallé, Majorelle and Daum. Paris. Picasso exhibits at Ambroise Vollard's. Fiesole. Death of the painter Arnold Böcklin.	1901
Florence. Enrols at the *Scuola Libera di Nudo* of the *Accademia di belle Arte* under Giovanni Fattori, leader of the Tuscan Macchiaiolian School.	Brussels. Toulouse-Lautrec retrospective at the Exposition de la Libre Esthétique. Paris. Picasso, Matisse and Marquet exhibit at the Berthe Weill Gallery. Monet shows new views of Vétheuil at Bernheim's.	1902
Venice. Enrols at the *Scuola Libera di Nudo*. Meets Ortis de Zarate. Discovers European Modern Art trends at the Venice Biennale. Probably visits England.	Paris. First *Salon d'Automne*, organised by Frantz Jourdain at the Petit-Palais. Death of Paul Gauguin in the Marquesa Islands. Paul Gauguin exhibition at Ambroise Vollard's.	1903
	Paris. Exhibition of the "English" works of Claude Monet. Cézanne's triumphant success at the *Salon d'Automne*	1904
	Paris. The "Cages aux Fauves" (the Fauves room at the *Salon d'Automne*). Maurice de Vlaminck discovers Negro art in a café in Argenteuil. Dresden. Foundation of Die Brücke.	1905
Paris. End January - beginning February. Comes to Paris. Stays in hotel at the Madeleine, then in a studio in the 'Maquis'	Paris. The "Cages aux Fauves" (the Fauves room at the *Salon d'Automne*). Maurice de Vlaminck discovers Negro art in	1906

LIFE OF MODIGLIANI	CULTURAL EVENTS
near the Bateau-Lavoir. Enrols at the *Académie Colarossi*, founded by the Italian sculptor at the end of the 19th century.	a café in Argenteuil. Dresden. Foundation of *Die Brücke*.
1907 Paris. Exhibits 7 works in the Salon d'Automne, where he discovers Cézanne. Meets Dr Paul Alexandre. Becomes friends with Maurice Utrillo, Paints at 7, rue du Delta (artists' commune created by Paul Alexandre) and at the *Couvent des Oiseaux*, rue de Douai.	Picasso paints *Les Demoiselles d'Avignon* at the Bateau-Lavoir. Khanweiler opens his gallery at 26, rue Vignon. Marcel Duchamp, first *Salon des Artistes Humoristes*. Vienna. Gustave Klimt paints *Danœ*.
1908 Paris, Exhibits 6 works (including *The Jewess*) in the Fauves room at the *Salon des Indépendants*.	The critic Louis Vauxcelles talks of "Little Cubes". Birth of "Cubism". Montmartre. Bateau-Lavoir banquet given for Le Douanier Rousseau by Picasso.
1909 Livorno. Summer with the family. Paints the *Beggarman*, influenced by Cézanne. Paris. Studio at 14, cité Falguière. Meets Brancusi and sculpts with him. First portrait of Dr Alexandre. Refuses to sign the Futurist Manifesto, drawn up by his compatriot, Marinetti. Also works at La Ruche, in the passage Dantzig, in rue Boissonnade and at 7, Place Jean-Baptiste Clément.	Paris. The Futurist Manifesto appears in the Figaro of 20 February. Picasso leaves the Bateau-Lavoir for a bourgeois building in the Boulevard de Clichy. First exhibition of his works in Munich. Piet Mondrian paints *The Red Tree*.
1910 Paris. 6 works in the *Salon des Indépendants*, including the *Beggarman* and the *Beggarwoman*, all painted in Livorno and strongly influenced by Cézanne. Favourable reviews. Visits the Matisse Exhibition and the Musée Ethnographique. Concentrates on sculpture at the Cité Falguière.	Paris. First Georges Rouault exhibition, Druet gallery. Steinlen illustrates *La Chanson des Gueux* by Jean Richepin. Marc Chagall arrives in Paris. Publication of the Futurist Manifesto in Italy. Death of Le Douanier Rousseau.
1911 Paris. Exhibition of sculptures and gouaches in the studio of Souza Cardoso. Modigliani visits Yport with his aunt Laure. Is living at 39, passage de L'Elysée des Beaux-Arts.	Munich. Foundation of the *Blauer Reiter* (Blue Rider) movement. Publication of Kandinsky's *Du spirituel dans l'art*. Paris. Arrival of Giorgio de Chirico.

LIFE OF MODIGLIANI	CULTURAL EVENTS	
Livorno. Summer. Unable to communicate with old painting friends. Paris. Meets Jacques Lipchitz, Jacob Epstein and Augustus John. Exhibits at the 10th Salon d'Automne: *Heads*.	Paris. Arrival of Chaïm Soutine. First Futurist exhibition at Bernheim Jeune. Egon Schiele, 22 years old, imprisoned for pornography. London. First Picasso exhibition in England.	1912
Paris. Meets the dealer Chéron. Paints in the basement of the gallery in Rue la Boétie. Becomes friends with Chaïm Soutine. Begins the *Caryatids* cycle. Works at 216, boulevard Raspail.	Paris. Arrival of Tsuguharu Fujita. Guillaume Apollinaire publishes "The Cubist Painters". New York. America discovers Modern Art at the Armory Show. Russia. Start of Suprematism.	1913
Paris. War is declared and Paul Alexandre is called up, never to be seen again by Modigliani. Max Jacob introduces him to Paul Guillaume who manages his sales until 1916. A difficult period. Modigliani lives for a while with Diego Rivera at 16, rue du Saint Gothard. Beginning of affair with Beatrice Hastings. Starts to paint again. Many portraits of Beatrice. Studio at 13, rue Ravignan, then at 53, rue du Montparnasse.	New York. First Brancusi exhibition at Gallery 291. Rome. "Probitas", the anti-Futurist Group exhibition. Barcelona. Opening of Güell Park, designed by Gaudi.	1914
Paris. He gives up sculpture. His painting takes off as a result of his sculpting.	Russia. Suprematism Manifesto, by Kasimir Malevitch. In the war, Braque receives a serious head wound.	1915
Paris. Exhibits in the studio of Emile Lejeune at 6, rue Huyghens (15 paintings and 3 sculptures). Léopold Zborowski, exiled Polish poet, admires his work and becomes his dealer. Returns to painting for good. First of the nudes.	Zurich. Dadaist Exhibition. Cabaret Voltaire. Berlin. First Max Ernst Exhibition (*Der Sturm*). Paris. Death of Odilon Redon. Guillaume Apollinaire is wounded and undergoes trepanning operation.	1916
Paris. Modigliani works at Zborowski's, at 3, rue Joseph-Bara. Sells him his work for a retainer of 15 francs a day. Series of portraits and nudes.	Paris. Death of Auguste Rodin. Death of Edgar Degas. First Fujita Exhibition at the Galerie Chéron. André Masson seriously wounded at the	1917

LIFE OF MODIGLIANI	CULTURAL EVENTS
1917 In March meets Jeanne Hébuterne, a young pupil at the *Académie Colarossi*. Zborowski rents them a studio at 8, rue de la Grande-Chaumière. Modigliani shows one work at the Dada Gallery in Zurich. The exhibition at the Berthe Weill Gallery is closed down on Private Viewing day, in response to public outrage.	Chemin des Dames, while Braque returns to Paris after a long convalescence.
1918 Paris. Deterioration of Modigliani's health. Leaves for Nice in March with Zborowski and his wife. Nice. Giovanna, the daughter of Modigliani and Jeanne Hébuterne is born on 29 November. They stay in Cagnes with Fujita and his wife, Soutine, Jeanne's mother and the Zborowskis. Modigliani paints 4 landscapes in Cagnes. Paris. Paul Guillaume organises an exhibition in his gallery of the works of young artists: Picasso, Matisse and Modigliani.	Paris. Death of Guillaume Apollinaire. Paris. Opening of the Paul Rosenberg gallery in rue La Boétie. Barcelona. First Joan Miro exhibition at the Dalman gallery. Paris. Degas' *Dancers* sells for a record price of 132,000 francs. Paris. Birth of the Purism of Le Corbusier and Ozenfant.
1919 Amedeo returns on 31 May, Jeanne a month later, once more pregnant. They go back to the rue de la Grande-Chaumière. London. "Modern French Art", exhibition organised by Zborowski and Sitwell Brothers. Paris. Exhibition of four paintings at the *Salon d'Automne*. First review by Francis Carco in the Geneva *Eventail.* Modigliani paints his last female portrait, little Paulette Jourdain.	Cagnes. Death of Renoir on 3 December. Milan. The National Futurist Exhibition solidifies the movement. Rome. First one-man exhibition of de Chirico at the Bragaglia Gallery. Paris. Important Matisse exhibition at the Bernheim-Jeune Gallery. Germany. Founding of the Bauhaus.
1920 Paris. Paints the *Portrait of Mario Varvogli* and the *Self-Portrait*, which are probably the painter's last two works. Taken to the Charité hospital on Thursday 22 January. Dies of tubercular meningitis on Saturday 24 January, without ever really	Paris. First Dadaist Morning at the Palais des Fêtes. Charles-Édouard Jeanneret (Le Corbusier) takes part in a revue *L'Esprit Nouveau*. Brussels. First Ensor exhibition at the Giroux gallery.

regaining consciousness.
Jeanne Hébuterne, eight months pregnant, commits suicide the following day.
On 27 January Modigliani is buried in Père Lachaise cemetry.
It is not until several years later that, at the insistence of the artist's brother, Emmanuel Modigliani, the body of Jeanne Hébuterne is exhumed and buried beside her lover.

Cologne. The Dadaist works of Max Ernst and Baargeld cause a scandal at the Brasserie Winter.

Bibliography

BUISSON, Sylvie:*L'Ecole de Paris et Modigliani.*
Graphis Arte, Livorno, 1988.

CELANT, Germano and PONTUS, Hulten: *Arte Italiana, Presenze 1900-1945.*
Bompiani, Milan, 1989.

CERONI, Angela: *Modigliani, les nus.*
La Bibliothèque des Arts, Paris, 1989.

CASTIEAU-BARRIELLE, Thérèse: Modigliani.
A.C.R., Paris, 1987.

CONTENSOU, Bernadette, MARCHESSEAU, Daniel: *Modigliani.*
Catalogue, Musée d'Art Moderne, Paris, 1981.

DURBÉ, Dario and Vera: *Modigliani, gli anni della scultura*
Mondadori, Milan, 1984.

MANN, Carol: *Modigliani.*
Thames and Hudson, London, 1980.

MARCHESSEAU, Daniel: *Modigliani.*
National Museum, Tokyo, 1985.

MARCHESSEAU, Daniel: *Modigliani.*
Exhib. Catalogue, Fondation Pierre Gianadda, Martigny, 1990.

MODIGLIANI, Jeanne: *Modigliani raconte Modigliani.*
Graphis Arte, Livorno, 1984.

NICOIDSKY, Clarisse: *Modigliani.*
Plon, Paris, 1989.

PARISOT, Christian:
Amedeo Modigliani, Centenario della nascita.
Pirra, Turin, 1984.
Amedeo Modigliani, dessins.
Guida, Naples, 1984.
Modigliani.
Graphis Arte, Livorno, 1988.
Paris, Patrie des peintres étrangers.
Mainichi, Tokyo, 1989.
Paris, Capitale des Arts.
D. Imbert, Paris, 1989.
Modigliani, il segno.
Electa, Milan, 1990.
Catalogue Raisonné Amedeo Modigliani. Vol. 1,
Graphis Arte, Livorno, 1990.

PATANI, Osvaldo: *Modigliani.*
Mazzotta, Milan, 1985.
Modigliani à Montparnasse.
De Luca, Mondadori, Verona, 1988.

RESTELLINI, Marc, PARISOT, Christian:
Portraits et Paysages chez Zborowski.
Carrefour Vavin, Paris, 1989.

ROY, Claude: *Modigliani.*
Nathan, Paris, 1985.

WARNOD, Jeannine: *Le Bateau-Lavoir.*
Mayer, Paris, 1986.
Les Artistes de Montparnasse.
Mayer, Van Wilder, Paris, 1988.

Acknowledgments

Archives Légales Amadeo Modigliani, Paris and Livorno
Guido Guastalla, Director, Casa Natale

Association des Archives Artistiques Buisson, Paris

Justman-Orloff and Kamir, Paris
Jeanine Warnod, Paris
R. Dufet Bourdelle, Paris
C. Arrigoni, Paris
Nicole Rousset Altounian, Mâcon
Maria Corral, Barcelona
Janet Anderfuhren, Paris

Didier Imbert, Fine Arts, Paris
Lucio Capparelli, President 'Casa di Risparmi di Livorno',
Livorno
Samir Traboulsi, Paris
G. Baudouin, Orléans
André Schoeller, Paris
Jean Digne, Paris
Stefano Pirra, Turin
Denis Roche, Paris
Enzo Maiolino, Bordighera
Guy Loudmer, Paris
Daniel Malingue, Paris
Paul et Gilbert Pétrides, Paris
Dominique Buisson, Paris
Ader, Picard, Tajan, Paris
Klaus Perls, New York

Ministère de la Culture, Paris
Fondation Granville, Dijon
Archives Hôtel Drouot, Paris

Galerie Melki, Paris
Musée de Montmartre, Curator: Claude Charpentier,
Administrator: André Roussard, Paris
Chicago Art Institute
Harvard University Art Museum, Harvard
Centre National d'Art et de Culture Georges Pompidou, Paris
Civiche Raccolte d'Arte di Milano, Milan
Galleria Nazionale d'Arte Moderna, Rome
Hanover Gallery, London
Kunstmuseum, Basle
Kunstmuseum, Lucerne
Musée Calvet, Avignon
Musée d'Art Moderne de la Ville de Paris, Paris
Musée d'Art Moderne du Nord, Villeneuve d'Ascq
Musée des Beaux-Arts, Grenoble
Musée des Beaux-Arts, Dijon
Museo des Bellas Artes, Buenos Aires
Musée du Petit Palais, Geneva
Museum of Art, Rhode Island
Museum of Fine Arts , Baltimore
Museum of Fine Arts, Edeton
Museum of Fine Arts, Philadelphia
National Gallery of Art, Washington
Pinacoteca Civica G. Fattori, Livorno
Solomon R. Guggenheim Museum, New York
San Diego Museum of Arts, San Diego
The Barnes Foundation, Merion
The Chester Dale Collection, New York
The Norton Gallery and School of Art, West Palm Beach
The Tate Gallery, London

and all those individuals who helped in the compilation of
this book, particularly Madame Carla Guastalla.

Produced with the assistance of L'Institut des Arts Visuels,
Orléans.

The artist's works reproduced in this book are listed in the Archives Légales, Amedeo Modigliani, Paris and Livorno.

Printed in France
by Horizon Group